DEATH *of a*
Pinehurst Princess

⟩⟩ DEATH *of a* ⟨⟨
Pinehurst Princess

The 1935 Elva Statler Davidson Mystery

STEVE BOUSER

Charleston · London

THE
History
PRESS

Published by The History Press
Charleston, SC 29403
www.historypress.net

First published 2010
Second printing 2011
Third printing 2011

Manufactured in the United States

ISBN 978.1.59629.180.5

Library of Congress Cataloging-in-Publication Data

Bouser, Steve.
Death of a Pinehurst princess : the 1935 Elva Statler Davidson mystery / Steve Bouser.
p. cm.
ISBN 978-1-59629-180-5
1. Davidson, Henry Bradley, 1892-1972. 2. Murder--Investigation--North Carolina--
Pinehurst--Case studies. 3. Davidson, Elva Statler, 1912-1935. 4. Victims--North Carolina-
-Pinehurst--Case studies. 5. Pinehurst (N.C.)--History. I. Title.
HV8079.H6B68 2010
364.152'3092--dc22
2010045210

Contents

CONTENTS

Prologue

Diane McLellan might seem an unlikely cold-case detective. If Central Casting went looking for someone to play a contemporary woman who becomes obsessed with the idea that a wealthy young socialite who died under suspicious circumstances three-quarters of a century ago is crying out to her from the grave to get to the bottom of her story and tell it to the world, Diane might not get the part.

But on a spring day a few years ago, it was that peculiar, unrelenting, near-supernatural sense of mission that first compelled Diane to drive from her home near the resort village of Pinehurst, North Carolina, to the nearby town of Southern Pines and call on the local newspaper editor.

That would be me.

Diane came to my office in the company of the late Mary Evelyn de Nissoff—who, before retiring, had spent many years covering Pinehurst for our thrice-weekly paper, *The Pilot*. Mary Evelyn thought Diane's determined effort to solve the obscure but tantalizing old mystery she had stumbled upon might make a good feature story for us. It didn't take me long to see that it was more than that.

Diane McLellan once described herself as "just an average person that you'd probably walk by on the street and never notice." After growing up in a blue-collar Ohio community and graduating from high school in 1970,

she married a career army noncom who spent a good part of his military career with the Eighty-second Airborne Division based at Fort Bragg, which occupies a sprawling section of real estate between Southern Pines and Fayetteville to the southeast. After he closed out his enlistment elsewhere, they decided to return to this area and hang it up.

"When we were on the way back here for the last time," she told me, "someone told us, 'Hey, you ought to check out Moore County.' So we came here, and it was like a whole different planet! And we stayed. We lived in Aberdeen, then Southern Pines, and now we've built a home on the outskirts of Pinehurst, buried in the woods."

Compared with its surroundings, lower Moore County is, indeed, a whole different planet. I've heard it described as "an island of wealth in the middle of a sea of poverty, an oasis of sophistication in the middle of a southern desert." Moore always ranks a couple of clicks above its neighboring counties in any listing of things like household incomes and educational levels, mostly because so many well-off, well-schooled, well-traveled people gravitate in this direction to retire or play golf. (Some folks are even lucky enough to come here to work, as I did in 1997. I had interrupted a conventional newspaper career to spend three or four years involved in idealistic and adventurous media assistance work in immediate post-Soviet Russia and Eastern Europe, until my wife and daughter, tired of being dragged all over, finally announced: "Okay, you've saved the world. Now we want a normal life again.")

The contrast between the Pinehurst area and environs is especially dramatic for people who, like Diane and her husband, Mike, come here from Fort Bragg/Fayetteville. The image that lingers with outsiders after they drive through the latter is one of an unrelieved urbanscape of traffic-clogged, four-lane roads lined with bars, garish fast-food emporiums, pawnshops, tattoo parlors and neon-lit topless joints that have signs outside urging you to "Support Our Troops." Cross over into Moore County and you feel the stress quickly falling away as you begin to encounter peaceful horse farms, well-groomed golf courses and quaint tree-lined streets flanked with funky old resort dwellings that often have forest floors of low-maintenance pine straw where their lawns should be. We support our troops, among other ways, by giving some of them a decent, normal, civilized place to live. A great many Special Forces officers and noncoms quietly raise their families here, just as quietly vanishing from our church pews and our PTA meetings when there's a crisis abroad. You lie in bed and hear wave after wave of heavy troop transport planes taking off and rumbling overhead at night, and you can only wonder what's going on half a world away.

It was a single old photograph, picked up at a yard sale, that turned Diane McLellan into a history detective. She found it among a mixed bag of old black-and-white scenes from the golden age of Pinehurst, most of which involved golfers, racehorses and hunting dogs. But she kept coming back to that one battered old print, bent and torn around the edges and aged to subtle tones of sepia and walnut brown.

At first glance, the image looked like little more than a snapshot of a half-dozen guys killing time in front of a low building. But a more careful look revealed layer after layer of detail, and there were intriguingly cryptic, handwritten inscriptions around the edges.

It wasn't hard to guess who the six men in the foreground were: hotshot photographers, apparently from big-city newspapers and wire services. But what were they doing down south in Smallsville? Covering a major story of some kind, perhaps. They wore well-pressed three-piece suits with razor-sharp creases in the pants and folded handkerchiefs in their breast pockets. They

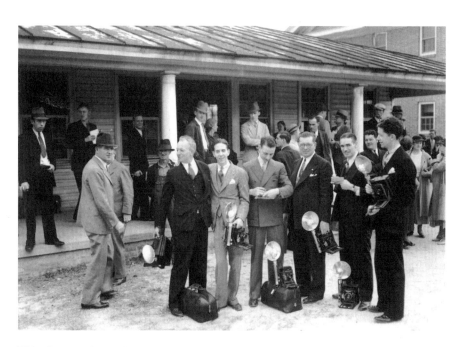

This photograph, purchased at a yard sale, first set Diane McLellan off on her investigative quest. Her curiosity was piqued by its mysterious inscription. *Courtesy of Diane McLellan.*

were standing in a dirt street or yard in front of a simple one-story wooden building, evidently during a recess in some kind of official proceeding. All six proudly displayed the latest thing in state-of-the-art imaging devices: bulky Speed Graphic cameras with shiny new leather gadget bags and identical flash attachments the size of satellite dishes.

The ample margins of the photograph displayed a random assortment of semi-decipherable notes. "Larry 'Nuts' Byrd" read the large, flourishing signature at the bottom. Somebody named Al identified himself as "the city boy from the country." In the lower right corner was this message: "Hope you are in Cuba when I spend honeymoon in N.Y.—A.E. Scott, Wash DC."

But it was the scribbled notation angled across the upper left, with one word she could only guess at, that grabbed Diane and wouldn't let her go.

> *Trial of the* [questioned?] *Davidson story—It may be murder but who can tell. One of those things. Pinehurst, N.C.*

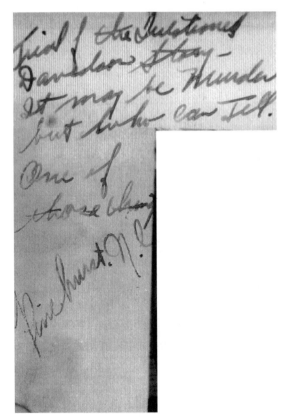

The inscription on the picture of photographers taken during the Davidson inquest in 1935 reads, "Trial of the [questioned?] Davidson story—It may be murder but who can tell. One of those things. Pinehurst, N.C." *Courtesy of Diane McLellan.*

The Davidson story? Murder? What was that all about? Unable to put that riddle out of her mind, Diane asked around about who might be able to shed some light on it. A couple of people directed her toward Khris Januzik at the Tufts Archives in the heart of Pinehurst, who knew where most of the figurative bones were buried in the village. The archives, named for the resort's founding family, contained a wealth of documents and artifacts.

Once Khris (who happened to be in her last day on the job) had had a look at the stack of old photos, she was quickly able to identify many of the people in them. But when she looked at the picture of the guys standing in front of the building and read the inscription in the corner, she exclaimed, "Oh, my God! That's the Elva Statler Davidson case!"

Khris then pulled her chair closer to Diane's and began filling her in: "Have you heard of the Statler hotel chain? Well, Elva was an adopted daughter of Ellsworth Statler. She married Henry Bradley Davidson in January 1935, right after inheriting the better part of $1 million. On Valentine's Day, about six weeks after their marriage, Elva got on a train from Pinehurst to Boston and had her will changed, leaving all she had to Brad. Two weeks later, she was found dead in her garage out here off Linden Road, alongside her 1934 Packard. It hit every newspaper front page in the country. There was an inquest, but they never officially determined what happened to her. It has been rumored that the Tufts family wanted this case buried. It was the Depression, and the last thing their little resort needed was trouble. A lot of people thought Brad did it—or at least played some kind of role in her death. But it was never solved."

Like most contemporary residents of the Pinehurst area, Diane had never heard even a whisper about Elva Statler Davidson or the lingering mystery of what happened to her on that cold morning in 1935. But even in those early moments, with only a beat-up old photograph to go on, she thought she knew.

"Sounds like he did it, don't you think?" she said. "He killed her. He had to have killed her for the money."

"I don't know if he did or not," Khris said, standing up to signal that she had other business to attend to. "Why don't you see if you can find out?"

Diane ended up spending years doing just that. She pursued every possible aspect of the Davidson case down a seemingly endless trail that led from courthouse basements to archive rooms in Washington, D.C., to a dozen libraries and newspaper morgues up and down the eastern seaboard, to a couple of distant cemeteries, to personal interviews with numerous aged witnesses or their descendants and to dozens of websites. She amassed boxes and filing cabinets bulging with court documents, diaries, newspaper clippings, photographs, maps, merchandise receipts, interview notes, e-mail printouts and books ordered from eBay, each contributing some new element to her meticulous reconstruction of the Davidson story in minute detail—all the way down to the color of the panties Elva wore on her wedding day: peach.

Along the way, Diane made the acquaintance of the brilliant, colorful and sometimes cantankerous Mary Evelyn de Nissoff, who had learned everything there was to know about Pinehurst in her decades of reporting for *The Pilot*—not to mention a great many things that Pinehurst would rather not have known. And not only that, but she had actually had a casual acquaintance with Elva Statler as a child. Tall and angular and given to severely short haircuts and outrageously clunky, dangling earrings of pink and aqua, Mary Evelyn also had a strong streak of the mystical and paranormal in her and believed in ghosts and predestination. By the time the two of them showed up at my office, Mary Evelyn had succeeded in infecting Diane with the notion that it may have been no accident that that old picture of the photographers at the inquest had found its way into her hands and one thing had led to another.

"I think things are intended," she later told me. "Somebody said coincidence is God's way of remaining anonymous. I think things have a pattern. I've found it to be so. Why would Diane, from the middle of Squedunk or wherever she's from—why would she find this picture at a yard sale and feel like this girl was calling out to her to solve the mystery? They say murder victims do not rest easily until the murderer is found. So I can see Elva pushing to get this story out—to get people to really look into it and find out if she really was done wrong by this guy."

Caught up in the "Elva Thing" myself, I, too, did quite a bit of independent snooping into it and remained convinced that it was more than a newspaper feature story. Still, I never knew quite what to do with it and, busy with my day job, found excuses to let it lie around for too long. Then my friend Jim Dodson, three-time *New York Times* bestselling author and editor of our sister publication, *PineStraw* magazine, persuaded me to do a cover story on it for him, which he headlined "Death of a Pinehurst Princess." The positive response from readers ultimately got me off my backside and sparked the expansion of that article into this book.

One important note: Diane McLellan prefers to stay in the background ("it's not about me, it's about her"), but it is she who single-handedly sparked the current revival of interest in the Davidson case. The research materials she gathered so painstakingly lie behind the bulk of the content presented here. Because she's not comfortable being part of the story herself, the reader will hear nothing more directly about Diane in this book. But she remains its *sine qua non*—"without which, nothing."

Occurrence at Edgewood Cottage

S hortly after 7:30 a.m. on Wednesday, February 27, 1935, butler Emanuel
Birch went to the front room of Edgewood Cottage, parted a curtain
and glanced outside. It was going to be a cold, sunny morning—downright
frigid for the normally temperate little inland resort colony of Pinehurst,
North Carolina.

The diminutive Birch, a black man of indeterminate age whom everyone
called "Mannie," expected to see an automobile sitting out there—the twelve-
cylinder 1934 Packard convertible roadster whose upkeep was his responsibility.
But on this morning, the horseshoe drive stood empty, except for a scattering
of longleaf pine needles that had fallen onto the white pea gravel.

Birch's newlywed employers, Mr. and Mrs. Henry Bradley Davidson, had
come home from a night of partying at who knew what hour. Normally they
would leave the car in the driveway. But they had the use of a garage at the
back of the next-door neighbor's house, and on this night they apparently
had decided to drive the Packard back there and put it away before they and
their houseguests came inside to sleep off their hangovers.

After doing some routine chores, the butler made his morning drive to the
Pinehurst Post Office to check on the box the Davidsons maintained there.
It was well after 8:00 a.m. when he pulled back into the rear yard of the
leased "cottage," really a ten-room mansion. He walked toward the porch
with the frosty grass crunching under his feet. As he stepped into the kitchen
next to his servant's quarters and took off his jacket, the aroma of freshly
brewed coffee greeted him. Pearl Watson, the cook and maid, was girding for
the descent of the white folks. As they waited, the two domestics exchanged

clucks of disapproval about the sometimes scandalous goings-on involving the girlish mistress and older master of the house and their racy circle of friends, who acted as if this were still the Jazz Age of the twenties instead of the Great Depression of the thirties.

The usual practice at Edgewood Cottage was for the two servants to awaken the residents and guests at 9:00 a.m. if they weren't already up by then. As that hour approached, Birch helped Pearl start breakfast. But he kept going to the window and looking out at the garage across the way. Was the car there or not? What if Mrs. Davidson had taken one of her early morning drives and fallen into some kind of trouble? In any case, if the car was there, he ought to see if it needed cleaning up.

Birch put his jacket back on, went outside and crossed to the garage. Arriving at the rightmost of the three segmented wooden doors, he took hold of its steel handle and hefted it upward, waiting as it completed its smooth course along the curved metal tracks and stopped overhead. The twang of the vibrating springs faded to silence. The black Packard sat there against the right wall, having been backed in. Birch took a step inside the dim building and reached up to begin pulling the door closed behind him. Then, as the warm air inside started flowing out, it hit him in the face: the powerful, stifling odor of trapped exhaust fumes.

Birch coughed and covered his mouth. He pushed the door back open again and stepped outside to take a few gasps of fresh, cold air. Then, turning back toward the garage, he saw that the driver's side door of the Packard was open. And something was protruding from beneath it: a woman's foot, wearing a house slipper.

"I was scared," Birch would later recall. "But I walked over and looked. It was Mrs. Davidson."

She was clad in a light wool sweater and skirt that didn't seem warm enough for this bitter weather. And what was she doing in that odd, contorted position, sprawled half in and half out of the car, one knee on the running board, face downward, arms extended across the seat and floorboard? Still coughing and covering his mouth, Birch stepped around the driver's door—glancing at the dashboard to notice that the ignition switch was still on though the engine had stopped running—and tentatively approached his mistress. He knelt and placed his hand on her shoulder, which still felt warm.

"Mrs. Davidson, get up!" he cried, shaking her. But she didn't move.

The 1935 Elva Statler Davidson Mystery

Curtis Campaigne and his wife, Edna, visitors from New Jersey, were still sound asleep in the downstairs guest room of Edgewood Cottage at 9:00 a.m., so they never heard Birch's anguished cry at the door of Brad Davidson's room upstairs: "My God, Mr. Davidson, Mrs. Davidson is dead!" But they knew at once that they had a bad situation on their hands when the maid, Pearl, came banging on their door seconds thereafter and jolted them awake with an urgent notification: "Something has happened to Mrs. Davidson in the garage!"

The Campaignes followed the agitated Pearl through the house to the back door. There, Edna paused while Curtis proceeded across the frosty backyard, half-walking and half-running as he approached the three-car garage in the adjoining lot. Inside, he could dimly see the tall figure of Brad Davidson, who had thrown on a pair of trousers and a sweater over his pajamas. He was standing with the shorter Birch on the far side of the 1934 Packard, which sat parked with its chrome-emblazoned front end facing the open sliding door, its shiny black finish emitting a sinister glint.

As he walked around the open driver's side door, Campaigne saw it: the youthful, athletic body of Elva Statler Davidson, motionless as a wax museum figure and wearing a brown sweater, wool skirt and slippers, lying oddly crouched in the car's doorway, half in and half out. She looked still and small and alone, dwarfed by the massive car, her short-cropped, dark blonde head bowed in final defeat.

Brad Davidson knelt at his wife's side, feeling for a pulse and finding none. There were no funeral homes in Pinehurst, no ambulance services anywhere near. Brad had Pearl telephone the house physician for the Carolina Hotel, Dr. M.W. Marr, who lived across Linden Road and down a few houses. As Birch waited for him out by the street, Brad took hold of Elva's body as if intending to pick her up or make her more comfortable. But at that moment, Curtis Campaigne blurted something out.

"Don't touch her!" he cried.

Davidson looked up at him questioningly. Campaigne explained that he had "read someplace that a body shouldn't be touched under such circumstances, if there was a chance of murder."

Murder? Who said anything about murder? Ignoring Campaigne's advice, Brad sat on the running board and cradled his wife's head in his lap. As they waited there, Campaigne asked the seemingly distraught Brad

what he thought had happened. He said he had no idea. The last time he had seen his wife, he said, was when they parted sometime before 5:00 a.m., more than four hours previously. The last words she spoke, he said, were, "Goodnight, darling."

When Dr. Marr finally arrived at Edgewood Cottage, carrying his black bag and not even having bothered to dress fully, he was quickly escorted back to the garage. There was no time for even subdued handshakes. He got right to his grim work.

As the others looked on anxiously, Marr knelt there amid the tools and garden implements, applied his stethoscope and lifted a half-closed eyelid to check on Elva's reflex responses. He took only a minute to ascertain that, alas, it was too late for him or any other person on earth to do any good. No heartbeat, no breath. Elva Davidson was quite dead. Though he thought the fit young body had begun displaying the first signs of rigor mortis, he was surprised at how warm it still felt. The coloration of the face, which Dr. Marr described as markedly "flushed," provided him with a broad hint as to the cause of death. Still, whether acting on the off chance that the girl could be revived or going through the motions in an effort to make her distraught husband and friends feel that something was being done, Dr. Marr stood up.

"Let's get her to the hospital," he ordered.

Brad Davidson, with assistance from Curtis Campaigne and Birch, wrapped Elva in a blanket, picked her up and laid her as gently as possible in the cramped back seat of the low-slung Packard. Her body, weighing about 130 pounds, was all dead weight, still awkwardly limp even if it was just beginning to stiffen. Then Brad, with Campaigne sitting next to him in the shotgun seat, pulled out onto McKenzie Road, drove up to Linden Road, turned right and stepped on the gas. Dr. Marr followed in his own car.

The new Moore County Hospital, a source of great community pride, stood three miles away on the other side of town. It fronted on Page Road, named for the family of the man who had sold the logged-over land that would become Pinehurst to James Walker Tufts in 1895. The route taken by the little two-vehicle emergency convoy, skirting the village on the south, took less than five minutes. The men got help conveying Elva to an examining room

inside the hospital, where Dr. Marr and two attendants, using a respirator, began trying to revive her. They gamely continued to press their futile effort for nearly two hours before the doctor finally gave up and officially declared his patient deceased at 11:20 a.m.

Scarcely twelve hours earlier, Elva Statler Davidson, bride of a few weeks, superb athlete, hotel heiress and society darling, had been hobnobbing with other socialites at a fancy charity dinner to benefit this very hospital. Now she lay cold and lifeless in one of its rooms.

As mysterious as the circumstances leading to her death that morning were several curious details that Dr. Marr and his assistants discovered: her body bore a number of bruises, some of them evidently fresh. Despite the raw February morning, she had been dressed inappropriately for a cold snap, wearing a sweater and a mismatched skirt that seemed way too big for her—so much so, it was later said, that if she had stood up, it might have fallen off. Rolled up in the hem of the sweater were a tube of lipstick, several golf tees and about thirteen dollars in cash. And, perhaps strangest of all, she wore no undergarments.

A Melancholy Gypsy Tune

The news raced along the village grapevine like fire along a fuse. By noon, almost everyone in the close-knit winter colony knew what had happened at Edgewood Cottage out on the corner of Linden Road and McKenzie. At that early point, many of the gossipers were attaching the "s" word to it: suicide. Locking oneself in a garage and turning on the engine had, after all, become a standard way of ending it all in the three decades since the advent of the automobile.

"A horrible day," Hemmie Tufts, granddaughter-in-law of Pinehurst founder James Walker Tufts and the friend who had introduced Brad and Elva just a year earlier, wrote in her diary. "Got word Elva had attempted suicide. Then Allie [Hemmie's sister-in-law, Allie Vail] came in with the news that Elva was dead. Carbon monoxide. It all seemed so horrible after being together just last nite…We went to movies for escape. 'All the King's Horses.' Took a walk alone. Couldn't talk about it…All is so horrible and unreal…Deadly sorry for Brad."

But some thoughtful residents had doubted from the beginning that a troubled Elva Statler Davidson had simply gassed herself and that was the end of the story. For one thing, there was the question of motive. "What people in Pinehurst's winter playground of the rich cannot understand," a United Press correspondent later wrote, "is why Mrs. Davidson should want to take her life. Outwardly, she had everything to live for: beauty, youth, wealth, social position and a husband who is a member of a prominent Washington family."

And then there were the nagging questions raised by the bits and pieces of evidence that had so far surfaced. No matter how you looked at them,

they didn't seem to add up to a story that made a lot of sense. Whether or not there was going to be a trial, as such, this was clearly not going to be a cursory examination that would go away quickly—especially given the prominent cast of characters.

Of all the mysteries hovering around the case of Elva Statler Davidson, none was so puzzling as the inexplicable, illogical position in which her body was found. At this early stage of discussion, every plausible explanation—suicide, murder or accident—seemed to leave a big question or two unanswered.

Suicide: If a despondent young woman were determined to kill herself with carbon monoxide inside a closed garage, surely she would sit down comfortably behind the wheel, start the engine and lean back to let the gas do its work. As a poor second alternative, she might go sit or lie near the tailpipe in hopes of getting a quicker, more potent dose.

Murder: On the other hand, if someone else were intent on murdering a young lady and making it look like suicide, wouldn't he take care to place her body (presumably already dead or incapacitated through other means) behind the wheel? Surely the last thing he would do is to dump her in a pile sure to arouse suspicion and then go away.

Accident: First of all, it was hard to imagine, under the circumstances that prevailed in this case, and considering how long it takes a lethal dose of monoxide to build up, how a fit young woman could possibly end up dying by accident in that garage, which had plenty of windows that could be broken out. And even if she had, was it likely she would end up being huddled how and where she was found?

As described by that small group of heartsick and helpless witnesses who had seen her, the position almost sounded like that of one who had collapsed while climbing uphill on hands and knees. Or backing downhill. "If you were stepping out of a car backward and suddenly fainted," a shaken Edna Campaigne told others in attempting to imagine a scenario that would somehow fit the awful thing she had seen that morning, "that would be the position her body was in."

An anonymous correspondent who filed an Associated Press story on that first day seemed to lean toward the theory that Elva, known to suffer

from insomnia, had taken an early morning drive and then somehow died accidentally while preparing for a trip to the golf course. But why would a young woman choose to take a drive or play a round of golf while wearing house slippers, somebody else's ill-fitting skirt and no hat, panties, girdle, brassiere, camisole or stockings?

One of those harboring early misgivings about the case was Moore County sheriff Charles McDonald.

Described as "a squared-away guy," he had one of North Carolina's most expansive counties (at more than seven hundred square miles, half the size of Rhode Island) to look after. And Pinehurst, an unincorporated village—really more of a company town—with no police department and no crime to speak of, was part of the sheriff's beat. The village had a lone constable, a man named Deese, but he seems to have bowed out early and left the investigation up to the high sheriff.

McDonald himself took his own sweet time picking up on the gravity of what had happened. It was 10:00 a.m. on that first day—while Dr. Marr was still working in vain to bring some life back to the body—when somebody called the sheriff's office in Carthage with the news of "a lady dead at the hospital." McDonald didn't arrive in Pinehurst (twelve miles away) until 11:30 a.m. The hospital called again at noon, only to find that the sheriff had gone off to his weekly Kiwanis Club lunch.

McDonald still had a toothpick in the corner of his mouth when he finally walked into the hospital a little after 1:00 p.m., but he quickly got down to business. He might have been a country boy, but he knew right away that he had a big case on his beat, and it didn't take him much longer to recognize that certain pieces of the puzzle didn't fit together quite right. He made sure that another man became involved in the investigation from the start: Acting Coroner Hugh Kelly. (Coroner Carl Fry was out of town.) McDonald and Kelly paid their first visit to Edgewood Cottage between 3:00 and 4:00 p.m. Neither had ever handled a case quite like this before, and they improvised as they went along.

First of all, they wanted to find out more about what had happened the previous night, most of which the Davidsons and their friends had partied away.

The first party that the group had gone to after putting on their tuxes and evening gowns was the premier local social event of the year: the annual Hospital Ball at Pinehurst Country Club.

"Everything that can be done to make a party a roaring success has been done by the finance committee of the hospital auxiliary, which is sponsoring the Charity Ball on February 26," *The Pilot* had reported a few days before the event. "Fred Kibler's Casa Nova orchestra will play, and we all know what excellent dance music that is."

Mr. and Mrs. Herb Vail, close friends of the Davidsons, weren't just attending the dance. They were part of the entertainment. "At intervals during the evening," the paper reported, "the Casa Novas will be relieved by the local amateur orchestra known delicately as the 'B.O.'s,' consisting of Mrs. Herbert Vail, Herbert Vail, Bob Page, John Leland and Liv Biddle... The dancing will take place in the regular ballroom. Specialty acts and stunts have been arranged to entertain between dances."

Herb Vail had become part of the Tufts family when his sister, Allie Vail, a good-looking, dark-haired horsewoman and tournament-class tennis player, married Richard S. Tufts, grandson of patriarch James Walker Tufts and son of Leonard Tufts, president of Pinehurst Inc. Herb and Minnie could always be counted on to be the life of any party.

Lots was going on that night. "Mrs. Myron Marr [wife of Dr. Marr, who would have his hands full in a few hours] and Mrs. Percy Thomson will be in charge of a 'take a chance' booth, where the customers may win a small fortune or lose their shirts," the paper advised. "Donald Sherrerd will act as official barker to lure suckers in!...Tickets for this gay three-ring circus are $5.00 for a couple and $3.00 for a single person."

So a good time would be had by all at the charity ball. Or almost all. There was one notable exception: Mrs. Henry Bradley Davidson. She was not having any fun at all. And she continued to be a party pooper all night, try though the others might to cheer her up and make her get with the program. Nothing seemed to go right in that regard. Local artists had contributed "posters of various kinds, amusing, decorative and even sketches of local celebrities," which could be bought at auction. They were described as "just what you've been looking for to liven up some particular corner of a room that has never looked just right." So Elva bought one of them, but Brad

had been overheard harshly disapproving of her purchase in mock playful fashion, rebuking her in front of others and plunging her even deeper into her apparent despair.

Not even the strolling accordionist who had been engaged to wander among the seated guests, "playing any tune anybody asks for," did anything to improve Elva's spirits. In fact, he later made things even worse.

Montesanti's Spaghetti Camp was a roadhouse located near a creek bottom off the old Morganton Road, which wound a kind of back route between Pinehurst and Southern Pines. The "camp" was really just an Italian restaurant housed in a rambling, wooden structure that looked as if it might have evolved section by section as a one-story wing was added on to an early

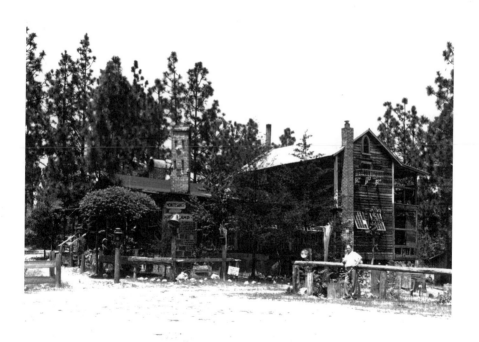

The building housing Montesanti's Spaghetti Camp, where the Davidsons and friends dined in the wee hours of the morning of her death, stood on land that is now part of the Lawn and Tennis Club. *Courtesy of the Tufts Archives, Pinehurst.*

two-story farmhouse. It had once served as a hunting lodge. There was an ancient stone chimney and weathered wooden siding that appeared never to have felt the touch of a paintbrush.

Angelo Montesanti had brought his tribe to Moore County in 1912. Besides running the camp on the side, Angelo was the chef at the Highland Pines Inn during "the season." In the summer, when Pinehurst mostly shut down, the family traveled to Charleroix, Michigan, to work at a sister inn. The casually inviting spaghetti camp was a popular spot with the fast Pinehurst crowd, which admittedly didn't have a wide array of choices for evening entertainment. The central village had always been known for rolling the sidewalks up and storing them away at 5:00 or 6:00 p.m.

Angelo was sound asleep when someone came pounding on his locked door and demanding service sometime between 2:00 and 2:30 a.m. on Wednesday, February 27. He looked out into the yard to see a party of eighteen people, some yawning and a little unsteady on their feet, climbing out of a convoy of snazzy automobiles. The women wore rumpled evening gowns, the men tuxedos with their ties loosened. They had just come from the charity ball at the Pinehurst Country Club, they informed the proprietor, and they were starving.

Whether welcoming an opportunity to live up to his own advertising slogan, "Where Hospitality Rules," or (more likely) responding to the promise or expectation that this bunch of rich playboys and party girls would make this wee-hours imposition more than worth his while, Angelo complied and invited the gang of impromptu guests in. Soon he was turning up the lights, firing up the stoves and waking up the help.

As he interviewed spaghetti camp employees in the harsh light of that same day, Sheriff McDonald quickly zeroed in on one witness: a waiter named John Nostragiacomio, whom newspapers later would invariably describe as "bushy-haired."

The thing that struck him, the waiter said, was that while seventeen of the guests who had barged in were having a good time around the pulled-together tables, one of them most clearly was not: Elva Statler Davidson. "Everybody in the party except Mrs. Davidson was laughing and having fun," he said. "She sat at the head of the table, and her husband sat several

chairs away from her. They had brought a harmonica player with them from the dance at the Country Club, and there was some music."

Nostragiacomio was wrong about the "harmonica" player. The musician was the aforementioned strolling accordion player, one Carlo Restivo, who had been brought along from the ball. But the waiter was certain of one thing: he didn't see Elva Davidson smile once during her stay at his establishment. "Her eyes were wet," he said, "and she finally began to cry. She cried very hard."

The bitter weeping continued for a long time, Nostragiacomio told investigators. He would notice it each time he brought another plate of steaming pasta, basket of crisp garlic toast or bowl of salad to the table.

The waiter also made a point of saying that he had not noticed Mrs. Davidson's husband making any attempt at all to comfort or console her. Rather, he seemed cold and remote, largely ignoring his conspicuously distraught bride as he talked, laughed and danced with others. Though not everyone who had been at Montesanti's could swear that they had seen Elva crying, and no one saw her quarreling with her husband at that stage, several friends recalled that she had "feigned gaiety but seemed depressed," both at the charity ball and later at the spaghetti house.

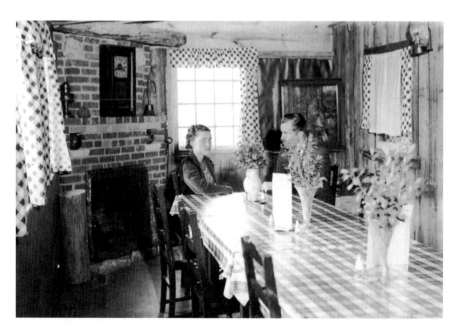

Interior of Montesanti's. *Courtesy of the Tufts Archives, Pinehurst.*

When the accordionist stopped near Elva, she requested a song. But when he played it, his fingers racing like spiders across the black and white keys, it only made Elva sob louder. The song that so affected her was described only as "a melancholy Gypsy tune."

The winter's dawn was less than three hours away when the members of the party, suspended somewhere between intoxication and hangover, finally paid their bills and tips, toddled out into Montesanti's sandy parking lot, bid each other adieu, slipped into their cold car seats and departed in their separate ways with their minds on a good day's sleep. At that point, several in the party agreed, tears were still welling in Elva's eyes.

Sheriff McDonald and Coroner Kelly had heard more than enough. Here they had a wealthy young woman who displayed signs that something was deeply troubling her at a couple of parties. Her husband of seven weeks turned his back on her. Back home, there was an oddly extended, wee-hours quarrel between the two of them about who would park the car. Hours later, she was found dead amid highly peculiar circumstances. The doctor who examined her body told of bruises and baffling attire or lack thereof. A husband/beneficiary who stood to become instantly wealthy as a result of his new wife's death seemed to have some explaining to do on several points.

McDonald and Kelly lost no time deciding what to do: they would order an autopsy. And they would call a closed-door inquest immediately, barring the press and everybody else except witnesses. They would order all those involved to show up, take an oath and come clean on what they knew—beginning that very afternoon, while their memories were fresh. The six humble, homegrown, hardworking members of the hurriedly assembled coroner's jury might not look much like "peers" of the idle, fun-seeking, upper-crust northern transplants who would be required to testify before them, but the two men resolved that they would damned well get to the bottom of this puzzling and increasingly sensational story.

And they would resist those forces that could be expected to try to cover the whole thing up—forces whose attitude was summed up in the phrase that had already become a standing local joke: "Nobody dies in Pinehurst."

Not Conceivably an Accident

U p at 10:50 to face another awful day," Hemmie Tufts wrote in her diary on Thursday, the last day of February 1935. "Took a walk…Had to listen to this gossip. Got mad. Convinced Elva was not a suicide! Tragic!"

It was an eventful day. By the time Hemmie had arisen, Dr. M.W. Marr of Pinehurst and Dr. C.C. Carpenter of the Medical School of Wake Forest College near Raleigh had already completed an autopsy on Elva Statler Davidson at the college, splitting her fit young body open down the middle the way one would dress a deer. They took out the heart, liver, lungs and other vital organs for more thorough testing and examination at nearby Duke University; took blood and tissue samples and corked them into test tubes; and sawed the skull open to cut loose and remove the brain.

What was left of the cadaver was returned to Powell Funeral Home in Southern Pines. Once it had been released, plans were to transfer it to New York State, where the family would hold a private burial service. "Everything right now depends on the report of what was in her stomach," Acting Coroner Kelly said that night, though he did not elaborate on what authorities expected to find there besides some half-digested spaghetti and perhaps a little port wine.

The two doctors issued a joint statement saying that they had found a dozen minor bruises (or a half dozen, depending on which paper you read) on the young bride's right hip and thighs. *The Buffalo Times* would call them "abrasions," though that was apparently an error. The statement said that none of the bruises was more than forty-eight hours old. Dr. Carpenter, a pathologist, described them as "superficial," and Kelly said they "apparently had nothing to do with the death." No bruises were found on the head or upper part of the body.

The doctors said carbon monoxide poisoning was the "only condition found capable of producing death," which wasn't the same as coming out and identifying it as the cause. Carpenter left for Wake Forest that night, saying he would file a written report as soon as possible on the further chemical analysis of the brain and organs.

Henry Bradley Davidson had at first resisted having an autopsy performed. But that was before Alice Statler, the widow of Elva's adoptive father, Ellsworth, and the woman known by many as the wicked stepmother, made her formidable presence felt from afar. Because Brad, oddly, had taken no pains to make sure she was informed of her stepdaughter's death, Alice learned about it only through chancing upon the early AP story in *The New York Times*. It was she who called Pinehurst Inc. president Leonard Tufts to demand the postmortem. Alice also put several executives of the Statler Hotels corporation on a train to Pinehurst, accompanied by two company attorneys, William Marcy and Edwin Jaeckel—all under orders to look after family interests and accompany the body back to New York.

Attorneys Marcy and Jaeckel would join J.M. Broughton, a lawyer from Raleigh, who had been representing the family at the inquest. The growing entourage of legal eagles had an odd twist. M.G. Boyette of Carthage, described as "the prosecuting attorney of the Moore County recorder's court," also attended the jury sessions. But contrary to what one might expect, he was not there to look out for the people's interests. He was "representing Mrs. Davidson's husband, H. Bradley Davidson and his family," apparently picking up a little money on the side.

Meanwhile, the six male members of the coroner's jury, sequestered in the little, one-story, white-columned Community House in Pinehurst, sat through a second day of the inquest, listening as witness after witness testified in private about the events leading up to the death and the circumstances surrounding it.

Friday, the first day of March, was even more eventful. Reporters, attracted by the smell of a good story, were arriving in the little village from all over. And the proceedings, which threatened to become a three-ring circus, had a new ringmaster.

The redoubtable Alice Statler, still calling the shots from her office at Statler Hotels headquarters in Buffalo, disapproved of the way Sheriff McDonald and Coroner Kelly were handling the case. So she put in a call to none other than the governor of North Carolina, John Christoph Blucher Ehringhaus, who agreed to bring in a bigger gun and put him in charge of the investigation: Solicitor Rowland S. Pruette.

"Solicitor" was merely the old English term then applied to the public official who would now be called a chief prosecutor or district attorney. Pruette lived an hour to the southwest in the Anson County seat of Wadesboro, headquarters of the six-county Thirteenth Judicial District, which then included Moore.

Careless reporters would frequently misspell both of Rowland Pruette's names in various ways during the coming days, but personal vanity was the least of his concerns—though he does appear to have relished the limelight once he got going. He knew how to pose and defend a good argument. As a student at Wake Forest College, he had served on the debate team that beat its Davidson College counterpart to win the 1911 Silver Loving Cup sponsored by the Greensboro Chamber of Commerce. The issue was: "Resolved, that the United States should fortify the Panama Canal," and the Wake Forest team successfully argued the affirmative.

Pruette hadn't been a prosecutor long. A hard worker whose full head of hair turned gray and then white at an unusually early age, he was forty-five at the time of the Davidson case. He weighed well over two hundred pounds, quite a bit for a man who stood no taller than five feet, seven inches.

After spending a few hours getting his feet on the ground that Friday, Rowland Pruette called the growing number of reporters together and informed them of a decision he had made. Though the jury had been ready to throw up its hands and return a verdict of "death by unknown means," he and Coroner Kelly were suspending the inquest until the following Tuesday, when it would be possible to probe more deeply into a case that was becoming ever more troubling. The resumed inquest would be open to the press and public. And, where the jurors had been vacillating between accident and suicide, Pruette

didn't hesitate to announce that he was adding another option to the range of possibilities: homicide.

"I am not satisfied with the facts," he said, lifting the slouch hat he liked to wear and scratching his head.

To be perfectly frank, I am puzzled. I do not know whether it was a case of suicide, accident or murder. I have heard enough since I have been here to make me feel that a full investigation is necessary to meet the ends of justice, because of circumstances surrounding the case. It is a peculiar situation for a woman to go for an early-morning ride with only mules, a skirt and sweater on. Other facts include one that the butler got up at 7:30, looked in front of the home for the car and discovered that it was in the garage. He made no investigation immediately but went to the garage to wash the car and found the body. The body was still warm at 9:05.

In postponing the inquest's adjourned session, *The Washington Post* reported,

Acting Coroner Hugh Kelly said the delay was out of deference for the family, which had a brief private funeral service this afternoon, and to give the sheriff and solicitor time to prepare for questioning witnesses. Mrs. Davidson's body was put on a train for New York tonight [Friday] *and burial will be at Mount Kisco, N.Y., tomorrow. Accompanying the body were her husband, his brother, Richard Porter Davidson, of Washington, and Mrs. Davidson, and Mr. and Mrs. Nat S. Hurd, of Pittsburgh.*

Hurd had been the best man at Brad and Elva's wedding a few weeks earlier.

Another reason for delaying the resumption of the inquest, Kelly told reporters, was to make possible completion of the autopsy report, about which some questions were still left hanging. "A preliminary report said no cause of death other than carbon monoxide poisoning had been found," *The Post* wrote, "but that discovery of apparently superficial bruises on the woman's thighs necessitated a more complete examination of the whole body. Dr. C.C. Carpenter, conducting the autopsy, said he was studying other facts which might throw some light on the manner of death."

In a paragraph that managed to misspell two key names, the writer for *The Post* added: "Pruett [*sic*] said he had subpoenaed, among others: Davidson himself, Mr. and Mrs. Curtis Champaign [*sic*], of New York, who were house

guests of the Davidsons, and all Davidson household servants. They will be questioned at the inquest, which now is scheduled to begin at 10 a.m."

In short, Pruette, unhappy with the way things had been handled so far, had huddled with the other men and decided to hold a second, more thorough inquest the next week, prompted by new evidence suggesting that this was more than the open-and-shut case they had earlier thought. Many of the same witnesses would be called back for more probing questioning, and others would be added to the list.

On Saturday, Pruette stated emphatically that his first twenty-four hours on the case had made him more certain than ever that the Davidson death had to be either suicide or murder. "I'm not prepared to say which," he said. "But it was not conceivably an accident."

Pruette sought to clear up lingering confusion about the time of death. He was certain, he said, that Elva Davidson was already deceased when butler Emmanuel Birch found her at 9:05 a.m. on Wednesday. "First reports said she was still alive, beneath the steering wheel, and that she died at a hospital when resuscitation efforts failed," the Associated Press reported. "Later it was brought out, however, that she was found dead, in a kneeling position on the running board, her face on her arms, which were spread across the car's floorboards."

The solicitor cast doubt on the original diagnosis of death from carbon monoxide poisoning and said "a careful check of that angle" was underway, though he didn't speculate, at least not out loud, on possible other causes. Dr. Carpenter did not seek to dispel those doubts. He said that when he first examined the body, he found "a condition that probably could have resulted from carbon monoxide poisoning" but that "there may be other contributing causes, and we are making efforts through chemical analysis to determine what they are."

In any case, Pruette told a *Boston Globe* reporter that he and Dr. Carpenter "would undertake immediately a study of the amount of gas necessary to cause death under such circumstances, and the possible effect of the amount possible to collect in the garage."

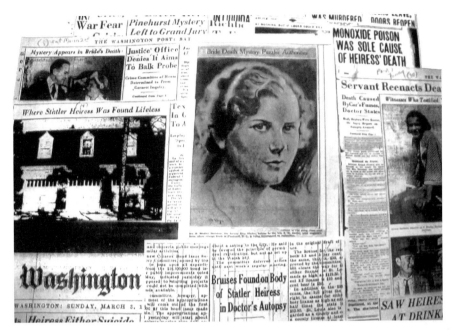

The Davidson case made front pages across the country. *Courtesy of Michael McLellan.*

One of the reasons Pruette gave that weekend for his doubts about carbon monoxide as the cause of death turned out to be groundless. He said he understood that there was "considerable ventilation clearance under the doors and the side of the three-car garage," which might have allowed some of the gas to escape and prevent the buildup of a fatal concentration. One wonders why he didn't just go out and look. A later examination showed that the doors fit snugly enough in their openings to make a tight seal and form an efficient—if oversized—gas chamber.

Pruette gave a mini-exclusive to a *Philadelphia Inquirer* reporter by confiding that he wasn't the least bit sure that Elva Davidson had slept in her bed at all after coming home from the party. "Although the covers were disarranged," he said, "it is not at all clear whether Mrs. Davidson slept there"—leaving open the question of where she might have spent the intervening four hours or so, especially considering that, as Pruette confirmed, her body was still warm when found.

The solicitor voiced an especially provocative theory to *The Washington Herald*'s Pat Frank. Frank wrote:

Mr. Pruett believes that if Mrs. Davidson was murdered, she was either drugged or poisoned and then later her body carried to the garage. His theory is that whoever carried the body either could not lift her into the seat, or just dumped her on the side of the running board. Then the engine was started and the doors of the garage closed in an effort to make the case appear either a suicide or an accident.

Touched by the Breath of Scandal

Sunday, March 3, was a remarkably beautiful, calm, spring-like day in Pinehurst—as in the eye of a storm. Temperatures had risen dramatically. Much had happened during the previous few days, and much would happen in the week ahead. For now, everyone craved a day of resting and catching up.

Solicitor Rowland Pruette had gone home to Wadesboro to be with his family and attend church. Pinehurstians lazed in the balmy weather, went through the motions of having fun, braced for the coming circus and tried to act for a moment as if everything were normal.

Each arriving train disgorged more newspaper and wire service reporters and photographers. They fanned out across southern Moore County, interviewing friends and neighbors of the Davidsons, badgering the sheriff and coroner, hanging around the rustically palatial Carolina Hotel and the modest Community House with its humble dirt yard and speculating about possibly sexy aspects of the story.

The local reporters learned that twenty-two mourners had gathered on Saturday under a canopy on a snowy hill in Kensico Cemetery at Valhalla, New York. The Reverend John Walter Houck, of Pilgrim Presbyterian Church in New York City, had conducted a three-minute service, after which Elva was laid to rest near her hotel magnate father in the Statler family plot. Brad Davidson's brother, Richard Porter Davidson, had been there, along with Richard's wife, Betty, and Elva's stepmother, Alice Statler.

"My wife's unfortunate death was purely accidental," Brad Davidson told journalists besieging him at the chapel. "I have nothing to say except that

I am satisfied that when the investigation is completed, the authorities will announce that finding."

After returning that Sunday from burying his wife, Brad did two things that the prosecutors would make much of: he played a round of golf, and he invited his close circle of friends over for cocktails, including several who would be called as witnesses in the public inquest starting Tuesday. He seemed to see nothing improper in either activity.

"Baked in sun all day," Hemmie Tufts wrote in her diary. "Glorious hot day...Brad for drinks. Looks awful."

The assembled reporters, with a little time on their hands, took advantage of Sunday's lull to bone up on Pinehurst, gathering background and local color for their coming stories. Several wrote sidebars about this peculiar little rural paradise in which they found themselves cooling their heels.

Pinehurst itself, located low on North Carolina's long underbelly and halfway between the Blue Ridge Mountains and the Atlantic Ocean, was lush with exotic vegetation. But the newsmen knew from looking out their train windows on the way in that the village amounted to a green oasis in a depressing, poverty-stricken sea of grit and spindly second-growth trees. This was the bedraggled Carolina Sandhills, the plight of whose inhabitants had been made all the worse by the ravages of the Great Depression.

This part of the South was an environmental disaster area as well as an economic one. Moore County, as some of the reporters took the time to learn, had once stood on the edge of a stately forest of longleaf pines that marched in unchallenged dominance across ninety million acres of land stretching from southeastern Virginia to southeastern Texas. By the 1930s, as a result of relentless depredations by man, mere shreds of the original old-growth stands remained in a few overlooked or inconvenient spots here and there.

The trees that were merely chopped or sawed down, dismembered and sent north in endless long, groaning trains to provide the lumber to build massive Victorian houses for a burgeoning American population were, in a sense, the lucky ones. At least they met a quick, if brutal, end. Millions of others were consigned to a death of slow torture, their bark stripped off in

great gashes so that their lemon-fragrant sap could bleed away. First that rich, golden life's blood was used for pitch and tar required to keep wooden fleets afloat. (The sticky-footed workers involved in this messy process of exsanguination became known as Tar Heels.) Then later, on a much more vast and destructive scale, swarms of busy human ants would boil the sap down into turpentine and rosin, which found many uses in the Industrial Revolution then transforming human civilization. When the loggers and turpentiners moved on, they left behind a stripped and silent moonscape that was so poor, folks said, that a crow flying across it had to pack his lunch.

Still, when a nattily dressed and courteous northerner named James Walker Tufts, who appeared to the locals to have more money than brains, rode in on the Aberdeen and West End Railroad in June 1895 and expressed an interest in purchasing a sizable acreage for a new town, local land baron Henry A. Page saw no reason not to ask top dollar for it. No harm trying. When Tufts asked him how much he would take for several adjacent tracts of particularly barren, blasted, cutover land north of Aberdeen, Page tried to keep a straight face as he replied, "Oh, I reckon any land ought to be worth a dollar an acre." To his amazement, the gullible Yankee met his price, and they shook on it. The first transfer was made immediately: 658 acres for $700. The rest, a total of more than 6,000, came soon after.

Tufts, approaching sixty, was a Boston idealist who had already made his fortune in soda-fountain equipment and was looking for a new challenge—something of a more humanitarian nature. Like many in his era, he was attracted to the idea of a utopian community. He had been drawn to Moore County by a piece of marketing propaganda distributed all over the North by a local entrepreneur named John Tyrant Patrick, a bearded prophet who had founded the nearby town of Southern Pines a few years earlier. Patrick promoted otherwise useless southern Moore County, derided by some as the "Sahara of North Carolina," as the ideal spot to which the breathing-challenged could come from afar to heal. Pine-scented air was said to cure consumption.

It didn't. But by the time Tufts found that out, he had already committed himself to building a health resort on his newly purchased land. He proceeded with blinding speed. By the end of 1895, he had paid famed landscape architect Frederick Law Olmsted to lay out a curvy-streeted, New England–style village, and workmen had thrown together dozens of cottages, a modest hotel, a couple of boardinghouses and even an electric power plant.

Tufts, pleased with his progress, needed to decide what to call his creation, which had already morphed from a TB sanitarium into a budget-priced winter retreat for weary, working-class northerners. After toying with clunkers like "Tuftstown," "Tuftown," "Pinalia" and "Sunalia," he gave his little utopia a name that mystified the locals. After all, who knew what a "hurst" was? (It's a sandy hillock or wooded eminence.)

Looking around at the Pinehurst of 1935, the out-of-town reporters didn't see many working-class people, unless you included the maids, bellhops and cooks looking after all the wealthy playboys and their women. That's because the place had morphed another time or two in the few decades since its founding. Tufts, who had run his personal fiefdom like a benevolent despot, could look back with pride on how remarkably much he had accomplished in a few short years, building from absolutely nothing. But at his death in February 1902, he had already set in motion the forces that would render his noble founding vision unrecognizable. Soon, under James's son Leonard, it would go corporate. Even as the old man breathed his last, his beloved Pinehurst was responding to economic realities by rapidly transforming from a place where regular people went to restore their health to a place where rich people went to play golf or retire or both.

The opening of the Carolina Hotel, then the grandest in the South, was a turning point in the history of Pinehurst. Though it brought in a lot of much-needed revenue, it substituted social stratification for Tufts's original egalitarian ideal. It drove a wedge between "hotel people" and "cottage people," or "cottagers."

But Pinehurst remained a magical place as well. Visitors couldn't seem to describe the remote little wonderworld without waxing extravagantly poetic. A good example is author Edward Everett Hale, best known for his novel *The Man Without a Country*. A longtime friend of Tufts, he had encouraged him in the Pinehurst project and become one of its most eloquent promoters.

"Ever since I returned home," Hale wrote after a stay in 1901, while Tufts was still alive, "I have been saying to tired people and worried people who have notes to meet: 'Why don't you go to Pinehurst?' At Pinehurst, I have

said, 'there is no care. At Pinehurst you do as you choose. At Pinehurst you simply breathe sweet air and drink pure water and walk under the blue sky and meet pleasant people, and you do not know that there is any worry in the world.'"

The early day village is said to have been especially lovely by night, when its imperfections and still-raw surroundings faded to black and the windows of all the newly painted buildings glowed like something out of a Caravaggio painting with light made possible by energy from Tufts's new-fangled generator plant. Entranced couples strolled the empty, sandy streets, holding hands and stealing kisses in the shadows.

By the mid-1930s, though, Pinehurst must have seemed to an outsider as if it had taken on a bit of a dark and decadent side, as idle scions of the prominent and powerful pursued their fun and games in this isolated, artificial little enclave while most of the rest of the country languished in poverty, despair and looming war.

"Pinehurst, the sun-drenched garden spot of North Carolina, has a sensational death," *Washington Herald* reporter Pat Frank wrote in a mood piece on that sunny Sunday in March 1935 as he and his colleagues/competitors waited for the public inquest to begin two days later. "And Pinehurst doesn't know what to do about it."

Leonard Tufts remained sequestered in his office and refused all interviews. Already having enough problems keeping Pinehurst afloat, he may have wished the whole Statler-Davidson thing would go away. But it clearly wasn't going to. Reporter Frank told of retired bankers on the championship golf course exchanging theories about how Elva had died. He told of their wives sitting on the lawns in front of sprawling resort hotels, whispering over the knitting needles, "Tsk, tsk, imagine Elva Statler being murdered; why, I can hardly believe it. I knew her when she was so high." He told of Elva's peers in the younger set staying to themselves and trembling in their shock at what was coming to be seen as the biggest event in the resort village's history.

"Pinehurst, in sports clothes, looks with amazed eyes on the corps of reporters which has suddenly descended on the resort, clad in business suits," Frank wrote. "The reporters, a score or more, picket the lobby of

the exclusive Carolina Hotel, where even Coca-Colas cost eleven cents. The reporters pounce on some principal in the case, and the socialites gather around furtively, to listen to what is said. In ten minutes everyone in Pinehurst knows about it."

Though Pinehurst was an ostensibly dry town, Frank noted that the wealthy were willing to pay a dollar apiece for alcoholic drinks, while their servants could purchase a whole pint of Carolina moonshine at the same price. Meanwhile, the law looked the other way.

Frank wrote:

> *There are slot machines in every drugstore and barber shop. Playing the slot machines is the principal sport of the debutantes when they're not dancing, golfing or riding. There is also a luxurious club and gambling house—Chalfontes, which specializes in roulette... This is Pinehurst, which for fifty years* [forty, actually] *was touched only by the pine-scented breezes, and for the first time is touched by the breath of scandal.*

CHAPTER 5

A Shadow of Ugly Suspicion

After the weekend break, which gave out-of-town reporters a chance to get their feet on the ground and dig up background for their stories, things picked up again on Monday, March 4, 1935, the suspenseful eve of the second and climactic phase of the inquest into the death of Elva Statler Davidson.

"I have a hole card," Solicitor Rowland Pruette rather cockily boasted, resorting to the language of the poker table at an impromptu news conference. "I can't tell you what it is. But it's going to be a big surprise for someone. This investigation wouldn't have progressed this far if it didn't have a pretty good hole card."

Pruette wouldn't elaborate. What hole card was he holding in reserve? The reporters assembled at Pinehurst could only venture guesses that Monday night over drinks and dinner—and occasionally a poker game or two of their own. The consensus seemed to be that it had something to do with what Dr. C.C. Carpenter of the Medical School of Wake Forest College, Pruette's alma mater, had found as he performed exhaustive tests on the victim's brain, vital organs and blood and tissue samples.

Carpenter had first examined Elva's body at Wake. Then, apparently finding something suspicious, he had ordered "the entire viscera" removed and sent off to Duke University's laboratories at Durham for further chemical analysis. All of her internal organs, in other words, had been cut loose, scooped out and hauled away like so much slaughterhouse offal. The chubby Carpenter, having performed the tests with state-of-the-art equipment at Duke, arrived back in Pinehurst with a portfolio containing a preliminary report on the autopsy under his arm and an enigmatic smile on

his face. He would say nothing to reporters except: "I guess you boys will be around here for a couple of weeks."

In the absence of hard revelations, speculation raged within the press corps. Most of it had to do with the "m" word: murder. And most of the rumors pointed an increasingly accusatory finger at the twenty-two-year-old dead woman's forty-two-year-old husband, Henry Bradley Davidson.

<p style="text-align:center">***</p>

Meanwhile, Solicitor Pruette, with his own flair for the dramatic, was doing nothing to allay the rampant suspicions. Indeed, he only fanned the flames. "I wouldn't be here if I thought it was a suicide," he said pointedly, noting that he had already ruled out accidental death. "The State of North Carolina isn't interested in suicides…As a matter of fact, no coroner's inquest is usually held unless there is a suspicion of foul play."

And if foul play there had been, Pruette left no doubt about who he thought the perpetrator was. He said he wanted to know more about Brad Davidson's activities and whereabouts on the morning of the death. He added that he was looking into the financial arrangements between the heiress and her husband. In response to questions, Pruette confirmed reports that he had sent investigators to Annapolis, Maryland, where Davidson had lived and worked before his second marriage. He said he was investigating reports that Davidson had been hanging around Annapolis in the middle of February of that year, about the time his new bride was in Boston willing him a king's ransom.

Pruette told the reporters that the Davidson cottage on Linden Road, having been neglected in the first couple of days, was now under tight guard day and night, with no one permitted in the vicinity. He added that he planned to subpoena as many as twenty-five witnesses, including "seventeen Pinehurst socialites," to testify at the inquest. But he had heard that some of them had already left the state, he said—in which case "I can do nothing to get them back to testify."

By way of review, Pruette ticked off what he considered the main outstanding questions to which he would formally seek answers beginning the next day:

- Why was Mrs. Davidson so despondent at one or both of the two parties on the night before her mysterious death, if indeed she was?

- What happened from the time that the Davidsons left the spaghetti restaurant about 4:15 a.m. until the still-warm body of the heiress was found at 9:05 a.m.?
- Why was the body in such a peculiarly cramped, kneeling position on the running board of her automobile?
- How did she get those bruises?
- Why did butler Birch swear that the garage was heavy with smoke and fumes when he entered it, while Davidson said there were no fumes noticeable except in the car itself when he went in minutes later?
- Why had the motor of the car stopped running with the ignition switch still on, at a time when the tank still held two or three gallons of gasoline?
- Why was Mrs. Davidson dressed as she was if, as claimed, she was just going for a drive?

Pruette just couldn't let go of that last question, the salaciousness of which clearly intrigued him. It's not every day that a prosecutor finds himself dwelling in public on the topic of women's underwear. "I can't conceive of any woman, unless she was dead drunk, dressing in a costume like that for the purpose of committing suicide," he said, noting once again that Elva had been found wearing neither stockings nor undergarments. He said experts had told him that women "never take their lives without first putting on their best clothes."

Noting that Davidson had testified the previous Wednesday in the first phase of the inquest that his wife suffered from insomnia and was in the habit of going for rides, Pruette indicated that he didn't buy that explanation either. He pointed out that the temperature got down to almost twenty degrees that night and expressed a firm opinion that if a woman were planning on either taking a drive or killing herself, "the attire would have been more adequate." Pruette also noted in passing that Elva had paid thirty-five dollars for a painting at the hospital's charity ball on the night before her death, adding: "Women with suicide on their minds don't go around bidding on pictures."

So those, Pruette said, were just some of the matters he wanted H. Bradley Davidson to clear up for him. And then the solicitor added this barbed zinger: "Of course, Davidson [not *Mr.* Davidson] can refuse to testify if he sees fit to do so…We have no way of knowing whether he regards himself as an accused person or not. If he should take that attitude, he may refuse

to amplify the voluntary statement he made at the first hearing or to submit to questioning."

Pressed by a reporter, Pruette hastily added in all seeming innocence that he saw no reason why Davidson should refuse to testify. But he had already accomplished what must have been his ulterior purpose. Barring an earthquake or a fatal heart attack, Brad Davidson would be on the stand the next day.

The State of North Carolina and the Statler family weren't the only ones sending in their big guns as the revved-up second inquest loomed. Though they had missed the boat in the early days, the editors at *The Washington Post* now decided that the Elva story was getting big enough to justify dispatching a superstar to cover it. And the reporter they chose to send packing to North Carolina was none other than Edward T. Folliard, thirty-six, who had been *The Post*'s White House correspondent since 1923.

It wasn't as if there were nothing going on for Folliard to cover in early March 1935 within the Roosevelt administration—which at that very moment was celebrating the second anniversary of its inauguration. As a result of the Great Depression, relief rolls had reached an all-time high of 22,375,000. The president's proposed $4.8 billion works relief bill was getting a going-over in the Senate, his plan for a revamping of the merchant marine was caught up in a legislative logjam and the House was debating a controversial bonus for World War I veterans.

Father Charles E. Coughlin and Louisiana Senator Huey P. Long (who had a date with an assassin) were peppering their demagogic speeches with bitter attacks on FDR, and the president was preparing to attend the funeral of former Chief Justice Oliver Wendell Holmes. England and Hitler's Germany had just ratcheted up their naval and air arms race. A monster dust storm had descended on Washington, bringing in tons of topsoil stripped from Kansas, Colorado, Texas and Oklahoma.

Still, *The Post* considered the Davidson story urgent enough to tear the competent, levelheaded Mr. Folliard away from all that and dispatch him to Podunk, North Carolina, for a few days. Or maybe he volunteered, eager for a little excitement and a change of scenery. He arrived Monday, March 4,

intent on quickly getting up to speed on the situation, filing his own first story that evening for Tuesday morning's paper and thereafter running circles around the lesser journalistic entities assembled there.

In that regard, Folliard had a "big surprise" of his own in store that week.

Few of the other journalists assembled in Pinehurst were snoozing. Most were digging for exclusives.

A reporter for *The Buffalo Times* had a story outlining what was at stake financially in the continuing investigation and what seemed sure to be a looming legal contest over Elva's fortune. E.M. Statler, he wrote, had established trust funds of $1 million each for his four adopted children in 1920, and there had already been litigation over the trust funds for two years.

The reporter recounted:

> *On Jan. 2, the day before Miss Statler, 22, married Mr. Davidson, a Supreme Court decision in Erie County, N.Y., ruled that she was entitled to $550,000 accrued interest from her trust with the provision that she establish two trust funds, one giving her full liberties to will and the other to follow the provisions of the other Statler trusts. Each fund was to be $275,000. On Feb. 14, securities for the total amount were forwarded from the Marine Trust Co. in Buffalo to a bank in Boston, where Ms. Davidson receipted for them.*

That was Valentine's Day. The next day, Elva voided her previous will, which had named three beneficiaries: her brother, Ellsworth Statler; her infant niece, Joan Marie Statler; and her intimate friend from her Radcliffe College days, Isabelle Stone Baer. Then, according to the paper, she "purported to make a will [it had not yet been probated] bequeathing the benefits of her own trust fund to her husband-to-be and also giving him other personal property, which included income from her share of the trust fund of the late Marian Statler, E.M.'s other adopted daughter. This sum is believed to total about $280,000, so the amount willed to Mr. Davidson apparently exceeds $500,000. Her own trust she broke up into an outright bequest to him of $100,000 and setting aside of $175,000 to provide an annuity of $12,000 for him. She died 17 days after making the purported will."

As Solicitor Pruette prepared to play his hole card, another reporter who managed to scoop Folliard with a relevant tidbit on his first day on the story was an unidentified correspondent who sent a two-paragraph story to *The New York Times*.

Not long before her death, it said, Elva had "accepted plans for a home to be built on a seventy-five-acre tract of land near Pinehurst, on which she had obtained an option. In addition there were to be stables, swimming pool and tennis courts. The papers had been turned over to attorneys, but had not been signed at the time of her death. It is understood that if the transaction had gone through, Mrs. Davidson would have had an investment of nearly $100,000 in her estate."

The significance of that would not be lost on investigators and amateur sleuths. Does planning for a palatial new home sound like something a woman contemplating suicide would do? Others put a more sinister spin on it. Could Brad have had other plans for that money and the rest of Elva's fortune? Had he resolved to find a way to keep her from squandering it?

A *Philadelphia Inquirer* writer got the jump on the story of how the supposedly grieving Brad Davidson, in the midst of the investigation, had gone to the Pinehurst Country Club with a group of friends to play golf. "He was shielded from all strangers by his brother, Richard Davidson, and Herbert Vail, who was a member of Tuesday night's drinking party," the paper said.

On the other hand, there was the exclusive interview that the same Philly correspondent got with Herbert Vail's wife, Minnie, described as Elva's confidante. He didn't have to seek her out—she approached him, anxious to volunteer a haunting story of a disturbed young woman driven by personal demons. There was no possibility of foul play in Elva's death, she insisted. It had to have been suicide. The Davidsons were devoted to each other, she said, and Elva had been happier since her marriage than at any time during her life.

Minnie Vail described Elva as "a strangely moody girl" and said her young friend's behavior at the spaghetti camp, when she kept weeping but then asked to be left alone so she could "snap out of it," was typical. "I saw her crying and went to her," Minnie told the reporter. "I put my arms around her and asked her what was the trouble. She went on crying and sobbed, 'No

one likes me.' I told her to forget it, that everyone liked her, and pretty soon she quieted down and was herself again. I had seen the same scene many times, and that was what she always said. She had an inferiority complex and always believed that people disliked her."

Mrs. Vail, who along with her husband had sat with the Davidsons at the country club, said it pained her to hear people saying that Brad had neglected Elva and waltzed the night away with other women. "Why, he danced almost every dance with her," she insisted. "He was always sweet and attentive. There can't be even a chance that anyone had anything to do with Elva's death except herself. But it must all be cleared up so that the world will understand it and no shadow of ugly suspicion will hang over anyone for life."

<p style="text-align:center">***</p>

It remained for a correspondent for the United Press, a wire service never known for restraint or circumspection in its headlong rush to get the scoop on AP, to stick his or her journalistic neck out the farthest.

"Every scrap of evidence they have been able to piece together," the UP reporter wrote with a flourish, "indicates that Mrs. Elva Statler Davidson was the victim of *a strange and scientific murder*, officials said tonight. All day they labored—lawyers, physicians and the coroner—and at evening said the possibility that the beautiful heiress walked out of her white house among the pines to take her own life was growing dimmer with every passing hour. They already have eliminated the theory that she died accidentally."

The UP staffer included one other explosive passage in that day's dispatch. When Elva's vital organs were being tested and analyzed at Duke, the story said, "it was learned that while carbon monoxide was in the lungs, there was a chance that *a more subtle poison* might have been the actual cause of death. Physicians and chemists at Duke have been working in the vital organs for more than 48 hours and still are not ready to report."

Having dropped those bombshells, the UP story concluded: "Tomorrow a coroner's jury convenes in Pinehurst's Community House to try to dig out all the facts of this puzzling tragedy in the midst of the winter playground of the wealthy."

No Bible to Take an Oath On

It was standing room only in Pinehurst's Community House for the anxiously anticipated resumption of the Elva Statler Davidson inquest on the morning of Tuesday, March 5, 1935.

"Papers horrible," Hemmie Tufts wrote in her diary. "Trial on at 10." It wasn't a trial, of course; it was an inquest. But in the minds of many, Brad Davidson was being tried for murdering his wife.

All 125 available seats in the small, square, white-painted building were crammed with spectators drawn by what a *Philadelphia Inquirer* reporter called "the insinuations which have been scattered broadside since Mrs. Davidson's death, and which have kept this society resort colony buzzing for a week."

Most of the insinuations had been scattered by Solicitor Rowland Pruette. All eyes were on him as he made his grand entrance, briefcase in hand, and took his place at a table alongside Coroner Carl Fry, who was still playing catch-up after being out of the county when Elva's body was found, and Acting Coroner Hugh Kelly, who had filled in for him during the previous two closed inquest sessions on February 27 and 28.

Pruette, talking with reporters that morning as they gathered for the big show, had stuck to his tantalizing poker metaphor, repeating: "I have a card up my sleeve which I am not going to play until well along in the inquest." And the consensus seemed to be that the supposed card, which sounded like it might be an ace of spades, had something to do with the toxicology findings.

The Post's normally fastidiously accurate Eddie Folliard, uncharacteristically getting both his gases and his internal organs mixed up, wrote on that day: "Dr. Heywood Taylor of Duke University, who examined the vital organs, said

Sunday night that there was sufficient carbon dioxide [*sic*] in Mrs. Davidson's stomach [*sic*] to cause death. He added, however, that there may have been 'other contributing causes.'" That was one of the things, Folliard wrote, that made this famous health resort think it had the first murder mystery in its history.

The air did seem to buzz inside the low-slung frame building, whose interior amounted to one big pine-floored, rough-raftered room. One reporter called it one of the strangest courtroom scenes the country had ever witnessed. He wrote:

> *Most of the witnesses and spectators alike were dressed in golf clothes, riding habits or tennis jackets. Some arrived in Rolls-Royces, others in 12-cylinder sport cars. The elite arrived first and got the best seats, for they were primarily interested. Elva Statler had lived in Pinehurst for years. She was one of the resort's most popular girls. After the socialites had found seats, the servants and tradesmen began to crowd in the windows and doorways. When it began to rain early this afternoon, they crowded inside, the windows were shut, and the air was stifling.*

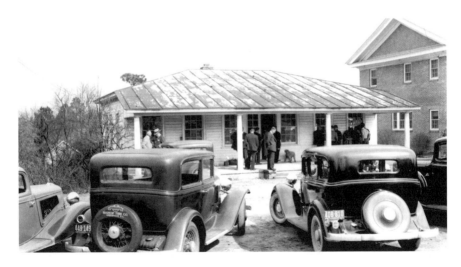

The inquest into Elva Statler Davidson's mysterious death, which became a national sensation, took place in Pinehurst's modest Community House. *Courtesy of the Tufts Archives, Pinehurst.*

Press flashbulbs began to pop in earnest when the door opened and an unsmiling Brad Davidson entered, accompanied by Curtis and Edna Campaigne and his brother, Richard Porter Davidson, and Richard's wife, Betty Hanna Davidson. Brad, who stood just over six feet tall and weighed 185 pounds, wore "somber funeral garb" consisting of a dark gray suit, black tie and white shirt. He was to be the first to testify that day. The buzz grew more subdued as he worked his way across the crowded room to the witness stand, which was in fact nothing more than a cane-backed wooden rocking chair positioned at one end of the room.

As he nervously glanced around the room, Davidson gave the appearance of feeling alone and isolated there in the spotlight. None of the other six witnesses to be heard that first day was anywhere in sight. To keep them from influencing one another's testimony, Pruette had ordered that they be sequestered and called in one at a time for questioning. As the dreaded proceeding began, Davidson was described as looking "taut and harassed." But it was noted that he "managed a smile" when a clerk discovered that there was no Bible on which he could take the oath.

<div align="center">***</div>

Sometimes remaining seated, sometimes rising and pacing back and forth in the close confines of the Community House, Pruette spent a full hour aggressively pursuing what was described as his "sharp" questioning of Brad Davidson. The witness, in turn, was characterized as replying to the solicitor's many pointed questions "in a crisp, firm voice."

In the second part of his quizzing of Davidson, Pruette intended to get into more general questions about the couple's relationship. First, though, he would spend considerable time on the events of the previous Tuesday night and Wednesday morning. Spectators hung on every word as the actual testimony at long last began.

"Mr. Davidson," Pruette asked after a few introductory formalities, "did you drink any liquor on the afternoon before your wife's death?"

"Yes, one highball," Davidson replied. "We had tea before dinner Tuesday night, and also the one cocktail. Then, after dinner, we left to attend a charity ball."

"What time did you leave?"

"We left the house for the Pinehurst Country Club between ten forty-five and eleven."

"Did you and Mrs. Davidson drink at the club?"

"We had perhaps one or two drinks."

"Did you dance with Mrs. Davidson?"

"Yes, twice."

Pruette paused and consulted his notes. "Now, Mr. Davidson," he finally asked, his voice hardening a bit, "was there any trouble at the charity ball between you and your wife?"

"Not really," Davidson replied. "She bought two pictures at the ball for thirty-five dollars. She asked me how I liked one of them, and I replied, 'Why, that's a rotten painting.' I was joking, but she seemed to take it very much to heart. She turned to a friend of hers and said, 'Look, Brad is angry with me.'"

"So you were joking," the solicitor said skeptically.

"Yes," Davidson replied.

"And where did you go then?" Pruette asked

"About a quarter of two, we left the country club with a party of about twenty and went to Montesanti's spaghetti house," Davidson said. "Between Pinehurst and Southern Pines."

"Why did you go there?"

"Before we left the table, Nelson Hyde [publisher of *The Pilot* newspaper] suggested a part of us take the accordion player to Montesanti's and have him play some more for us. He was very good."

"Did Mrs. Davidson drink at Montesanti's?"

"She had a highball in front of her, but I don't think she drank it. I think it lasted her all evening."

"But there was considerable drinking there, wasn't there?"

"No. I was never under the influence of liquor."

"How long did you stay?"

"Two or two and a half hours."

"What were you doing?"

"Listening to this chap play."

After the party broke up, Davidson said, they and the Campaignes started for the house on Linden Road, driving separately and arriving there about 4:30 a.m. Wednesday morning. The Campaignes, he said, got there first.

Moving in a little closer, Pruette wanted to know if there had been any trouble at that point. Davidson took a deep breath and sounded slightly annoyed, as if having to spend more time on a subject than it deserved.

"When we arrived at the door of the house," he replied, "Mrs. Davidson said, 'I'll put the car in the garage.' We have to drive out of our driveway around on the main road into an adjoining driveway. So I said, 'No, don't do it. I'll put it away.' We were arguing back and forth about that when Mrs. Campaigne finally said, 'Do you mind if we go into the house? We're both tired and want to go to bed.'"

Davidson said he had complied. After he had escorted his guests into the house, he said, he returned to the car, where his wife was still standing, and the seemingly pointless little debate resumed.

"Please let me put the car away," he recalled pleading. "You are awfully tired, and I don't mind doing it."

"No, I am going to do it," he quoted her as saying, stubbornly standing her ground.

He said he finally settled the argument by saying: "Let's leave the car right here. You come along and go to bed." And that's what he said they did, leaving the car parked in front of the house. Once they had gone up to their rooms, Davidson said, he helped his wife off with her coat, kissed her goodnight and told her to let him know if she wanted anything. And they went to their separate bedrooms.

Pruette's ears perked up. "Had you been using separate rooms?" he asked.

"I would say about half and half," Davidson said, clearly uncomfortable having the subject discussed publicly. "Sometimes I would go to her room and sometimes she would use mine. They were directly across from each other." Davidson explained that there were twin beds in his wife's room and a single bed in his.

"Do you remember the last thing she said that night?" Pruette asked.

"Yes," Davidson replied. "She called from her room, 'Goodnight, darling.'" The last time he saw his wife alive, he said, she was removing some clips from the green evening dress she had worn to the ball. "I could hear her fussing about in her room, undressing," he testified, "but I didn't pay any attention to it."

"Were both doors open?"

"Yes, both doors were open."

Exhausted from being up all day and most of the night, he said, he fell asleep within five minutes. And the next thing he knew, the butler was banging on his door.

One journalist described Davidson as looking "grave and self-possessed" as the questioning moved on to the traumatic events of the next morning.

"What time were you awakened?" Pruette asked.

"About 9:00 a.m.," Davidson said. "Birch, the butler, came into my room and said, 'My God, Mr. Davidson, Mrs. Davidson is dead!'"

"Had you heard any sound during the night?

"No."

Davidson described how he pulled some trousers on over his pajamas and hurried down the stairs, out the back door and out to the garage.

"What did you see when you went to the garage?" Pruette asked.

"Well, the door was up," Davidson said.

"Did you detect any odor or see any smoke?"

"Well, I was so upset when I went in I didn't notice anything at all. I had only one thought."

"Where did you find her?"

"Left-hand side. She appeared to have been trying to get out."

Pruette asked about the position in which he found his wife's body.

"One knee on the running board," Davidson said, "one in the car or almost in, one arm on the seat, one on the floor, her head on the floor."

"Did you examine the car itself then or later?"

"No. The only thing I noticed was when I started the car to drive to the hospital, the switch was on. I made no other examination." At this point in his testimony, one journalistic observer said that "his face muscles were rigid and his lips were a thin line as he spoke."

Pruette asked Davidson whether he had checked to see if the motor was hot, and he replied that it had never entered his mind to do so. "I was leaning over Elva," he said, "trying to find out what it was all about. I took my hand and felt her head, and it was warm. I felt her wrist, and it was warm. But I felt no pulse."

He made no attempt to carry her into the house, he said, and he did not know whether she was alive or dead. That was the point, he said, at which Campaigne, who had entered the garage shortly after he did, warned him not to touch the body.

"But I picked her up and held her on my lap on the running board and told Mr. Campaigne to call a doctor," he said. "Dr. M.W. Marr got there and said we must get her to the hospital. I wrapped a coat around her and placed her on the back seat. Dr. Marr said, 'I think I know what's wrong.'"

Davidson said he chose to drive because Campaigne didn't know the way.

<center>***</center>

At that dramatic point in the testimony, with the dead body of a young woman jostling in the back seat of a 1934 Packard racing toward the Moore County Hospital, Pruette left spectators hanging by shifting abruptly into back-story mode.

"Where have you made your home in the past twenty years?" he asked.

"Well, in 1915 I lived in Berryville, Virginia," Davidson replied. "Then, when the war started, I went to Fort Myer and after the war returned to Baltimore. In 1929, I went to Waukegan, Illinois, on business and two years later to the Milwaukee lock manufacturing plant, where I remained three years. Then I went to Washington after my father's death, then Baltimore, and then Annapolis, and finally Pinehurst." (Either Davidson or the newspaper reporter got that wrong. He went west in 1928 and stayed in Waukegan and Milwaukee for a total of three years, not five.)

"When did you meet Elva Statler?" Pruette asked.

"Last spring," Brad said. "We became engaged in December."

"You have been married previously, haven't you?"

"Yes, to Jessica Aylward."

"You are divorced and have some children?"

"Yes. The children are living with their mother in Berryville, Virginia."

"How old are the children?"

Davidson had to pause and do a little mental arithmetic before replying, "Ten, twelve and eighteen."

"What business are you in?" Pruette asked.

"None."

"None?"

"I had a job with the Sherwood Oil Company in Baltimore. It provided me with a modest income to contribute to the support of my children. But I gave that up just before Christmas because Elva wanted me to come down here to Pinehurst and live."

"At the time you married Elva Statler," Pruette asked, "your finances were depleted, were they not?"

"No," Davidson replied. "I had previously had a very good job in Washington." (He was referring to his position as manager of the struggling Annapolis Roads Club, which in fact he had given up when it stopped paying him any money.)

"Isn't it true, Mr. Davidson," Pruette demanded to know, "that when you were asked just before your marriage to Elva Statler how you were going to support her, you said you intended to live on her income?"

Davidson was described as "bristling" at the question. "Positively not," he snapped. "That's wrong. I did not say that."

"Did you know she made a will shortly before she died?" Pruette asked.

"I happened to be very much in love with her," Davidson almost shouted, glaring back. "I didn't pay any attention to monetary matters."

Pruette, practically in Davidson's face now, raised his voice in disbelief. "You mean you didn't know that her will left you an annuity of $1,000 a month and $300,000 in either cash or securities?" he asked.

Davidson stood his ground, his lips again tightening. "Not until I read it in the newspapers," he said.

Leaving the jurors and spectators to draw their own conclusions on that one, Pruette paused. Again his voice softened for a moment. "Was Mrs. Davidson expecting the birth of a child?" he asked.

"No," Davidson replied in a resentful tone. "At one point, she thought she might have been pregnant. And, without consulting her about it, I went to Dr. Marr. I told him I did not think Mrs. Davidson was in physical condition to bear a child. Dr. Marr agreed that she was highly nervous." Both he and Elva had wanted children, he said, "but we didn't think it was the proper time to have them."

Then Pruette was suddenly on the offensive again: "Mr. Davidson, didn't you and your wife sometimes quarrel?"

"No," Davidson replied. "We did not."

"I ask you," said Pruette, "if it isn't a fact that you have a domineering personality?"

"No, I think not."

"Weren't you sometimes abusive to your wife?"

"Of course, I say no. I was never abusive toward her. I would say that the contrary was the case."

"I believe Mrs. Davidson's body was bruised," Pruette said.

"She showed some bruises to us Saturday before she died," Davidson said, "just after we had been playing tennis. They were on her right hip, I believe."

"Didn't she have a bruise on her left arm?"

"If she did, I didn't know it."

Asked if he knew of any other existing injuries that his wife had suffered, Davidson mentioned two—one very old and the other more recent. In her

This photo, from the *Pinehurst Outlook*, shows the Davidsons in January 1935, just days after their wedding and days before her death. *Courtesy of the Tufts Archives, Pinehurst.*

early youth, he quoted her as saying, she was riding a bicycle down a hill and ran into an automobile, suffering a head injury that necessitated the insertion of a small silver plate in her skull. And on their honeymoon trip through Georgia in early January, he said, Elva suffered a bruised back and torn shoulder ligaments in an automobile accident. She refused treatment, he said.

Pruette had one more question: was it true that Davidson, just back from taking his wife's body to New York for burial, had gone to the Pinehurst Country Club on Sunday and played ten or eleven holes of golf?

"Yes, I did," Davidson replied. "But I didn't go near the clubhouse." Reacting to murmurs from the spectators, Davidson felt the need to add an explanation: "I felt I had to have some recreation."

Before leaving the stand, "his face emotionless," Davidson answered some softball questions from Carthage attorney M.G. Boyette, the moonlighting prosecutor whom he had hired to represent him. Seeking to beat somebody else to a sensitive question and put the best spin on it, Boyette asked: "Mr. Davidson, is it true that you were not in favor of an autopsy?"

"Yes," Davidson replied. "But only because I didn't like the idea of having my wife's body handled."

"You later agreed?"

"Yes."

"Have you offered your assistance to the officers or investigating authorities in clearing up facts concerning Mrs. Davidson's death?"

"I have been available at all times. I have not contacted the attorneys here other than to invite them to the funeral services."

Finally, Boyette asked if Elva had frequently suffered from insomnia. Davidson replied that she had and that she had kept two "sleeping potions" on hand to calm her nerves. He identified them as aluminol and allonal. She also went for frequent long drives by herself on nights when she couldn't sleep, he said. "She told me that she wanted to be alone on those occasions and that she had gone off in her car that way all her life," he said, adding that Elva usually wore sport clothes on those early morning rides.

"I can't say how she was dressed the morning she was found in the garage," he said. "I didn't notice because I was only thinking of her. So far

as I know, she was not especially unhappy that night at the club and at the spaghetti camp."

Boyette chose not to pursue that last comment—"not especially unhappy that night." But those in the room who were familiar with the statements of other witnesses about extended fits of inconsolable weeping on Elva's part had to wonder whether Brad Davidson, who had been sitting two or three chairs away, was (1) a blind man or (2) simply lying through his teeth.

CHAPTER 7

Waiting for the Hole Card

Having coaxed and badgered all the testimony he could out of Henry Bradley Davidson on that first Tuesday morning, Solicitor Pruette still had time for a couple of other witnesses before lunch. The first one he called was Emanuel Birch.

After establishing that Birch's employment with Elva Statler had predated the Davidsons' wedding, Pruette got down to business, asking the painfully uncomfortable black butler how much drinking had gone on in the Davidson household. Birch replied that he had served one cocktail to both husband and wife before dinner.

"What happened after dinner?"

"They left about eleven o'clock for the charity ball, and I went to bed."

"Did you hear them come home?"

"No, sir."

"Did you hear the car start up any time that night?"

"No sir."

"Did you hear anybody out in the garage during the night?"

"I didn't hear anybody, and I didn't hear the garage doors pushed up. And they make considerable noise if they aren't pushed up just right, too."

The solicitor then directed him to tell what had happened early the next morning.

"I got up about seven-thirty o'clock," he said. "Pearl Watson came in at eight o'clock."

"She's the maid?"

"Yes, sir. I stayed in the houses and did some chores. Neither Mr. and Mrs. Campaigne nor Mr. and Mrs. Davidson had asked for breakfast. Sometimes Mr. and Mrs. Davidson left their car out front, sometimes in the garage. That morning it was cold and the car wasn't in front. I looked for it, but it wasn't there."

At nine o'clock, he said, he finally decided that he would stop waiting for either couple to wake up and would go on out to the garage to clean up the Packard. "The door was down," he said. "When I pushed the door up and stepped in, I smelled gas, like it had burned. I had closed the door after me, but there was gas so strong that I couldn't stand it. I pushed the door back up."

"Was the ignition switch on or off?" Pruette asked.

"It was on," Birch said. "But the motor wasn't running."

"Then what happened?"

"I went to the left of the car to get the hose to wash it. And that's when I found Mrs. Davidson."

"What did you notice about her?"

"The strange way she was slumped over the running board."

"What did you do?" Pruette asked.

"I ran back to the house. The cook met me when I went in. I said, 'Say, Mrs. Davidson is sick or else she is dead out there in the garage.' I told her to wake Mr. and Mrs. Campaigne and I ran upstairs, calling Mr. Davidson."

"What did you say to him?" Pruette asked.

"I believe I said, 'My God, Mr. Davidson, Mrs. Davidson is dead!'" he replied, his voice still reflecting traces of the anguish he had felt that morning a week earlier.

"And what happened then?"

"I helped Mr. Davidson get his shoes, and then he went to the garage."

Birch couldn't be of much help about what had happened after that, since he had gone out in front of the house to wait for Dr. Marr. But in reply to a question by Pruette, Birch did say that he had not seen Davidson take his wife onto his lap as Davidson had testified.

"No, sir," he said, "I didn't see that."

Pruette questioned him for a time about the operation of Mrs. Davidson's twelve-cylinder automobile.

"The car had an automatic choke that releases itself, and it doesn't choke easy," Birch said, relieved to slip into a subject of which he was more in command.

"Was the gas lever on or off?"

"I didn't notice, sir. But the car will idle for fifteen to thirty minutes without feeding it."

"How much gasoline was there in the tank?"

"I didn't notice, sir."

Pearl Watson, who gave her age as thirty-five, wrung her hands and rocked back and forth nervously as she answered questions from J.M. Broughton, the Raleigh attorney representing Statler interests. Pruette had asked him to take over for a time.

"Miss Watson," Broughton began, "when did you go to work for Mrs. Davidson?"

"Last January."

"Did you know her before that?"

"No, sir."

"What was the nature of your work?"

"Just general duties. I cooked and cleaned. I made up the beds, among other things."

"What time did you usually come to work?"

"About eight o'clock."

Asked if there had been any times when she had come to work and found that Mrs. Davidson was out for a drive in the car, Pearl said that there had been no such times. Directed to recount what she had done on the morning of February 27 after Birch ran into the kitchen to tell her that he had found Mrs. Davidson unconscious in the garage, she said she had gone to the first-floor guest room to awaken the Campaignes.

"Were they asleep when you went in?"

"Yes, sir."

"And what did you tell them?

"I said that Mrs. Davidson was out in the garage, either ill or dead."

After she testified about being told to call the doctor and doing so, Broughton jumped ahead in time to ask about another detail. "Miss Watson," he said, "did you go upstairs after Mr. Davidson and Mr. Campaigne had left to take Mrs. Davidson to the hospital?"

"Yes, sir."

"And what did you see there?"

"The sheets on Mrs. Davidson's bed were rumpled, and both beds in her room looked like they'd been slept in."

"Slept in?" Broughton asked. "Couldn't they have just been sat on?"

"I suppose so, yes, sir," Pearl replied.

"And was there clothing in the room?"

"Yes, sir. Her evening dress was hanging in the bathroom," Pearl said, adding with a note of disapproval: "Inside out."

"I believe you have said that you found her underclothes scattered about the bathroom and bedroom," Broughton said.

"Yes, sir," Pearl said, "but she usually left her clothes all over the place."

Attorney Boyette, representing Davidson, took over and pursued that line of questioning a bit further. "Miss Watson," he asked, "did you see a nightgown in the room?"

"Yes, sir," she replied. "It was on the back of a chair."

"How would you describe its condition?"

"It looked like it had been slept in."

Boyette looked at Broughton, who had one more question before lunch. "Now, Miss Watson," he said, rising and trying to maintain a mock casual tone, "after Mrs. Davidson's body had been found, isn't it true that Mr. Davidson told you not to say anything about it?"

The surprising question, raising an implication that had not surfaced before, hung in the air.

"Why, no," Pearl replied, squirming and trembling in her chair. "No, sir, he didn't say that."

Content with having entered his damaging question, Broughton dropped the subject as quickly as he had brought it up.

Curtis and Edna Campaigne, both well into their forties, were several years older than Brad Davidson and a generation older than his twenty-two-year-old wife. Yet it was Elva whom the Campaignes had met in Pinehurst in early 1934. They hit it off, and the Campaignes returned from their home in Montclair, New Jersey, for Elva's wedding to Brad Davidson at the beginning

of 1935. They stayed around for a few weeks, which is why they happened to be houseguests of Elva and Brad on the night of February 26.

Solicitor Pruette called Curtis Campaigne as the first witness after lunch, to be followed shortly by his wife.

"Mr. Campaigne," Pruette began, still seated, "will you please tell the jury what happened the afternoon before Mrs. Davidson's body was found?"

"Late in the afternoon," Curtis replied, "Davidson called and asked us, 'How about a game of bridge?' We played until about six o'clock, had tea while playing and drank highballs afterward before dinner."

"Did Mrs. Campaigne have a highball?"

"No. She doesn't drink. And, though Mrs. Davidson poured one, I don't think she finished it."

"And what happened after dinner?"

"We went to the country club. To the charity ball."

"Did Mr. Davidson dance with his wife?"

"He danced with her once."

"Did she dance with anyone else?"

"I don't think so."

"Did he?"

"Yes."

Pruette let that sink in for a second. Then—

"Was Mrs. Davidson under the influence of liquor?"

"No," Campaigne replied. "Not at any time."

"How would you describe her mood?"

"Mrs. Davidson was gay and happy when the pictures were auctioned off. She bought two, which she said she would hang in the hall."

"And later, at the spaghetti house, did you sit near Mrs. Davidson?"

"I sat on her immediate left."

"Did she drink there?"

"There was some red wine passed around, and I saw Mrs. Davidson pour some, but I can't swear she drank it."

Pruette stood and resumed his pacing.

"After you left Montesanti's," he asked, "what time did you get back to the Davidsons' cottage?"

"About four thirty in the morning," Campaigne replied.

"And what happened when you arrived there?"

"Mr. and Mrs. Davidson had a friendly argument."

Pruette raised an eyebrow.

"Friendly?"

"Yes. Mrs. Davidson suggested that she take the car around to the garage. Mr. Davidson said, 'Let me do it,' and he got out and opened the door and ushered Mrs. Campaigne and me into the hall. When I got to the door, I said, 'I'm going to turn in, Brad. I'm tired.'"

"And you and Mrs. Campaigne went to your room?"

"Yes."

"Do you know what happened next?"

"No."

"Did you see the Davidsons enter?"

"No, we didn't. But we heard footsteps going up the stairs."

"Did you hear the car drive around during the night?"

"No."

At this point, Pruette slipped in another surprise question seemingly designed to challenge the integrity of this witness as well. "Mr. Campaigne," he said, "didn't you previously state that the three of you—you and your wife and Mr. Davidson—had waited for Mrs. Davidson to put the car up and then parted company and said goodnight?"

Campaigne appeared to search his mind and draw a blank. "No, sir," he said, "I don't believe I made such a statement."

Having gotten in his little zinger, Pruette let that matter drop as well. "All right," he said, sitting back down. "Tell the jury what happened the next morning.

"The maid came to the door and told us, 'Something has happened to Mrs. Davidson in the garage.'"

"Did she seem agitated?"

"Yes."

"Was Mr. Davidson up by that point?"

"Yes."

"Had you heard the butler calling him?"

"No."

"What did you do then?" Pruette asked.

"Mr. Davidson and I ran out to the garage," Campaigne said.

"You saw Mrs. Davidson's body?"

"Yes."

"What did you and Mr. Davidson do then?"

"He started to pick her up, and I told him not to."

"You told him not to?"

"Yes."

"Why?"

"Because I had read or recalled being told that it was better not to pick up a body if there was a chance of murder."

Pruette's eyebrow shot up again. "Of murder?"

"Yes."

Pruette was back on his feet. "How did he react?"

"He said, 'Oh, I can't do that.' And he put his hands on her head."

In proceedings of this sort, jury members enjoyed the prerogative of asking questions themselves. One of them chimed in at this point. "Did Davidson hold her on his lap?" he asked. "On the running board?"

"He sort of held her head," Campaigne replied, re-creating the position as best he could, "and supported her with his arm when the doctor arrived."

Pruette took over again. "Did you detect any gas or smoke in the garage?" he asked.

"No."

"None?"

"None at all."

"Did you think Mrs. Davidson was dead at that point?"

"I didn't think she was dead."

The solicitor's debating skills kicked in. "Yet you told Davidson not to pick her up?" he asked, "because 'it might be murder'? How could it be murder if the person was not dead?"

Campaigne shifted his weight in the chair and backpedaled a bit. "I didn't know whether she was or not," he lamely replied.

<p style="text-align:center">***</p>

Edna Foote Campaigne, a tall, lanky and gracious brunette known to friends and family as "Ted," was next. Dressed in a fashionable suit with a wide-collared white silk blouse and a small boutonniere in her lapel, she testified only briefly, corroborating much of her husband's testimony about the bridge game, the highballs, the after-dinner conversion and the trip to the charity ball.

Pruette once again wanted to know whether everyone at the party was drunk, and she replied: "None of the guests at the country club were under the influence of whiskey that I recall—that is, at our table."

Pruette began to ask another question, but Edna Campaigne startled him and the audience by interrupting and launching into a little announcement.

"I'd like at this time to say something which no one heard but myself," she said. "Mrs. Davidson was sitting next to me at the party at Montesanti's. The man who played the accordion played three pieces in succession—one, two, three. When he finished, Elva said, 'Play that second tune again.' He wanted to play something a little livelier, but she insisted. And when the piece was over, she was sitting there almost in tears. She said, 'That was my father's favorite tune.'"

In her short time in the rocking chair, Edna Campaigne offered one other compelling detail: her useful description of the ever-puzzling position in which Elva's body was found. "If you were stepping out of a car backward and suddenly fainted," she said, straining to convey a mental image, "that would be the position her body was in."

<p style="text-align:center">***</p>

The last two witnesses of the day, Herb and Minnie Vail, of Glen Cove, Long Island and Pinehurst, testified even more briefly than Edna Campaigne. In their mid-thirties, Herbert and Minnie fell at the midpoint between Brad and Elva in age.

Herb Vail ran through the events of the party night without adding anything particularly new.

"Was Mrs. Davidson despondent at the spaghetti camp?" Pruette asked him.

"I wouldn't say she was exactly crying," Vail said, "but she was sad and melancholy."

"You knew her quite well before her marriage. Isn't that right?"

"Yes."

"I ask you if her demeanor did not change. Didn't she appear more depressed after her marriage?"

Vail was not about to go along with that. "No," he replied firmly. "I saw no change."

In response to another question from Pruette, Vail acknowledged that he had played golf with Davidson on Sunday in Pinehurst, the day after Elva's burial in New York. He did not sound apologetic about it.

Minnie Vail, described as "an attractive blonde young matron," wore a sport suit over a red sweater. She brought up the rear by reinforcing her

husband's testimony. "I saw the Davidsons at the country club, and I saw them dancing together more than once," she said. "Later, at the spaghetti camp, she was sad and leaned over and said, 'Nobody loves me.'"

"Was she crying?" Pruette asked.

"She wept," Minnie replied. "But I had often seen her as despondent as she was then."

Minnie Vail said that she, like Pearl Watson, had gone up to Elva's room on the day of the death. Her description of what she saw there largely squared with the maid's: the beds were messed up, and there was clothing dropped here and there.

But she injected one small and intriguing difference into her spin on what she had seen. Pearl Watson, it will be recalled, had testified in the morning that she had found Elva's wrinkled nightgown over the back of a chair and that "it looked like it had been slept in." But Minnie Vail, for whatever reason, saw the wrinkled condition of the nightgown as indicating that "she might have tried to sleep and been unsuccessful."

Leaving some to wonder: how much can you read into a wrinkled nightgown?

It had been a long session, and the reporters hurried out to write and file their stories. But a note of letdown and dissatisfaction ran through them. The mystery had only deepened. What was going on? Was this all there was? Had poker player Rowland Pruette overplayed his hand? Was he bluffing?

"Pruette, who has expressed strong suspicion that murder was committed, said he had 'a hole card that I am going to play at the inquest,'" wrote *The Post*'s Eddie Folliard. "He did not play it today. No testimony was obtained from any witness that pointed to murder, and most of the evidence seemed to support the theories of accidental death or suicide."

Those stretching their legs and leaving the Community House and lighting up smokes outside were left wondering: If, as had been broadly hinted, H. Bradley Davidson had committed "a strange and scientific murder" by administering a "subtle poison" to his wife and trying to pass its effects off as those of carbon monoxide, then why would he have gone out of his way to testify that he noticed no trace of gas or smoke inside

the garage? Or if it was in Davidson's interest to have it thought that his wife's death had been a suicide and not a homicide, why in the world would he have made a point of contradicting others by saying that "she was not especially unhappy that night"?

The inquest was to resume the next morning, Wednesday, and it was expected to run another couple of days. And one of the early witnesses, supposedly, was Dr. C.C. Carpenter, pathologist from the Wake Forest Medical School, who had performed the autopsy and been hard at work since on chemical analyses of the vital organs. Maybe he would have some startling findings.

Meanwhile, Solicitor Pruette remained unflappable. "I'll show the hole card," he said, "after I've shown the other four."

Some were beginning to wonder if he even had one.

CHAPTER 8

No Other Foreign Matter

Solicitor Rowland Pruette got the bad news on the evening after the first day's testimony: Tuesday, March 5, 1935. Or the next morning at the latest.

Dr. C.C. Carpenter had left the pathology lab at Duke University and driven to Pinehurst, though failing to get there in time to head off Pruette's overconfident repetition of his "hole card" boast as he debriefed reporters. The news the doctor brought was the last thing Pruette wanted to hear. He would have to rethink Wednesday's game plan, and in a hurry. He would have to take another look at his other four cards and salvage some strategy for possibly snatching victory from defeat—or at least managing a stalemate. It wouldn't be easy. It might be impossible. The fates were about to call the poker player's bluff.

Dr. Carpenter had offered Pruette tantalizing semi-assurances that traces of some sinister substance had been found or would be found in the blood and tissue samples taken from Elva Statler Davidson's autopsy-desecrated body. But in the end, despite all their sophisticated tests, he and his colleagues from Duke had come up empty-handed.

That fact wouldn't become known to the spectators in the courtroom until the inquest's last Thursday morning session. But an anonymous Associated Press reporter would find out about it on Wednesday night—suddenly making it clear to him why that second day's testimony had seemed so anticlimactic, unfocused, repetitive and lacking in anything resembling a blockbuster revelation. Pruette, as the reporter suddenly understood, had simply been stalling for time on that all-important second day. His star witness had pulled the rug out from under him.

"Pruette produced a string of witnesses," the AP reporter wrote, "but failed to uncover the 'hole card' he'd promised to support his theory [of murder]. An authoritative source revealed tonight that Duke University and Wake Forest College experts had reported finding evidence of sufficient carbon monoxide in the body to cause death, and some alcohol, but not enough to produce intoxication. This source said the tests of the experts failed to show evidence of any other foreign matter."

That "authoritative source"—the wire service writer's Deep Throat—had to be none other than Dr. Carpenter himself. Hanging around Pinehurst while waiting to testify, he had had a snort or two and blabbed to the casually inquisitive reporter—but only on the condition that his name be kept out of it.

"No other foreign matter." Now that his hole card was off the table, Pruette had to shift gears hurriedly and take another approach. Having thought it over and consulted with the others on the prosecution team, he came up with about the best possible strategy under the circumstances: he would fall back on a simple process of elimination.

"Few persons here think that Mrs. Davidson was murdered," *The Washington Post*'s Folliard wrote on that day. "At the same time, they find it difficult to believe that she would have committed suicide or that her death could have been an accident." Barring supernatural intervention, though, Pruette was certain that Elva's death had to have resulted from one of those three possible causes: (1) accident, (2) suicide or (3) murder. (There was no talk of natural causes.) At the risk of replowing some old ground and losing momentum, the solicitor would do all he could to demolish 1 and 2, leaving the jury no choice but to settle on 3 as the most likely. In pursuing that goal, he would have to lean even more heavily on motive and opportunity, since his best bet in the means department had been taken from him.

It would be a difficult strategy, relying too heavily for comfort on circumstantial evidence and conjecture. But at least the solicitor had one big legal reality on his side: this was not a murder trial, requiring him to convince the jury beyond a shadow of a doubt. It was a coroner's inquest, in which the members had only to be guided by what seemed to be a preponderance of evidence. If they thought the case looked more like murder than anything

else, they could so decide. If they did, there would still have to be the filing of charges and a whole new trial with different rules of evidence.

Folliard, though unaware of the AP's coming scoop about the pathology findings, would instinctively begin to understand Pruette's strategy as he saw it unfolding on Wednesday. He wrote: "Solicitor Roland [*sic*] Pruette, who indicated at the outset his belief that Mrs. Davidson was murdered, set to work at the outset this afternoon to explode the suicide and accident theories."

Pruette would attempt to make an accident seem unlikely by dwelling on Elva's youth and superb physical fitness and on the ease with which the doors of the garage opened, making it all but impossible for her to have become trapped inside. He would pour cold water on the suicide scenario by casting sufficient doubt on stories that she had been despondent enough to do herself in—though impressions on that were a mixed bag at best. And he would steer the jurors toward a homicide finding by reminding them of all that Brad Davidson had to gain financially from Elva's death, by hinting at ways other than poison that the death could have been intentionally produced—and by painting a picture of a newlywed relationship so stormy and quarrelsome that it resulted in bruising to the bride.

Pruette could hardly strike Dr. Carpenter's name from the witness list, but he would save him for Thursday morning's third and last session. He had already called an array of second- and third-tier witnesses for Wednesday, and he would have to go through with hearing briefly from them, even though their testimony was sure to add up to an inconclusive muddle.

But as the main order of business on that middle day, he would bring Brad Davidson and Mannie Birch back to the stand and hammer away at both of them on some key points in hopes of tripping them up and bolstering the case for murder. Without his own smoking gun, it was the best he could do.

Though maintaining an even keel and keeping his emotions to himself had been an important part of his job description, Emanuel Birch was clearly perturbed at having been called back to the wooden rocking chair for yet another bout of testimony at 10:00 a.m. The AP described him as "nervous." And his mood didn't improve as his turn on the stand wore on and things began to get unexpectedly confrontational.

As was his habit, Pruette—said to have been dissatisfied with Birch's "insufficient testimony" in his first appearance—began by asking a line of relatively innocuous questions.

"Now, Mr. Birch," he said, "I believe you told us that you drove uptown to the post office to pick up the mail on the morning of February 27, before you found Mrs. Davidson's body. Is that right?"

"Yes, sir."

"Whose car did you use?"

"My own car."

"Where did you keep it?"

"In the backyard."

"That was near the garage?"

"No, sir. Not so close."

"So you didn't go near the garage at that point?"

"No, sir."

"Was the garage door locked that morning?" Pruette asked.

"Oh, no, sir," Birch replied.

"How do you know?"

"Because I was able to open it later from the outside."

"How does one lock that door?"

"It has a handle on the inside that locks when you turn it. You have to have a key to open it from the outside."

"And who has that key?"

"I carry it with me."

"I see. Were you in the garage on that Tuesday, the day before?"

"Yes, sir."

"Did you lock the door then?"

"No, sir. I left it unlocked."

"So anyone could have opened it from the inside."

"Yes, sir."

"Without turning the handle."

"Yes, sir."

"For that matter, they could have opened it from the outside."

"Yes, sir."

"Is it easy to open?"

"Oh, very easy. It has springs. All three of them do."

Having stopped at the table, Pruette began leafing through a legal pad, finally pausing at the page he was looking for. He turned back toward the witness.

"Now, Mr. Birch," he said, referring to the notes, "Sheriff McDonald has told us that those doors—and I quote—that those doors 'would drop to the floor if not raised more than twenty-four inches, would remain stationary between twenty-four and thirty-six inches, and would shoot up to the top if raised more than thirty-six inches.' Is that correct?"

"Yes sir, I'd say that sounds about right."

"So wouldn't that make it impossible for someone to become trapped inside? Against their will?"

"I don't see how they could. All they would have to do is slide the door up."

"And that was easy to do."

"Yes, sir. Very easy."

Pruette tossed the pad back on the table and sat down.

"Thank you, Mr. Birch. Now. Do you recall the position in which you found Mrs. Davidson lying last Wednesday morning?"

"Oh, yes, sir."

"And haven't you made the statement that you didn't believe she could have fallen into that position?"

"I have."

"And how do you think she might have gotten into that position?"

"It looked to me like she might have crawled into it."

It wasn't exactly what Pruette wanted to hear, but he had to leave the subject at that for now. He stood up again and prowled restlessly for a few seconds, marshalling his thoughts. Then—

"Mr. Birch, did Mrs. Davidson ever take automobile drives at night?"

"Yes, she did on occasion."

"Can you give us an example?"

"I remember that she did it just before Christmas one night."

"I see," Pruette said. "And are you aware of any occasions when Mrs. Davidson went for a drive at night since she and Mr. Davidson were married?"

Birch searched his mind before answering. "No, sir," he said.

"None?"

"No, sir."

Pruette then bore in on his main question.

"Have you ever heard the Davidsons quarrel?" he asked

"Not to my knowledge," Birch said. "I never heard them have cross words."

"Really? Isn't it true that you heard them quarrel frequently after their marriage on the third of January? Haven't you said that?"

"I don't believe I have, no, sir."

"You haven't? Didn't you, in fact, tell a reporter for *The Washington Herald* that they had often quarreled? Didn't you say the same thing to some of the other butlers from neighboring houses?"

"I don't think so."

"Isn't it true, in fact, that Mr. and Mrs. Davidson had a quarrel before leaving for the club on that very Tuesday night?"

"Not that I know of."

Pruette turned on his heel.

"No further questions," he said, suddenly all business. "I now call Mr. Pat Frank to the stand."

Birch remained seated for a few seconds, uncomprehending. Pruette turned back.

"That's all, Mr. Birch," he said. "Thank you."

The witness stood stiffly, looking wrung out after nearly a half hour on the stand, and walked toward the door, again thinking his ordeal was over.

What happened next was the kind of thing that makes any newsman uncomfortable: reporter Frank, who worked for the now long-defunct *Washington Herald*, had to become part of the story. And this at a time when reporter confidentiality was not the issue it has become today.

Under oath, Frank felt compelled to testify to what Birch had told him the previous Sunday: that the Davidsons usually slept in separate rooms, that they "followed this procedure because of misunderstandings" and that "sometimes they quarreled."

The next witness was the waiter John Nostragiacomio. As he walked to the rocking chair, the spectators could clearly see that he was, indeed, quite bushy-haired. After struggling with the witness's surname, Pruette asked him if he was acquainted with both Mr. and Mrs. Davidson. He said he knew them both well.

"How many were in their party on Tuesday night of last week? Or perhaps I should say Wednesday morning."

"There were eighteen of them."

"What did they do once they had arrived?"

"They came in and sat around the fireplace in the dining room while the meal was being prepared."

After Nostragiacomio told of later showing the party to their table, formed by pulling smaller tables together, a juror named Russell Sullivan piped up, wanting to know how the seating arrangement was decided on. He seemed to place some importance on that.

"They picked their own seats," the waiter said.

Sullivan nodded and sat thoughtfully back in his chair.

Pruette took over again, asking if Nostragiacomio had noticed "anything about Mrs. Davidson's behavior that night."

"Yes, I did," the witness said. "When I started serving the spaghetti, she was crying. She took out her handkerchief and wiped her eyes."

"Would you describe her tears as profuse?"

"Yes, I would. So much so that Mrs. Herbert Vail went over to her."

"Mrs. Herbert Vail?"

"Yes."

"Did Mrs. Davidson cry for a long time?"

"Some time. I don't know how long."

Pruette asked if there had been any other guests there, besides the party from the country club.

"No," he said. "Just them."

"Did you serve anything to drink?"

"Some wine. Three bottles of claret. And someone had some whisky in a pint bottle."

"I see. Doesn't Montesanti's have a bar?"

"Not a regular bar."

Pruette smiled and glanced at the spectators.

"I understand," he said. "It couldn't be. This *is* North Carolina, isn't it?"

Laughter rippled through the audience.

Pruette made quick work of the next four minor witnesses. Their names were Freeman, Turner, Reinicke and Hyde, but they might as well have been Eenie, Meenie, Minie and Moe. All were local men who had been at one or both of the parties, but they either differed on whether Elva had seemed

upset or said they hadn't noticed her at all, and they generally had nothing of interest to offer—although Hyde would provide a tidbit when Pruette recalled him at the end of the morning.

After Eenie et al. came a cluster of three witnesses who, though they also testified only briefly, caused the all-male jurors to perk up considerably. All were attractive young ladies—no more than girls, really. All were socialite acquaintances of Elva's. And all were of an exotic avian species that those stolid locals could only wonder at and sometimes resent: flighty, brightly plumaged snowbirds that always came winging into Pinehurst from New York or New England in the fall and fluttered away again in the spring, enjoying the luxury of being spared both the North's bitter winters and the South's sweltering summers.

The first of these pampered pigeons was Miss Jane McMullen, described as "a debutante of Pinehurst and Hyannis Port, Massachusetts," which meant she spent the summer social season hobnobbing with the likes of Joe Kennedy's multitudinous offspring.

Pruette began by asking her his favorite question: whether she had had anything to drink on the night of February 26. She "blushed when he asked the question and admitted that she had a 'small one.'" Asked whether Elva had been in tears at the spaghetti camp, Jane said: "Mrs. Davidson was crying at the table. Her expression made me feel she was fairly morbid and depressed. She would stop crying and then start all over again."

But Jane's sister, Isabel, swore that she hadn't seen Elva weeping or displaying any other signs that she was the least bit unhappy. Isabel, dressed in a tight-fitting, bright yellow knitted blouse and a dark green skirt, did not hesitate to admit that she had had *two* drinks at the country club that night.

"Was there any liquor at Montesanti's?" Pruette asked. As he questioned her, one reporter noted, "he puffed on a cigarette and tilted back in a straight chair to an unstable angle," trying to look cool but almost falling over backward.

"There wasn't any more liquor," she said. "They had had a couple of drinks before—that is, those we went to the party with."

The third snowbird was Miss Polly Lovering of Boston, who kept her long winter coat pulled protectively around her and never smiled during her brief time in the rocking chair. While she had known the Statler heiress for some time, she said, "she was never in a pensive or sad mood when I saw her." And that was all she could or would say.

Pruette was ready for the midday break. But lawyer Broughton, representing Statler family interests, wanted to briefly recall witness Bernard Freeman, Pinehurst publicity man. He had been the Eenie of Eeenie, Meenie, Minie and Moe.

Freeman confirmed Nostragiacomio's testimony that there had been no hard liquor available at Montesanti's "since there was no place to purchase it and you had to bring your own."

Then, asked about Elva Davidson's mood at the earlier party, Freeman could remember only one detail. But it was a compelling one: "I heard Mrs. Davidson say, 'I'm going to get tight.'"

"Are you sure of those words?"

"Yes. 'I'm going to get tight.'"

The phrase echoed in the minds of spectators as they gathered outside the Community House or headed for lunch. If a happy young lady speaks those words, it sounds like she's out to tie one on and have a good time. But if a conspicuously unhappy young lady says, "I'm going to get tight," it sounds like something altogether different. It has overtones of a wronged woman seeking some kind of bitter satisfaction.

Reporter Folliard was so taken by the phrase that he characterized it as a "threat," though none of the witnesses would testify in public that she had carried it out.

Looking On with a Pained Expression

Brad Davidson was again wearing his "somber garb" and seemed weary when Solicitor Rowland Pruette called him back to the now all-too-familiar rocking chair after lunch on Wednesday.

"How old are you?" Pruette asked.

"Forty-two," Davidson replied

"And how old was Mrs. Davidson?"

"Twenty-two."

"I believe you were divorced from your first wife last May."

"That is correct."

"And what were the grounds?"

Davidson took a deep breath, casting his glance around the silent room.

"Desertion," he finally said, almost under his breath.

"What did you say?"

"Desertion."

"And your wife—the first Mrs. Davidson—brought the action?"

"Yes."

"In speaking of partially supporting the children of that marriage," Pruette said, "you stated yesterday that you had a private income. What was the source of that income?"

"Several small securities."

"What was the income from them?"

"Negligible—seventy-five to a hundred dollars a month."

Davidson said he had resigned his last job around Christmastime.

"How long had you been employed?" Pruette asked him.

The 1935 Elva Statler Davidson Mystery

"Less than a month."

In response to further questions, Davidson again insisted that he knew nothing before marrying Elva Statler about the million-dollar trust fund that her father had established for her—the fund that produced an income of $2,500 a month.

"But after the marriage," Pruette asked, "didn't she set aside $1,000 a month to your credit?"

"Yes."

Having succeeded in reminding the jury of all the material benefits that were intended to flow to Davidson upon his wife's death, Pruette returned to the subject of those suspicious bruises found on Elva's right thigh and hip. He reminded Davidson of his testimony from the day before: that Elva had been bruised by a tennis ball the previous Saturday and by a fall on the ice in Boston in mid-February.

"Do you stand by that?" Pruette asked.

"Yes," Davidson said.

That was all Pruette needed to hear.

Having thus set the stage, and with Davidson again sequestered out of earshot, Pruette called Elva's grave, aging family physician, Dr. Myron Marr.

"Dr. Marr," he said, "I believe you knew Elva Statler for several years."

"That is correct," Marr replied.

"Was she of a cheerful disposition?"

"Yes," the physician answered, "unusually so."

"And how would you describe her physical condition?"

"She was athletic," Dr. Marr said. "Exceptionally athletic."

"Strong?"

"Yes."

"Had you treated her recently?"

"When she returned from her honeymoon, I treated her for a bruised and swollen shoulder."

Pruette turned to the morning of Elva's death. Marr told of hurrying to Edgewood Cottage after receiving a frantic call from maid Pearl Watson, imploring him to "come quick, even if you're not dressed." Inside the garage, he said, he found Davidson bending over his wife.

"Was her body still warm when you arrived at the garage?" he asked.

"Surprisingly so," Marr said. "I noticed it when I lifted her arm to check for a pulse."

"Did you feel one?"

"No."

"How long do you think she had been dead?" he was asked.

"I think now that she could have been dead as little as a half hour."

A murmur arose among the spectators. "At this point," one newspaper reported, "the society women, dressed in bright spring sports costumes, and the millionaires attired for golf and the eager townspeople crammed at the doors and with their faces pressed in the windows, crowded closer."

Marr told how, despite his belief that Elva was dead, he had ordered her rushed to the county hospital so that all possible efforts could be made to revive her. He said that the flushed condition of her skin caused him to conclude immediately that she had died of carbon monoxide poisoning, and he added that he had not changed his opinion since.

Pruette then moved on to his real subject: the bruises. "Where were they?" he asked.

"On her right hip and thigh," Marr answered.

"And how old do you think those bruises were?"

"I now believe that they must have been received from a half hour to forty-eight hours before her death."

The murmur grew louder. "A half hour to forty-eight hours?" Pruette asked, pressing home his point. "How do you know that?"

"By their color," Marr said. "Up to a certain point, the age of bruises can be determined by the coloration."

"It changes as time passes?"

"Yes."

"Dr. Marr, Mr. Davidson has said that his wife was bruised by a tennis ball four days earlier and by a fall on the ice about three weeks earlier."

"That may be. But those can't be the bruises we found on her body."

Reporters scribbled furiously in their notebooks. The doctor's statement was described as having "startled the crowd of spectators and aroused keen interest among the six men who are asked to determine how Mrs. Davidson came to her death."

Feeling better than he had expected to be feeling at the end of this second day of testimony despite his big setback, Solicitor Pruette adjourned the

inquest until the next morning. "We hope to finish by noon tomorrow," he said. "We have several more witnesses to examine."

But first, with a little time left on his hands, he announced that the jury was going to take its first and only field trip.

Pruette wanted the jurors to see the death vehicle with their own eyes. The original intent, according to what lawyer Broughton confided to some reporters, was to require Brad Davidson to drive his wife's twelve-cylinder touring car to the Community House that morning. Then Birch would be recalled to the stand and asked to show exactly the position in which he had found Elva's body.

Next, the authorities planned to ask a young woman to sit in the driver's seat and, feigning unconsciousness, attempt to fall forward to the floor. They knew that either she would be obstructed by the broad steering wheel or else she would fall out of the car altogether. This would demonstrate that she could not have passed out while sitting in the car and ended up in Elva's final position on the running board.

The show didn't come off that way. Perhaps the prosecutors decided the logistics of making Brad drive the car to the Community House and setting up their demonstration there were too complicated. Maybe Brad simply refused to cooperate. Most likely, they thought it more effective to have the Packard viewed in its natural habitat. Whatever the reason, they decided to move the mountain to Mohamet. If they couldn't bring the car to the jury, they would take the jury to the car.

Donning their coats and hats, the six members of the panel worked their way through the crowd, filed outside the Community House and climbed into a couple of automobiles waiting at the edge of Community Road. Other officials and witnesses got into other cars. Then, "trailed by a curious crowd," the little convoy headed west. Their destination, less than half a mile away as the crow flies but closer to a mile via Pinehurst's winding streets, was Edgewood Cottage.

Once they had arrived there and parked along the shoulder of Linden Road and McKenzie Road, the curiosity-seekers were prevented from

DEATH OF A PINEHURST PRINCESS

drawing near the big two-story garage that sat at the back of the lot next to the cottage, behind an imposing brick house called the Pines. From a distance, they could dimly make out activity inside the garage as the members of the jury and others walked around and rubbernecked at the building's interior under the supervision of Solicitor Pruette, who wore his trademark slouch hat.

The jurors could be seen testing the three garage doors, evidently finding them so easy to slide up and down as to rule out the possibility that anyone could have gotten trapped inside and died accidentally.

Then an unusual sight presented itself. Acting on instructions from Pruette, Birch started getting into the shiny, black automobile parked inside. But he didn't sit down in the usual manner.

"While the jurors watched," Folliard wrote, "he climbed halfway into the 12-cylinder convertible touring car. His head and shoulders were lying across the gear-shift lever and his legs dangled to the running board."

After that, the jurors themselves could be seen swarming over the car. Three of them followed Birch's lead, trying to duplicate the position of Elva's body. Some sat on the seat and let themselves fall forward onto the steering wheel. Others got down on their hands and knees and tried to crawl up onto the running board and into the car.

Through it all, it was reported, Brad Davidson looked on "with a pained expression."

CHAPTER 10

Electrifying the Courtroom

A s the Community House began filling up for the climactic day of the inquest on Thursday, March 7, 1935, Solicitor Rowland S. Pruette was still smarting from the loss of his own hole card. He couldn't have known that the other side was about to raise the stakes of the game at the last minute by playing one of its own.

Coroner's inquests—a legal proceeding since abolished in North Carolina, along with the office of coroner itself—weren't supposed to have "sides" at all. They were supposed to be dispassionate medical and scientific inquiries. But the nature of the Elva Statler Davidson case, juiced up by sensational allegations and the presence of national media, had turned this particular proceeding into the next thing to a full-fledged murder trial. Under those circumstances, it would have been unrealistic to expect the high-powered lawyers involved to pull any punches.

Brad Davidson's family, friends and attorneys had hoped to see Elva's death swept under the rug as an unfortunate accident rather than a suicide. That was obviously the least embarrassing and damaging of the three options. But when the needle threatened to swing all the way over to the other end of the scale, into the red "murder" range, they decided it was time to do whatever necessary to pull it forcefully back into the middle: suicide.

And Herbert Vail was their man.

But first, before Vail could fire off his torpedo, even before they could bring on Vail's wife, Minnie, to set the stage for him, those in the Davidson camp would have to sit through the lengthy testimony of Dr. C.C. Carpenter. Pruette had put him off as long as he could and had abandoned his pet poison theory. But the state could still be counted on to milk "the chubby, smiling little Dr. Carpenter" for all he was worth.

Statler family attorney J.M. Broughton—who would go on to become governor of North Carolina four years later—handled the questions for Pruette.

"Dr. Carpenter," he began by asking, "what is your profession?"

"I am a professor of pathology at Wake Forest College," he replied.

"How long have you held that position?"

"Nine years."

"How many autopsies would you say you have performed?"

"About one thousand."

"At the first hearing," Broughton said, "you testified that your initial diagnosis of death was carbon monoxide poisoning. How did you reach that conclusion at such an early stage?"

"For one thing," Carpenter replied, "the skin of a person poisoned by carbon monoxide has a characteristic cherry color."

"Has your subsequent research confirmed that conclusion?"

"Yes. Our chemical analysis showed sufficient carbon monoxide poison to cause death."

"Did you find anything else to which death could be attributed?"

"No."

Having gotten that out of the way, Broughton pressed forward, asking Carpenter about the results of a study he had made of the effectiveness of the Davidson garage as a gas chamber. As it turned out, he and an assistant had carefully measured the interior of the building. Without consulting notes, the doctor said he had found it to be 36 feet wide; 19 feet, 10 inches deep; and 8 feet high—for a total volume of 5,700 cubic feet.

"In a building that big," Broughton asked, "could one automobile generate enough carbon monoxide to cause death?"

"Yes," Carpenter said. "There would be enough to make a person unconscious in from half to three-quarters of an hour. Another quarter-hour probably would cause death."

Carpenter told of a field test he had performed with butler Birch's assistance. They started the Packard's engine, he said, and then closed all the doors and waited outside for forty-five minutes. Upon reentering, he said, they found fumes "very marked." He ran a test and found enough carbon monoxide to kill a person.

Having established these facts, Broughton led Carpenter further into the area of conjecture, peppering him with a fast-paced series of hypotheticals aimed at undermining the possibility of either accident or suicide.

"Tell me," he said. "If a person, awake and in good health, had tried to get out as the carbon monoxide began filling the garage, would it have been possible for her to do it?"

"Yes," Carpenter said. "If she had to, she could have broken a window."

"Could a person walking into the garage and standing by the steering wheel have fallen into that position—or even voluntarily assumed it—and have retained it as unconsciousness crept upon her?"

"No," Carpenter said, explaining that a person rendered unconscious by monoxide would have a tendency to straighten out, whereas "Mrs. Davidson's legs were bent, with her knees on the running board."

"Would a person who was placed in the garage while unconscious from another cause have been subject to carbon monoxide?"

"Yes, provided respiration wasn't cut off."

"Could a person sitting at the wheel of the car have fallen into the position in which Mrs. Davidson was found?"

"In my opinion, no."

"How long do you estimate Mrs. Davidson had been dead?"

"She could have been dead as much as two hours."

In a final effort to bolster the murder option, Broughton then steered the discussion toward the multiple contusions and areas of discoloration that the cadaver of Elva Davidson had displayed.

"Did you examine the body for bruises?" he asked.

"I did," Carpenter replied.

"What did you find?"

"On the outer surface of the middle section of the left arm, there was a slightly raised area with a pinpoint perforation in the middle that had the appearance, in my judgment, of having been caused by a pinch with a solid object."

"What other such areas did you find?"

"Below the right hipbone, there was a blue area 5.5 by 2.2 centimeters [roughly one inch by two]. In front of that, there was a similar, but smaller,

area. On other parts of the thigh there were six other such areas. There were three of similar appearance on the left thigh. There was a slight blueness on the lower part of the back and a scratch on the upper right thigh. On the front of the right leg there were three old injuries."

"Except for the old injuries, how old do you say the bruises were?"

"They were incurred within forty-eight hours of death."

"Do you think the impact of a tennis ball on Saturday—four days before her death—could have caused any of those bruises?"

"I do not believe so."

"If Mrs. Davidson had voluntarily knelt on the running board and remained so until death, was there anything which could have caused those bruises?"

"Not in my opinion."

"Was there a bruise on the head?"

"No."

"Did you find a silver plate in the head?"

"No."

"Was there *any* mark on the head or face?"

"No."

"If she had *fallen* into the position described, would it not have produced some mark?"

"In my opinion it would have. But I found none."

"Could the bruises you did find have resulted from the application of force?"

"Yes. They could have resulted from a firm grasp, or from blows stricken by a human hand."

A human hand. Broughton started to ask another question but chose to sit down instead, leaving those words hanging in the air. After all, did anyone in the room doubt whose hand they were talking about?

When his turn came, J.M. Boyette, the county prosecutor turned Davidson advocate, returned to that intriguing "pinpoint perforation" in the middle of the bruise on Elva's left arm. Knowing what some jurors might be wondering, and seeking to get the subject out in the open and deal with it, he asked a startling question.

"Dr. Carpenter," he said, "could the bruise on Mrs. Davidson's left arm have been inflicted with a hypodermic needle?"

"Yes," Carpenter replied in what was described as a clipped, firm tone. The crowd leaned forward, hushed.

"Couldn't it have been made by a hypodermic injection at the hospital," Boyette asked, "when they were attempting to revive Mrs. Davidson?"

He didn't get the answer he was hoping for.

"I understand that a needle puncture was made in her chest to inject adrenalin," the doctor said, "but none was made in the arm."

"Couldn't the puncture have been made after death?"

"Absolutely not."

Sorry he had brought the subject up, Boyette grasped at one more straw. Noting that Elva had a Great Dane and another dog, he asked if the puncture on her arm could have been caused by a dog bite. One can almost hear Carpenter snorting as he said it could not.

By late morning, the jurors, who had been led to believe that things would wrap up at midday, were growing restive. But time had to be allotted for the other "side"—what had come to be thought of in this non-trial as the defense.

Boyette first called Minnie Vail, a round-faced woman with sleepy-looking, Betty Boop eyes.

"You knew Mrs. Davidson very well, did you not?" he asked.

"Yes," Mrs. Vail replied. "I met her a year ago."

"Where?"

"Here. In Pinehurst."

"Tell us about her disposition," he said. Then he added, as if this witness needed any coaching: "Was she temperamental?"

"Yes. She was very temperamental. She was moody and depressed for no reason I could see."

"Can you tell us about that in more detail?"

"Well, last fall, when she was visiting me, I saw two of her moods in one day. The first time was at the luncheon table with Mrs. Richard Tufts and me—and again that afternoon."

"What happened then? In the afternoon?"

"She had a visitor. He was reading a newspaper, and suddenly she arose and ran out of the house and got in her car and drove away. She came back twenty minutes later."

"What did you think was wrong with her?"

"I thought she got into that mood because no one was paying specific attention to her at that time."

"Was she a woman who craved and demanded special attention?" Boyette asked.

"Yes," Minnie replied. "And she was moody when she didn't get it."

"Did you hear her say no one loved her?"

"Many times."

"Did she have a silver plate in her head?"

"She told me she did. She said she had a head injury and might crack or die at any time."

"She might 'crack or die'?" Boyette asked. "What do you think she meant by that?"

"She meant that sometimes she wasn't herself, I suppose."

After Minnie had stepped down, Boyette's next witness was Helen (Allie) Tufts, the good-looking, dark-haired horsewoman who was married to Richard, grandson of Pinehurst founder James Walker Tufts, and the man who would take over the running of Pinehurst a few years later.

"How would you describe Elva Davidson?" Boyette asked.

"I would say she was always up and down," Allie replied.

Boyette waited for her to elaborate, but she showed no inclination to do so.

"Up and down?"

"Yes. Awfully happy one minute, and the next all the way down. For no reason at all."

"What was Mr. Davidson's demeanor toward his wife?"

"Very courteous, very polite, very attentive when I saw them together."

It went on in that vein until J.M. Broughton could stand no more. When the time came to cross-examine this sweet-talking witness, he was instantly in her face concerning something he had gotten wind of, something that was news to most of the others in the crowded room.

"You've been at the Davidson home since Mrs. Davidson's death, and while this inquest has been going on, haven't you?" he demanded. "For a cocktail party."

His accusatory tone took Allie aback.

"Not what I'd call a cocktail party," she said, maintaining an outward calm and trying not to sound defensive.

"Then what would you call it?"

"Highballs were served. That's all. It is a universal custom in Pinehurst houses."

"It is?" Broughton sputtered. "Drinking highballs while an investigation is being carried on? Of a death in the family?"

"Yes," she said, meeting his stare. "I've known doctors to prescribe them."

Nothing more of this startling exchange remains on the record. If Broughton pursued that tantalizing line of questioning further, it wasn't reported. Again, this was not a trial, so nobody could request or declare a mistrial. But if ever a situation cried out for a mis-inquest, surely this was it.

Here Solicitor Pruette was, taking pains to keep witnesses separate so they couldn't compare notes and get their stories straight. Yet the defendant, if you can call him that, was throwing a cocktail party, to which he invited some key testifiers? If Allie Tufts was there, wouldn't the Vails have attended as well—and the Campaignes, who were staying in the Davidson home?

There was little opportunity for spectators to wonder how much rehearsing and choreographing that little group of close friends had done over their drinks. Because no sooner had Allie Tufts stepped down than it was time for the grand finale: a return appearance by Herbert Vail. It would, in Ed Folliard's words, "electrify the courtroom."

The lawyers for the "defense" made a point of recalling Vail to the rocking chair at the tail end of the inquest's final morning. They made sure that his astonishing story would be the last words ringing in the ears of the six jurors—and in those of "the very cream of the exclusive social set which winters here, who were crowded into the Community House," as Folliard wrote.

It was a story that Vail said took place when Brad and Elva had the Vails over for dinner on the night of February 6, a month after the Davidsons' wedding and three weeks before Elva's death. He would have some tall explaining to do as to why he had neglected to tell the story publicly before. But for now, attorney Boyette was content to lead him gently through it.

"What was the evening like?" he asked.

"Mrs. Davidson was charming and gracious when we came in," Vail said. "Everything was all right until our dinner had been practically served. Then she became depressed and moody and abruptly left the table."

"And what did you do then?"

"My wife followed, and they went into the living room. Brad Davidson and I remained at the dining room table and had our coffee. When we joined them, Mrs. Davidson appeared to have become herself again after a talk with Mrs. Vail."

"And then?"

"When we reached the living room, my wife went out into the hall and played several numbers on the piano. The rest of us drifted out and joined her, and presently she suggested that Mrs. Davidson play for us. She consented to do so and sat down at the piano."

"Did she play?"

"She tried, but something seemed wrong. She couldn't seem to finish anything that she started to play. She seemed to grow discouraged with her fingers, or whatever it was, and immediately she was back in the mood that was so unpleasant for her—and for us, too."

"Was she crying?"

"Yes, she was. She left and returned to the living room again."

"Did anyone go with her?"

"I did. I felt that someone needed to comfort her. My wife and Mr. Davidson stayed by the piano, but I followed Mrs. Davidson and sat down beside her. She continued to cry and seemed very despondent."

"Did she say why?"

"I don't recall her exact words as to why she was so discouraged and upset. But I do remember what she said next, because it shocked me so."

"What did she say?"

Vail took a deep breath.

"She said, 'I think the best solution would be for me to go out into the garage and turn on the motor.'"

There were audible gasps. Broughton threw down his pencil and looked as if he would have leapt up to object if there had been a judge to object to. The room erupted in such a hubbub that Boyette had to wait for things to quiet down before he could proceed.

"Would you repeat that, Mr. Vail?" he finally asked. "She said—"

"She said, 'I think the best solution would be for me to go out into the garage and turn on the motor.'"

"You're certain?"

"Yes. That was what she said, in her exact words."

"And did you confide this scene with anyone?"

"Just Mrs. Vail. But it made such an impression on me that when I heard about Elva's death, I immediately told her, 'I knew she was going to do that!'"

"Would you say she was in the same mood that night that you observed her at Montesanti's Spaghetti Camp on the morning of her death?" Boyette asked.

"Practically," Vail replied.

"Do you think she was mentally unbalanced between the night of the dinner party and the time of her death?"

Vail, who had sounded tentative in his answers up to then, now spoke with greater firmness, as if glad to have something off his chest.

"I think she's been mentally unbalanced ever since I've known her," he said.

The reporters scribbled madly in their notebooks.

When it was time for his cross-examination, Broughton had only a few questions. But he made no effort to disguise his hostility toward this surprise witness, the timing of whose testimony was so questionable.

"Mr. Vail," he said, "I believe you have expressed the opinion previously that Mrs. Davidson's death was an accident. Is that not so?"

"It is," Vail answered in a low voice.

"This is quite a story you've told us here this morning. But you have concealed it in your previous talks with us, haven't you?"

"Yes."

Broughton moved in closer.

"And you are testifying to it now, and making these intimations of suicide, only because the evidence here shows that her death could not possibly have been accidental, aren't you?" he said.

"Yes."

Knowing how that must sound, the suddenly weary Vail felt compelled to add an explanation. "An accident would have been the easiest way," he said.

Boyette, Davidson's lawyer, stood and sought to nudge Vail a little further along that road with one more of his gentle questions.

"Mr. Vail," he said, "I believe it was your intention previously to keep Mrs. Davidson's death from being designated as a suicide because of concern for her husband and things of that kind?"

"Yes," Vail replied. Then he added in an anguished voice: "There was no reason I didn't tell this before except that I hoped it would be found to be an accident. I hoped all along that it would be decided that way instead of—the other."

Of course, there were two "others," but Boyette decided to leave it at that. Vail left the rocking chair, averting his eyes from the audience, and the testimony was suddenly over.

Vail's abject confession of perjury, and his attempts to justify it as an effort to spare his friend further pain, aroused a degree of sympathy among some spectators. But others had to wonder: if he was lying before, how do we know he isn't lying now?

<p style="text-align:center">***</p>

Pruette had given the jury five possible verdicts, ranging from "accident" to "suicide" to "death caused by carbon monoxide poisoning under circumstances not known to the jury," on through "murder by persons unknown" and up to "murder by a specific person."

The members of the jury, all male and all white, were L.M. Tate (foreman), Ernest Hunt, Melvin McCaskill, Patrick Garrity, Robert Shaw Jr. and Russell Sullivan. Between the secret, abortive first inquest and the open, exhaustive second one, they had dutifully sat through five days of complicated testimony. But once they retired at 2:45 p.m., Pruette hardly had time to enjoy a cigarette before they bounced back at 3:00 with a verdict.

The newsmen scrambled to report it. Eddie Folliard scribbled out a bulletin and sent it winging by telegraph to Washington, where rewrite men waiting at *The Post* hastened to turn it into typed copy, which they then sent by pneumatic tube down to the smoky bowels of the composing room:

Pinehurst, N.C. March 7.—The death of Elva Statler Davidson, 22-year-old heiress and bride of two months, remained an official mystery tonight after a baffled coroner's jury had rendered what is known in North Carolina as an open verdict. It found that the young woman, wife of H. Bradley Davidson, Jr., of Washington, had come to her death by "carbon monoxide poisoning under circumstances unknown to this jury."

His Thin Face Smilelessly Imperturbable

C ircumstances unknown.

The inquest jurors, "confronted by a set of bewildering circumstances and conflicting stories," had simply agreed in the end that they couldn't agree on what had happened to Elva Statler Davidson. They were back to the verdict that they had been prepared to deliver a week earlier, before Solicitor Pruette had suspended the inquest and jacked it up to the level of a trial and put everybody through so much.

Though it seems clear that the jurors didn't know what to make of Herb Vail's last-minute story of suicidal urges on the victim's part, he might have succeeded in sowing enough doubt to forestall a conclusion of murder.

Where was H. Bradley Davidson when the jury brought its verdict? Oddly, newspaper reports differ on that fundamental question.

One paper writes that Davidson, "his tanned, thin face smilelessly imperturbable, sat in a rear row when the jury returned to the tense, packed Community House," and that "without comment, he walked from the emergency court room when the verdict was announced." Eddie Folliard paints an entirely different picture: "Davidson was not in the makeshift courtroom when the jury filed back…He was seated outside in his automobile, and the news was carried to him by his brother, Richard Davidson, who was in attendance with his wife, the former Betty Hanna."

Wherever Brad was, it is clear that he betrayed no emotion upon hearing the news. And when reporters later crowded around him, he would say only: "I have no comment to make."

Things wrapped up with blinding speed once the jury had spoken.

Sheriff McDonald made it clear that he still considered the case open. "I'm going right ahead to continue the investigation," he told reporters. "If we find further evidence which warrants the arrest of anyone, that person will be arrested, and the case immediately sent to the grand jury."

The sheriff made clear that he would be "assisted" in that investigation by private gumshoes employed by the Statler estate.

"He will cooperate with L.P. Whitfield, of Atlanta, district manager of the Burns Detective Agency, who has been here at the behest of Buffalo attorneys representing the Statler family," Folliard wrote. "Whitfield said tonight that he would remain in Pinehurst until the conflicting circumstances and the aura of mystery had been cleared. Whitfield was joined today by 'Buck' Healy, Burns representative from Buffalo, famous character of northern New York." Disappointingly, there would be no more word of this "famous character," Mr. Healy.

As for Solicitor Rowland S. Pruette, he was out of there. All of a sudden he couldn't wait to get back to his wife and four kids—back to his real town and away from this unreal town with its unreal people and their insoluble mystery.

"So far as I am concerned, any further action is up to the grand jury," Pruette told reporters as he hurriedly packed up his briefcase. "The grand jury has a regular term in May, but they can meet in special session any time they want to. I am leaving for my home in Wadesboro immediately."

The grand jury never reopened the case.

"Davidson case ends," a weary Hemmie Tufts wrote in her diary on March 7, 1935. "Verdict death by CO_2 [she meant CO], cause unknown. Thanks be that's over. Let there be light."

A great many people in Pinehurst, especially Hemmie's father-in-law, Leonard Tufts, shared her thankfulness at seeing the inquest over and its damaging publicity ended—even on such ambiguous and inconclusive terms, which would lead to years of lingering gossip and conspiracy theories.

At the time of the Davidson story, *The Pilot* of Southern Pines was a weekly coming out on Fridays. So it was able to publish a fairly complete account of Thursday's climax on March 8, though it had nothing that the bigger papers didn't. The competing *Moore County News*, based in Carthage,

had the misfortune to publish on Thursdays. So it had to wait a whole week until March 14 before coming out with its story, which by then was old news.

The News did offer its readers its own exclusive interview of sorts, with an anonymous woman who claimed to be an "intimate friend" of the Davidsons. They were visiting her at her home in New York not long after their January 3 wedding, she confided, when Elva announced that she had to go to Boston alone on business. That was when Elva made out her will, leaving more than a half million dollars to her husband, the source said—and she did it without his knowledge.

"Mrs. Davidson, I know, was devoted to her husband," the source told the editor, "and it was perfectly natural for her to make a will in his favor."

Though the mystery woman remained unidentified, she must have been none other than Minnie Vail—still working with her husband to help Brad Davidson put the best face on the messy affair, still trying to remove that "shadow of ugly suspicion." The New York connection fits, since the Vails had a second home on Long Island. And Minnie had already demonstrated a propensity for approaching journalists with her own particular pro-Brad spin.

The groundwork was already being laid for the next ugly court confrontation in the Davidson case: an all-out challenge by Statler family interests aimed at keeping Elva's will from being executed as written. But that wouldn't reach its climax for another year.

As of March 14, 1935, all the big-city boys had long since packed up and departed to pursue other sensational stories in distant places. And things in Pinehurst were already getting back into their former carefree swing.

The News reported:

> While several mysterious circumstances in connection with the death of Mrs. Davidson remain to be cleared up, it is believed locally that the verdict of the coroner's jury, which found that she came to her death from monoxide poisoning from causes unknown, has written "finis" to the case...In the meantime, millionaires and their servants, who listened attentively for developments and attended the inquest last week, shelved discussion of the case for the time being. Golf and bridge and the recreations making up the normal routine of the resort town are again the order of the day...
>
> In its 40-year history, Pinehurst never has had a major mystery to compare with the Davidson case, which brought attorneys, private detectives, Moore County officers, newspaper men and news photographers

to investigate and report. The jurors who returned the verdict were a livery stable operator, a waiter, a butcher, a chauffeur, a golf professional and a butler, and they had also resumed their normal activities and showed a reluctance to discuss the case.

As the paper was being put to bed, an adjacent column by the editor noted that it was "raining dogs and cats."

In much of New York State, by contrast, that week brought a late-winter snowfall. The first random flakes that came to rest on a swollen rectangle of fresh black earth on a sloping hillside in Kensico Cemetery seemed to accentuate the contrast between it and the surrounding grass.

But the more briskly the flakes fell, the faster Elva Statler Davidson's grave—Plot 6, Circle 1320.25, Section 3A-2, Area 56—waned from view. Soon, its secrets locked away, it became indistinguishable from the rest of the silent snowscape that faded on all sides to the palest white.

CHAPTER 12

Nobody Dies in Pinehurst

It is hardly an exaggeration to call the Davidson case the Scott Peterson or O.J. Simpson trial of its day. It may not have held the nation's attention for as long, but for a week or two the Davidson saga bumped the ultra-sensational Charles Lindbergh case off the nation's front pages. Bruno Richard Hauptmann's trial in the abduction and murder of the superstar aviator's baby had ended with a guilty verdict and a death sentence on February 13, only two weeks before Elva's death.

Yet after flaring up so brightly but briefly with the coroner's inquest in 1935, and again even more briefly in 1936, when her family challenged her will, the Elva case was destined to sink to the pitch-black bottom of the ocean without a ripple, forgotten by all but a few old-timers and local history buffs. It would languish there in silence like the wreck of the *Titanic*, accumulating undisturbed layers of silt for two-thirds of a century.

It is perhaps easier for us to put the Davidson case in historical perspective than it was for all those savvy, sharply dressed out-of-town journalists jostling and joshing one another while getting Moore County sand on their well-shined wingtips in March 1935. Larry (Nuts) Byrd and A.E. Scott and the others who posed for that now-faded photograph knew they were down here to cover a good story before moving on to cover another one somewhere else. What they couldn't have known was that a far bigger story was breaking all around them—one that they were part of, though it was too close for most of them to see: America was transforming itself. An old era was dying. And another age was in the painful throes of being born.

In 1935, the unemployment rate hit 25 percent and the country bottomed out in the Great Depression. It was the year that stood exactly halfway between the stock market crash and Pearl Harbor. Exactly halfway between the Wright brothers and Apollo. For that matter, exactly halfway between the beginning of the Civil War and today.

For Pinehurst itself, that little elite northern outpost struggling to stay alive in the middle of the South, 1935 marked another kind of midpoint. It came forty years after idealistic Yankee millionaire James Walker Tufts selected a spot on a sandy, logged-over rise and drove a wooden stake to mark the center of the ambitious village that at that point existed only in his fertile brain—and nearly forty years before the Tufts family would make the mistake of selling the place lock, stock and barrel to a company called Diamondhead, which would proceed to despoil and exploit it and all but run it into the ground before it could be repurchased, rescued and restored.

The year 1935 was when Adolf Hitler built up his navy and made other great and ominous strides toward bringing his dark vision to fruition. It was the year when Louisiana's demagogic Governor Huey Long was assassinated; when Congress passed the Social Security Act; when Richard Byrd returned from his two-year expedition to Antarctica; when the Dionne quintuplets went on tour; when George Gershwin's folk opera *Porgy and Bess* premiered on Broadway; when *Mutiny on the Bounty* won the best-picture Oscar; when Parker Brothers introduced the game of Monopoly.

More important to this story, the year 1935 came at a time when fast-evolving changes in the public's demand for news happened to intersect with technological leaps that made it easier for the media of the day to meet that demand. Not only had the radio networks entered a golden age of Walter Winchell and Jack Benny and Fibber McGee, but newspapers were also leaping forward in better-quality reproduction and high-speed printing. It had been only two years since the Associated Press stopped sending stories out to papers on its "A Wire" by Morse code over old-fashioned telegraph keys and started transmitting them instead to newfangled Teletype machines that clunked along at the then-blinding rate of sixty words a minute.

And only at the beginning of that very year, 1935, had AP introduced the revolutionary Wirephoto machine, which, with its rotating helix rubbing rhythmically against a roll of damp paper, made it possible to get black-and-white pictures into far-flung editors' hands in minutes over telephone lines instead of taking days to send them by mail. They would make good use of

this brand-new, cutting-edge advance in disseminating some of the photos being shot in Pinehurst.

As 1935 dawned, a Depression-weary and anxiety-ridden American public hungered for the thrill and sense of momentary escape to be found in stories of ritzy affluence, crime among the upper crust, celebrity sin, unexplained deaths and dramatic court proceedings. They wanted them in real time. If it happened yesterday, they wanted it this morning. Or in the case of the still-thriving p.m. dailies, if it happened this morning, they wanted it this afternoon. And the media stood newly empowered to travel to even remote places and satisfy that appetite with previously unimagined dispatch.

One can almost picture editors casting about for a good, out-of-the-way proving ground in which to test out and show off their new technology—in rather the same way that Germany would test out advanced new weapons systems by allying itself with the fascist rebels in the Spanish Civil War, which was to start the following year. What the media needed was a good, juicy scandal story somewhere in the boonies—one they could bring directly to their readers as it unfolded day by day. One with love, sex and betrayal and money, death and mystery.

If the Elva Statler Davidson case hadn't come along, someone would have had to invent it.

Normally laidback and fun-loving Moore County had never seen anything remotely like the Davidson inquiry, not to mention the media circus surrounding it. "Direct wires were run into the old Pinehurst Community House, over which the testimony was sent to press headquarters as rapidly as it was given," wrote *The Pilot*, a publication more accustomed to covering hospital balls and county commissioner meetings. "Specially chartered airplanes carried photographs from the witness stand to distributing points in Atlanta and New York each day."

Shortly before his death in 2006, Joe Montesanti Jr. still vividly remembered the frenzy of excitement surrounding the inquest seventy years earlier. He told of playing hooky and hanging around the back of the Community House on his bicycle, available to rush various dispatches to the telegraph offices as needed. "They wouldn't allow us in," recalled the eighty-six-year-

old Montesanti, a descendant of the family who ran the spaghetti restaurant in which Elva ate her last supper. "When they had something on the case that they wanted to telegraph—the reporters and the lawyers and the others— why, they'd hand it out the back window. And I'd get on my bike and take it up either to the Western Union or the Postal Telegraph, I can't remember which. And I can't remember how much they paid me. A dime, maybe."

The Moore County News, chief competitor of *The Pilot* in the 1930s, wrote:

> *Acting Coroner Hugh Kelly, as well as others connected with the investigation into the strange death of Mrs. Davidson, has been besieged with long-distance calls and requests for interviews by big-city papers the length and breadth of the land. The prominence and wealth of the young woman, to say nothing of her athletic record, made her unfortunate death "big news," especially for the papers located in cities where Statler hotels are operated. The case also had the elements of mystery calculated to catch the popular fancy, the people clamoring for details and the press struggling to supply them.*

Despite their local contacts and the many insights they must have had into the lives of key players in the drama, neither local paper seems to have nailed down any significant exclusives on the substance of the story. They spent most of their time ogling all the comings and goings of the big-city guys and second-guessing them on minor details—if not engaging in downright plagiarizing of the metro dailies' stories.

At one point, an anonymous writer for *The News*, presumably female, saw fit to chide the male investigators and reporters in print for their ignorance in the matter of feminine footwear. "The feet of Elva Statler Davidson…were not clad in 'mules,' Solicitor Rowland Shaw Pruette and The Associated Press to the contrary," she lectured. "'Mules,' in case you do not know, are simply bedroom or boudoir slippers, but, admitting that it sounds less intriguing, Mrs. Davidson wore a pair of plain suede slippers." The metro guys presumably stood duly corrected.

The reporter for *The News* did score one macabre little scoop on her fast-lane brethren—and it also had to do with women's attire. Acting Coroner Kelly, she wrote, had received "quite a jolt" on the Sunday after the death when a big-city journalist asked about the whereabouts of the garments the dead girl had been wearing. Safeguarding of evidence not being what it is now, Kelly drew a blank. He knew at once that he was in trouble.

"He leaped into a car," wrote the reporter, who knew a good sidebar story when she saw it, "and hurried to the Southern Pines undertaking establishment where the body had been prepared for burial, and where the clothing had last been seen by him. An attendant, in response to his frantic request, rustled up the shoes and sweater for him, and then went to get the skirt, which had been hung on a clothesline outside. To the consternation of all concerned, the skirt was not to be found."

By this time, Kelly was beside himself. The item of clothing would surely be called for during the inquest that was then about to resume, especially since certain troubling questions had been raised about the apparel. And what would he say? One can almost hear him standing there outside the funeral parlor and yelling at the hapless young attendant: "What do you mean you don't know where the damned thing is?"

Then luck intervened—in the person of a fireman who happened to be working outside the nearby Southern Pines firehouse and heard the commotion.

"What are you looking for?" he shouted.

"A woman's skirt," Kelly replied.

"I have it," the fireman yelled back.

The acting coroner and the young mortician-in-training looked at each other with grins of disbelief. Asking them not to go anywhere (he needn't have worried), the fireman then went inside, retrieved the carefully folded piece of clothing and soon had it back in Kelly's eternally grateful hands.

So what was a Southern Pines fireman doing in possession of a wool skirt that would soon be marked Exhibit A? "It turned out," *The News* reported, "that the fireman had thoughtfully removed the skirt from the clothesline and carried it to the firehouse when he saw a couple of little Negro boys sidling up to the garment with the evident intention of stealing it." Kelly, we are told, "heaved a sigh of relief when, a few minutes later, he deposited the clothing into the safekeeping of the sheriff."

By mid-March 1935, once all the excitement was over and the big-city journalists had departed, most Moore Countians seemed more than willing to "shelve discussion of the case for the time being," as *The News* wrote. There were

several reasons for this willingness to put the thing out of mind. Many of the locals were tired of being the topic of sensation and eager to get back to their fun and games. Others were weary of trying to solve the seemingly insoluble Davidson mystery and ready to think about something else. Still others in the upper echelons of Pinehurst had more selfish concerns: the resort community had had more than enough damaging publicity and didn't need any more.

The late Mary Evelyn de Nissoff said that Pinehurst, protecting its image as a carefree getaway place, did all it could to keep the lid on from day one. At the time Brad Davidson's new bride died under such unsavory circumstances, she pointed out, the place had already been reeling in crisis mode for years. As the Depression dragged on, Pinehurst was hanging on for dear life, trying to put on a happy face, barely bringing in enough guests to keep the lights on. The last thing it needed was a world-class scandal on its hands. "The resort had scheduled a big tennis tournament in March or April of 1935 and didn't want anything casting a pall over it," Mary Evelyn said a month before her death in 2005. "I think Bill Tilden and Don Budge, the big tennis players, were going to come. Pinehurst and the Tuftses didn't want Elva's death to be the talk of the town and keep people from coming here for the tournament. So I think they pretty much tried to hush it up."

If Pinehurst did try to soft-pedal Elva's death, there was more than just Pollyanna squeamishness involved. It was also a matter of hard-nosed public relations and careful image cultivation. "First of all, you've got a resort here," Mary Evelyn said. "And it's dependent on people coming here. And they'd had a really good reputation for single women being able to come here and be safe and chaperoned and all that sort of thing. Also, they were very careful about gold diggers." Bad press was bad news in Pinehurst, she explained, and the Pinehurst PR people routinely swept it under the rug. And she knew what she was talking about, since she did some of the sweeping herself. "You were never supposed to write anything bad about Pinehurst," she said. "You were supposed to bury things. Always. I used to work for the resort. I knew about burying things." She remembered that when obituaries were sent out to area papers for someone who had inconveniently passed away in Pinehurst, they routinely bore a Southern Pines dateline. "They never said Pinehurst," she said. "If you saw an obit for a Pinehurst person in the Charlotte or Raleigh paper, it always said Southern Pines. It was all part of that 'Nobody dies in Pinehurst' thing."

How far would the sunny little village go to perpetuate the myth that the Grim Reaper never visited its curvy streets? Old-timers swear that Carolina

The 1935 Elva Statler Davidson Mystery

Hotel personnel, instead of using stretchers, sometimes put dead bodies in wheelchairs and rolled them out so they'd look like they were just dozing or kept them under wraps until the wee hours of the morning and spirited them down the freight elevator while everyone else slept.

Gay Bowman, a resident of the village since moving there at age fourteen in 1939, says Pinehurst had three golden rules in the old days: "No Negroes, no Jews and no funeral homes." Bowman likes to quote a story told by the late Mildred McIntosh, the original Tufts archivist. It seems a man was sent out from Pinehurst in the middle of a spooky night to deliver a dead body to Southern Pines in a mule-drawn covered wagon, only to discover upon his arrival at the funeral parlor that the wagon was empty. The body had fallen out. He raced back the way he'd come in a panic, the mules almost trampling the corpse before he spotted it lying on its back there in the road, its sightless eyes gazing at a sky full of stars.

Not every Pinehurstian wanted the Elva case to go away, of course. Many remained tantalized by the story and unwilling to settle for the frustratingly anticlimactic verdict that had ended the coroner's inquest on such an inconclusive note—"death of carbon monoxide poisoning under circumstances unknown to this jury."

The story was by no means over. There would be an entirely new trial of sorts, and a dramatic one, in which two teams of legal titans would contest the hastily drawn will in which Elva had left everything to her husband. But the wheels of justice ground slowly, then as now, and it would be nearly another year before the court in Carthage would hear days of explosively heated arguments in that case.

The lull gave all the lawyers a chance to return to their various home bases and prepare their cases. It also gave local curiosity-seekers at the time—as it does us today—a chance to step back, fill in some blanks and seek answers to some basic human questions that had gone neglected: Just who was Elva Statler, this bad-luck orphan for whom nothing seemed to go right? Who was Henry Bradley Davidson Jr., the opportunistic mystery man who swept her off her feet? And what do we know about their brief, doomed marriage?

CHAPTER 13

The Style to Which He Was Accustomed

Though Elva Idesta Statler clearly fell heavily for Henry Bradley Davidson when friends introduced them in Pinehurst in 1934, many wondered why. He was clearly a lazy, charming, enigmatic man who combined some of the least admirable characteristics of the con man and the gigolo. Having been born to wealth and then lost it, he appears to have set out to maintain his status in life by whatever means necessary.

Henry Bradley Davidson Jr. was born on September 10, 1892, to Henry Davidson Sr. and his second wife, Mary Stannard Porter. The Davidsons lived at 1413 G Street, Washington, D.C., and Mr. Davidson was in the real estate business. Brad had a much older stepsister, Louise, from his father's first marriage. His brother, Richard, would come along eight years later. Brad's father and grandfather were both well known as sportsmen and well established in old-line social circles. One of their ancestors was Scottish-born Samuel Davidson, who came to America before the Revolution and acquired extensive landholdings that later became part of the new national capital. He is said to have sold off a tract that later became the sites of the White House, Treasury Department and Lafayette Park.

"The Davidson family at one time owned a large portion of southern Montgomery County, Md., which adjoins the northwest section of the District of Columbia," *The Buffalo News* wrote in a Washington-datelined sidebar to its March 4, 1935 United Press story about Elva's death. "Several years ago, most of this land was broken up into residential subdivisions now known as Somerset and Chevy Chase…The old family house, not now occupied by the Davidsons, still stands in Somerset, looking out of place among the

smaller and more modern houses that have been built around it." To this day, Chevy Chase includes a Bradley Boulevard and a Davidson Drive.

Young Brad, then, was born with a silver spoon in his mouth. But it got jammed down his throat pretty early when his tribe fell on hard times.

In 1912, when Brad was just getting out of high school, his father and some fellow investors hatched a plan to make a killing by carving out a posh development on the shores of the Potomac where the well-to-do could escape Washington's miasmal summers. They aspired to out–Chevy Chase Chevy Chase, and they called their new venture Bradley Hills. Sales brochures told of plans for a country club, a golf course and ample room to ride to the hounds—sort of a Pinehurst North.

But from the beginning, the Bradley Hills undertaking seemed shaky, if not shady. In the end, the developers got no further than building a road, a trolley line, a small amusement park at the Great Falls of the Potomac and a few demonstration homes before the thing fizzled out. Besides questionable finances, Bradley Hills fell victim to the recession of 1913–14, compounded by the outbreak of World War I and the subsequent influenza epidemic. By 1920, creditors had pulled the plug on it.

<center>***</center>

The Pinehurst Outlook would later say that Brad Davidson had graduated from the National Cathedral School in Washington and from Cornell University, no doubt relying on information he had provided. But he never finished at either institution.

He began his education at the exclusive Jacob Tome Institute, housed in a brand-new cluster of Georgian Revival buildings on a two-hundred-foot bluff overlooking the Susquehanna River near Port Deposit, Maryland. He was seventeen years old in the fall of 1909, when his parent packed him off to the National Cathedral School in Washington for his last two years of secondary education.

Young Davidson excelled at tennis, track, baseball and basketball at the Cathedral School. He was even athletics editor for the school paper, *The Albanian*, which published a photo in which Brad, already taller than most of his teammates, was seen holding a basketball with "Champions 1911" lettered on it in white paint. But he left behind an undistinguished academic

Henry Bradley Davidson (center) played basketball at National Cathedral in Washington, D.C. *Courtesy of Washington National Cathedral.*

record, maintaining a C-minus average. And though he was considered a member of the class of 1912 and identified himself as such, he in fact left the Cathedral School—later renamed St. Albans—in the middle of the year without graduating.

For the next three years, Brad helped his father and uncle in their D.C. real estate business, Davidson & Davidson, and virtually dropped out of sight. He next shows up in the Collegiate Church of New York City on September 9, 1915. That's when he married Jessica Aylward, of Berryville, Virginia. He spent the next two years on her sprawling estate in the Shenandoah Valley of Virginia, during which time they became parents of a baby girl, whom they also named Jessica. They would have two more children, sons Henry Bradley Davidson III (whose friends called him "Dave") and Herbert Aylward Davidson (Herb).

In 1917, when the United States entered what was then known as the Great War, Brad left Virginia, moved his family to Baltimore and enlisted in the army. He was commissioned as a pilot and sent to Europe, where he achieved the rank of captain and served in France. There appear to be few available records about his military service.

In 1919, Captain Henry Bradley Davidson came back from World War I to find the nation heading into the Roaring Twenties and the Bradley Hills subdivision gasping into its death throes. He rejoined his father and uncle, who tried to make a go of it with their real estate business during the next ten years, but the twenties didn't roar for them. The stock market crash of 1929 administered the coup de grâce, pretty much sending what was left of the family fortune gurgling down the drain.

By then, Brad had already been gone for a year. For reasons that remain mystifyingly unclear, he had headed west in 1928—essentially abandoning his young family, though he and they apparently stayed in contact. He spent three years in the Midwest, working first in Waukegan, Illinois, and then at a lock manufacturing plant in Milwaukee, before returning to Baltimore.

In 1931, three big things happened to Brad: his father died. Jessica filed for legal separation. And, demonstrating his usual acute business judgment, Brad became involved for three years with another ill-fated development on the Potomac. But this time, his involvement wasn't as an investor (there was nothing left to invest) but as an employee of a flamboyant woman named Rella Abell Armstrong, widow of playwright and screenwriter Paul Armstrong, who set out to turn the family farm into an ambitious development to be called Annapolis Roads. She needed someone with real estate experience to help sell the lots, which may have been where Brad Davidson first came in. But soon he was being listed as manager of the Annapolis Roads Club.

Things went swimmingly at first. But then the real estate market turned sluggish as financial pressures mounted and the country sank into the Depression. In January 1934, the Equitable Company of Washington foreclosed on the mortgage, and Rella and her employees were out in the cold. Annapolis Roads had gone the way of Bradley Hills. Though he apparently worked briefly in an unknown capacity with Sherwood Oil Company in Baltimore, H. Bradley Davidson Jr. was assembling quite a record of failure.

As 1933 ended, he was still a hanger-on in the upper-class Greater Washington circles amid which he had grown up, though he no longer had the wealth to support himself in the style to which he had grown accustomed. And things just wouldn't break his way. Not only was his job disappearing under his feet, but his estranged wife, Jessica, sued him for divorce in March 1934 in Bethesda, Maryland. The judge granted the petition in May. He ordered the penniless Brad to make alimony and child support payments, but Jessica clearly wasn't holding her breath.

In early 1934, then, Henry Bradley Davidson's life was in pieces. He had no wife, no job, no money and no particular prospects. Down and out and needing a rest and a change of scenery, he took the train down to visit his

Brad Davidson plays golf at Pinehurst, probably in 1934. *Courtesy of the Tufts Archives, Pinehurst.*

brother Richard, who had taken out a season's lease on a house in the brand-new development of Knollwood, near Pinehurst, North Carolina. Brad had already established a habit of turning to his smarter, better-looking and more socially nimble brother when things got bad. According to information from local courthouse dockets, Richard Porter Davidson had shown up in Pinehurst to take up residence and try to bring some of the rich hangers-on there to put up money for some kind of unidentified business deal.

It was Richard's wife, Betty, who—with the encouragement of Hemmie Tufts and others in the gang they hung out with—decided to play matchmaker and lend some focus to Brad's social life by bringing him together with a likely companion of the opposite sex. Looking around for an available match, she settled on an unattached young socialite from Buffalo, New York, who shared Brad's enthusiasm for sports.

Her name was Elva Idesta Statler.

Poor Little Rich Girl

Nobody knows to whom the blonde baby girl who would later be named Elva Idesta Statler was born, but the date is known: June 7, 1912—two months after the *Titanic* disaster. She is thought to have come into the world in New York City, the port toward which that unsinkable ship was headed when it sank.

Though Elva's life would later turn into something of a shipwreck itself, marked by much heartbreak and bad luck, she and three other unwanted or orphaned children had a singular stroke of good fortune at early ages: they were all plucked out of poverty and anonymity and adopted by an altogether extraordinary gentleman, Ellsworth W. Statler.

E.M. Statler's life was the original Horatio Alger story—a rags-to-riches drama that saw this son of a poor, obscure Pennsylvania country preacher rise to become one of the captains of American business. By age thirteen, the hardworking and courteous Ellsworth had landed himself a job as a bellboy at the McClure Hotel in Wheeling, West Virginia. By fifteen, he was head bellboy. Then night desk clerk. Then head desk clerk. By the time he was nineteen, he had learned about all there was to learn about hotels and was running the place.

The year 1895, when James Walker Tufts launched Pinehurst, was also a banner year for the restless "Bellboy of Wheeling." He married Mary Manderbach, of Akron, Ohio. After a successful venture into the food-service business, he took a bold chance by opening a massive temporary hotel in Buffalo, New York, for the Pan-American Exposition held there in 1901. Neither the exposition nor the hotel did very well, but Ellsworth

repeated the venture with greater success by building the Innside Inn for the 1904 Louisiana Purchase Exposition in St. Louis. Though things went better there, he suffered a near-fatal accident involving a coffee machine and was confined to a wheelchair for many months.

Having recovered from that, and having saved up enough money from his two temporary hotels, he decided the time had come to open a permanent one back in Buffalo in 1907. He called it the Statler. He designed it to be as efficient and guest-friendly as possible, making good use of every square foot of space and offering "a room and a bath for a dollar and a half." He was the first to put telephones, full-length mirrors and built-in closets in every guest room.

Over the years, E.M. opened Statler Hotels in Cleveland, Boston (his flagship, with thirteen hundred rooms), Detroit and New York. He kept pace with advances in technology, equipping all his rooms with radios beginning in 1927. He always demanded only the best performance from his workers, but he also gained a reputation as an enlightened employer, initiating a five-day workweek and programs of job and retirement security that were way ahead of their time.

As good as E.M. Statler was at cranking out spectacularly successful hotels, he and his wife, Mary, failed to produce the one thing they both wanted most: children. (One story has it that the coffee-machine accident in St. Louis had rendered him impotent.) Mary was active in programs to help underprivileged youngsters, and E.M. was said to have a special way with kids and some pet theories on how they should be raised. The two of them often had "orphanage charity gatherings" at their home.

"It was the irony of fate that a man who loved children as he did should never have had any of his own," *The Buffalo Times* wrote in an editorial at the time of E.M.'s death. "But even that did not faze him. He adopted four babies, turned the third floor of his house on the Parkway into a nursery, and with the first Mrs. Statler watched these youngsters grow and develop."

The first of those babies brought home to 154 Soldiers Place in an upscale residential section of Buffalo was a boy, Milton Howland, born in 1906. Then came a girl, Marian Frances, born in 1907. Both were six or seven years old when adopted. Elva Idesta and Ellsworth Morgan were the last two,

Beginning in her teens, Elva Statler enjoyed riding at Pinehurst. *Courtesy of Andrew Edmond.*

both born in 1912 and adopted two years later. Nothing was ever revealed about the birth parents of any of the four, although there are intriguing hints that some or all of them could have been children of Ellsworth's brother, Osceola, who seems to have had problems holding down a job and putting down a bottle and might not have been able to support them. The fact that Elva and Ellsworth Jr. were born on the same day, June 7, strongly suggests that they were twins.

Although E.M. Statler was a kind and generous man and a devoted adoptive father, he does seem to have brought some of the same rigor and go-by-the-book perfectionism to parenthood that he applied to the art of making guests comfortable. He turned child rearing, like everything else, into a science designed for the betterment of mankind. Fortunately, Mary Statler was always around to temper E.M.'s masculine discipline with feminine warmth and acceptance.

In the summer of 1924, E.M. Statler sold the family's comfortable Buffalo home and moved his entire household, including twelve-year-old Elva, to New York City. There, they took up residence on the entire top floor of his Hotel Pennsylvania—the only one in his empire that didn't bear the name Statler. His wife, he said, had had to spend too much time alone because of

all the time he was obliged to spend in New York on business, and he wanted her near him.

And then, scarcely a year later, on October 25, 1925, "a sweet and gracious woman passed on to her reward when Mary Idesta Statler, wife of Ellsworth M. Statler, formerly of Buffalo and later of New York, died in that city this week," *The Buffalo Courier* wrote. "Mrs. Statler endeared herself to hosts of friends, for she was a woman of generous impulses and her charities were many. She had a special tenderness for little children, and particularly for those who were handicapped by poverty or illness."

Elva Idesta Statler would feel precious little of such tenderness from that day forward. She had a mere ten years left to live at the time her family moved to New York. And almost every one of those years seems to have dealt her some kind of emotional blow, major disappointment or personal upheaval. Each time, she would manage to pick herself up, only to get slammed back down again.

Less than a year after her mother's lingering death from pneumonia, thirteen-year-old Elva was packed off to Dwight School for Girls in New Jersey. She worked hard to make a go of it during her four years there, becoming heavily involved in sports and after-school functions and maintaining about a C average. She made a few close friends, who gave her the nickname that would stay with her after she moved on: "Stat." She didn't smile much—and no wonder. She had little to smile about during those few Dwight years, when three major events shook her life in quick succession.

First, in April 1927, her sixty-four-year-old father surprised all who knew him—and disappointed many of them—by marrying his secretary of eleven years, the thirty-four-year-old Alice Seidler. It seemed beneath the dignity of the great hotelier, conservative Republican and staunch Presbyterian. And it raised obvious, if unspoken, questions about office hanky-panky.

"Wedding plans were carried out with great secrecy, and nobody was more surprised to learn of it than the bridegroom's associates at the Hotel Pennsylvania in New York," *The Buffalo Times* wrote. "It was said he arrived there this morning from Boston, saying nothing whatever about his intention of getting married." So this is the point at which Alice, the woman who would play Wicked Stepmother to Elva's Cinderella, enters her life.

Then, only a few months later, on a stiflingly hot August day, Elva's beloved older sister, Marian, died of pneumonia at the Statlers' summer home in Long Neck, New York, shortly after returning from a cruise. She was twenty years old. Elva, then fifteen, stayed by her side to the end.

It had been a wrenching year. As 1928 dawned, the Statler family—or its grieving remnants—desperately needed to get away from it all and seek what relief could be found in a change of scenery. Perhaps E.M. also thought a trip together might help expedite the never-easy task of cultivating an amicable relationship, or at least an armed truce, between a teenage girl and her new stepmother.

Whatever the reason, E.M. took his new wife and Elva for a stay in a place that all of them had heard much about from their wealthy friends but where none of them had ever been before: Pinehurst, North Carolina.

Statler had probably received frequent invitations from Leonard Tufts and his PR department, always eager to lure celebrities to Pinehurst Resort during those difficult Depression years so that their presence could then be exploited in press releases to drum up business.

"I learned something I am going to put to good use," E.M. obligingly gushed in a promotional article in *The Pinehurst Outlook* on January 10, 1928. "I learned that if I can get a week off in winter I can play as much golf as I can if I get the week off in summer. There is only an overnight ride to Pinehurst, and a week will provide a man with seven full days of golf, without missing an extra day." He and Mrs. Statler took up riding, he said, and did a lot of it.

Though little else is known about that first excursion, it is clear that Elva loved the place, felt at home in it and quickly made some new friends there. Several things about Pinehurst appealed to her. The most obvious is that the outdoor sports she loved so much—such as golf, tennis and riding—were daily fare there. And where she might previously have imagined Pinehurst to be a boring haven for old folks, she found plenty of people her own age. On the way home, she begged her father to return, and he agreed to do so someday.

But again, fate had something else in store. On April 16, 1928, just three months after the return from Pinehurst, Ellsworth Statler himself took ill,

Elva Statler's adoptive father, Ellsworth Statler Sr., poses with his adoptive son, Ellsworth Jr., while playing golf at Pinehurst in January 1928. Ellsworth Jr. is thought to have been Elva's twin brother. Ellsworth Sr. died four months later. *Courtesy of the Tufts Archives, Pinehurst.*

also with pneumonia. He seemed to rally near the end but then took a sudden turn for the worse and slipped from his anguished family's hands. Statler's doctors said that worry over a million-dollar lawsuit filed a couple of years earlier had taxed his health and hastened his death. Grief-stricken over losing his wife, he had canceled his annual Florida cruise, instead agreeing to lease his yacht, *Miramar*, to an acquaintance, E.M. Smathers. But before the craft could be delivered, it foundered in a hurricane off the Florida coast. All eleven hands on board perished, and their families sued. A federal judge dismissed the suit after Statler's death.

"Big in all that he visioned, he had his reward in far greater measure than falls to the common lot," *The Buffalo Times* eulogized. Thousands of admirers were stunned at the sudden demise of this giant of a man. And Elva Statler, at age fifteen, was an orphan again.

Two bereft teenagers, Elva and Ellsworth Jr., briefly remained at home in the Pennsylvania Hotel penthouse, living with a virtual stranger. (Milton, their older brother, was already out on his own.) Their father's

body was hardly cold in the family plot at Kensico Cemetery before Alice Seidler Statler, who had made quite a leap from secretary to filthy-rich heiress in a matter of twelve months, lost no time in letting them know that she didn't want them underfoot anymore. She did everything but make them sleep by the hearth amid the cinders. She soon got rid of both of them, packing the mentally handicapped Ellsworth off to an institution in England and banishing Elva back to Dwight, where a sympathetic piano teacher informally adopted her for a time.

Not long after her husband's death, Alice filed a petition claiming that all the money and holdings of the Statler company legally belonged to her. She didn't succeed in that, but she did in challenging the portion of the will specifying that each of the surviving children should take a seat on the board of directors with Alice when they came of age. Both Ellsworth Jr. and Elva ended up having to sign documents giving up their board seats in order to get their ten thousand shares each of preferred Statler stock.

Despite all her crises and setbacks, Elva still managed to get back in the swing of things in her senior year at Dwight. She sang in the choir, the

Elva Statler (upper left) was an accomplished athlete who played basketball in 1929 at Dwight School for Girls in Englewood, New Jersey. *Courtesy of Dwight Englewood School.*

glee club and an octet; appeared in the school play, the banquet play and the Christmas pageant; played basketball, baseball and hockey; and served as choirmaster, chairman of charities, president of the Dramatic Club and house senator. She graduated from Dwight in 1930 and went on to Radcliffe College in Cambridge, Massachusetts. She majored in fine arts and practiced daily on the piano, which she learned to play with considerable skill. "Highly introspective," *The Pilot* newspaper later wrote, "she became an accomplished pianist, and would have made her concert debut but for illness."

During winter breaks—and indeed in almost every year after that first family visit in 1928—Elva found time for relaxing trips to Pinehurst. She met many people there and early began to engage the services of Emanuel Birch as her butler. She often took friends along with her to North Carolina, especially her closest friend from college, the willowy Minnesotan Isabelle Baer.

Though she didn't set the woods on fire academically at Radcliffe, Elva excelled in many activities—and had one brief, potential brush with international athletic acclaim. Just as she had at Dwight, Elva dominated almost anything at Radcliffe that had to do with sports and extracurricular activities. She excelled in swimming, and if it hadn't been for a diving accident that injured her spine in her junior year at Radcliffe, she might well have made the U.S. Olympic swim team, competing before Hitler and the world in 1936.

It was also in her junior year at Radcliffe, in December 1933, that Elva learned that her older brother, Milton Statler, had died in an automobile crash on a dark, winding road near Tucson, Arizona. He was twenty-seven. That plunged Elva into yet another period of intense grief and left her with only one living sibling—her apparent twin brother, the institutionalized Ellsworth Jr.

Elva, who had been so heavily involved at Radcliffe, surprised her friends by dropping out in early 1934. She seems to have had two reasons for her abrupt decision to end her academic career. The first was that she was still suffering health problems from her diving accident. One cryptic note from a school doctor, included in some of her file material in the college archives, says that Elva's "headaches have ceased" but that she is "still worried over

litigation and being sued from the second accident." It is unclear what that refers to. Whatever the "second accident" was, it was probably automotive. She appears to have been at fault in it and may have been worried that the other party had learned about her wealth and saw an opportunity to latch on to some of it.

But Elva had another, more compelling reason for turning her back on Radcliffe and walking away just when she had a degree in her grasp. She had been back down to Pinehurst and met someone. She was in love. For once in her life, it looked as if something might finally be going her way.

CHAPTER 15

The Many Faces of Elva

The more you learn about Elva Statler, the more hauntingly elusive the young woman remains. Just when you think you've pictured her face, she slips through your fingers like an evocative melody that you've become obsessed with but suddenly can't hum. Even her name, which could be mistaken for a feminine version of Elvis, is ambiguous. One source says Elva is a variant on the name Olivia. Another says it comes from the Anglo-Saxon for "elf."

There are a number of photos of Elva from various sources. Oddly, though, each one looks like a different girl. You go through them repeatedly and place them side by side and search in vain for a common thread, like face-recognition software failing to make a match. It isn't the Three Faces of Eve being examined here, but the Many Faces of Elva.

It is even hard to tell for sure whether she was pretty. Several reporters referred to her as "the pretty heiress," and one went so far as to call her "the beautiful heiress." But you get the idea that they were merely engaging in cookie-cutter journalese straight out of a Dashiell Hammett novel or *L.A. Confidential*. After all, none of those reporters ever saw her in person. Neither did former Tufts archivist Khris Januzik, but from the pictures she declared Elva to be "not pudgy, just healthy-looking by the standards of her day—not outrageously gorgeous, but pretty."

Though the late Mary Evelyn de Nissoff never became friends with Elva, who was ten years older, she did know her as a child. Mary Evelyn said not long before her death:

The 1935 Elva Statler Davidson Mystery

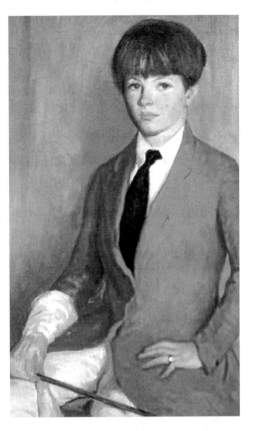

This portrait shows Elva as a youthful horsewoman. *Courtesy of Andrew Edmond.*

She was quite athletic. She played golf and played tennis and rode horses. She did not have a pretty face. I would say she was more sharp-featured or pinched, although in one or two pictures, she looks quite attractive. She was kind of innocent-looking. Dirty blonde, I would say. And everybody said she was "pigeon-breasted," whatever that meant. I think it meant there was a bone in there that stuck out or something. She wasn't really that attractive… As for her personality, all I remember is that she just seemed lost.

In one likeness, a copy of a three-quarters sketch by *The New York Times* artist Tom McCoy, Elva appears positively glamorous. Looking as if she's going out for the night, she has her hair in a fashionable crimp and wears elegant

pearl earrings. Since it's a drawing instead of a photo, it was no doubt unrealistically flattering. But there's something compelling in the vulnerable, accusatory stare of her eyes and the slight pout on her small, Clara Bow mouth, as if she's somehow demanding honesty of the viewer.

A couple of papers printed a photograph of Elva that is so similar to the sketch that *The Times* artist must have based his work on it. The angle and the expression are the same, though in the photos she looks a little rougher around the edges. Pretty? Hard to say.

Another picture, a high-quality photocopy of a sepia-toned, soft-focused snapshot, shows a younger Elva, perhaps in her late high school or early college years. But there is more than just a time difference between this face and the almost delicate, somewhat more mature one with the pearl earrings. Here she is athletic-looking, with a powerful neck and shoulders from all that swimming. She appears to be wearing an open-necked blouse and some kind of jumper. She's unsmiling here, too, and her hair is severely parted, combed back and tucked behind her ears, as if she might have let it dry that way after coming out of the pool. Kind of a female jock. Not the same girl.

Elva Statler (third from left) and her close friend, Isabelle Stone Baer (second from left), enjoy a day at the Pinehurst Gun Club, probably in 1932. *Courtesy of the Tufts Archives, Pinehurst.*

The 1935 Elva Statler Davidson Mystery

Elva (right) and an unidentified woman hold live turkeys after winning a turkey shoot at the Pinehurst Gun Club. *Courtesy of the Tufts Archives, Pinehurst.*

In some photos, she looks just a bit boyish. In others, quite feminine. (*The Washington Herald* described her as "buxom.") In some pictures, she appears warm and gracious. In others, distant, pensive and uncomfortable. In one, she looks like a typical happy teenager hanging out with her dog. In another, which shows her coming out the front door of her new brother-in-law's house after her Pinehurst wedding, she's wearing an ungainly gown and an unfortunate white cap and looking up at Brad with a moon-faced, worshipful expression that can only be described as embarrassingly goofy.

It is hard to escape the suspicion that the Many Faces of Elva are at least partly a reflection of what must have been a troubled personality—a lost soul who didn't know who she was and spent her short, unhappy time on earth in an unsuccessful search for herself. If she went from version to version of her own identity, it shouldn't be surprising that she looked different every time one saw her or snapped her picture.

Regrettably, there is virtually nothing in her *voice*. One wouldn't expect a recording—just something she might have said or written, something in her own phraseology that might open a door onto her personality. Other than a few snatches from letters and telegrams to the man who was so fleetingly her husband, and her supposed last words, "Goodnight, darling"—themselves of uncertain authenticity—little seems to remain but impenetrable silence.

Whether the leading lady of our story really said "Nobody likes me" or "Nobody loves me" on the night before her death, she obviously had plenty of reasons—even on the surface of things—to feel unloved and abandoned. But it went even deeper than that. Despite her many advantages, it is all too touchingly clear that she felt like a nobody herself.

That would have seemed strange to the millions of down-and-outers standing in urban soup lines during those turbulent thirties, out of money and out of hope. She was a member of the wealthy, self-indulgent stratum

Elva Statler plays golf at Pinehurst in 1932. *Courtesy of the Tufts Archives, Pinehurst.*

of that era, which became the closest thing to a nobility or a ruling class that America had produced at least since the robber barons of the late nineteenth century. They wielded much power and indulged many extravagant whims in those unregulated days. The papers were full of their exploits and scandals, which entertained the restless masses trying to make ends meet. Elva was a member of that aristocracy. To the suffering commoners looking enviously across the social void, that would have made her Somebody. But to herself, at some profound psychological level, she was poorer and more deprived than they.

"Be kind to her," Elva's great-grandnephew, Andrew Edmonds, said when interviewed for this book. "Elva wasn't perfect, but her life was so tragic." And so it was. She started out her sojourn on earth by being found in the bullrushes and placed among strangers, with no idea about her real parents or her real station in life. Then, at an age at which most sheltered American children have never experienced a single death in the family, she had already watched almost all those near and dear to her die agonizingly, one by one. She had two remarkable skills, as a pianist and as a swimmer, and showed promise of great accomplishment in either or both. But illness deprived her of one and injury of the other. Before she had even reached her twenty-first birthday and entered adult life, she was already a walking disaster area.

<center>***</center>

Elva and many of the other principal characters in the Davidson cast appear in articles published from 1928 through 1935 in *The Outlook*, Pinehurst's social register and propaganda organ.

Miss Isabelle Baer paid a visit to Miss Elva Statler prior to Miss Statler's marriage to Mr. H. Bradley Davidson. Mesdames H. Bradley Davidson and Herbert Vail served as patronesses of the Black and White Ball. Mr. H. Bradley Davidson dressed as a sailor at a Valentine's Day masquerade (when Mrs. H. Bradley Davidson was out of town). Dr. M.W. Marr, Pinehurst's resident physician, dressed up as a doctor treating five ladies dressed in baby clothes as the Dionne quintuplets, who were all the rage at the time.

"Special Parties Accommodated," Montesanti's Spaghetti Camp advertised. Mrs. Betty Hanna Davidson (continually overspending her allowance from her wealthy Ohio family after marrying Richard) had gone

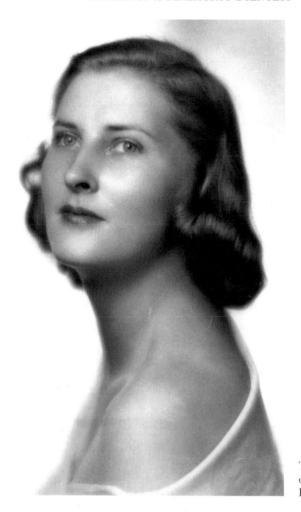

This formal portrait is of Elva's best friend, Isabelle Stone Baer.

into business, setting up an Elizabeth Arden salon. That same Mrs. Davidson sponsored a dance during the Mid-South Golf Tournament, giving the affluent snowbirds an opportunity to benefit the undernourished indigenous children of Moore County.

Miss Elva Statler of New York, wearing an elegant gown, and dashing young Mr. Jack Rudel of Montreal, resplendent in a tux, won a New Year's Eve scavenger hunt. Among the items they had assembled in less than an hour were a crusty old bachelor, a finicky old maid, the U.S. Constitution, a last year's bird nest, a Massachusetts license plate, a hand of tobacco, a useless Christmas present, something incongruous and a deck of cards minus the ace of spades.

The 1935 Elva Statler Davidson Mystery

Then there is that splashy layout that appeared on January 5, 1935, under the headline "A Pinehurst Wedding of Great Interest," detailing "the marriage of Miss Elva Idesta Statler and Mr. H. Bradley Davidson Jr. on Thursday noon at the home of Mr. and Mrs. Richard P. Davidson in Knollwood."

The story takes up more than a page. Accompanying it is a photo of the newlyweds grinning as they examine a piece of paper, perhaps a scorecard, on some kind of sporting field. He towers a head and a half over her. Both of them are dressed in stylish layers against the cold, and both are looking about as good as they could look. They seem happy, and they seem like a couple.

"The bride was escorted to the altar by Mr. Richard P. Davidson and was given in marriage by her sister-in-law, Mrs. Milton Howland Statler of Tucson, Ariz., who was matron of honor," the paper reported. "Mr. Nat S.

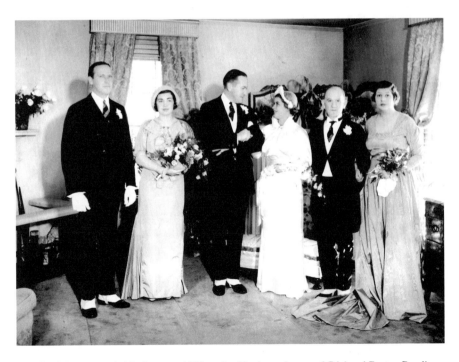

The Davidsons married in January 1935 at the Pinehurst home of Richard Porter, Brad's younger brother. *From left*: Richard Porter; Mrs. Nat Hurd, Elva's next-door neighbor; Brad; Elva; Nat Hurd; and Betty Hanna Davidson, Richard's wife. *Courtesy of Andrew Edmond.*

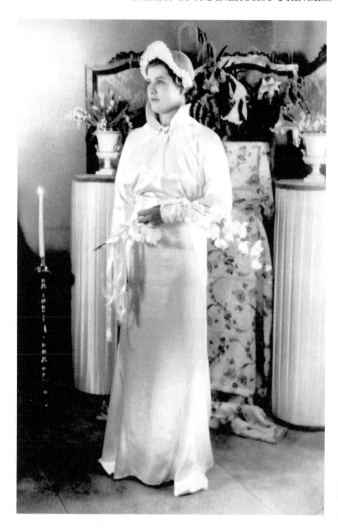

Elva beams on her wedding day. *Courtesy of Andrew Edmond.*

Hurd of Pinehurst was best man. The ceremony was performed by the Rev. Dr. Murray S. Howland, of Binghamton, N.Y."

The improvised altar, the article says, was decorated with madonna lilies and lilies of the valley, and the house was decorated with white lilies, lilies of the valley and white snapdragons. Elva had even brought in a string quartet from the North Carolina State Symphony, founded only a couple of years before, to play the Lohengrin wedding march.

"The bride wore a white satin wedding dress with an Elizabethan collar," the article says. "Her cap was of white net with a collar of orange blossoms. She carried white orchids. The matron of honor wore a blue taffeta dress

made in Empire style, with pleated ruffles, and a blue hat to match. She carried yellow roses. Miss Statler's going-away costume was a gray tailored suit with hat to match, and a topcoat of gray caracul."

The new Mrs. Davidson was "graduated [not exactly] from Radcliffe College in 1934," the paper said. "She has been to Pinehurst many times with her family and this winter for the first time joined the cottage colony, leasing the 'Edgewood' cottage on Linden Road. She is known at Pinehurst as an expert horsewoman and has won many prizes here."

The rest of the article devotes itself to a detailed account of the many parties held during that "active and gay" week and who attended them, providing a veritable who's who of Brad and Elva's friends. Brother Richard and his wife had a dinner for the couple. A Miss Helen Louis Heim gave a tea for the bride. Mr. and Mrs. Richard Tufts of the Pinehurst ruling family gave a buffet supper for the groom's mother. The night before the wedding, while Elva entertained the womenfolk in her house, Brad threw his stag dinner at—where else?—Montesanti's Spaghetti Camp.

Mary Evelyn de Nissoff had a more blunt and jaded version of what Pinehurst life was really like in the 1930s. It provided a helpful counterpoint to all that high-society gloss in *The Outlook*. "The fact is that this gang put Elva together with Brad because he needed a rich woman and they wanted to get her married off," she said. "There used to be men like that, who came from good families that had lost their money, and they used to do the resort scene here and in Europe. Because this is where the rich women went—usually older women—who were willing to support these gigolos."

What struck Khris Januzik, the former Tufts Archives lady, was the ironic contrast between the extravagant, scorched-earth coverage *The Outlook* devoted to Elva's wedding and the terse, one-paragraph squib it gave to her death a few short weeks later—at a time when papers from coast to coast were printing front-page stories with all the juicy details their reporters could beg, borrow or steal. Clearly this was not a newspaper; it was a spin sheet.

"All *The Outlook* has about her death is just this tiny little thing regretting her passing," Khris said. "Just shortly before, there's the big write-up of her wedding, and you look at the guest list and everything and realize that she

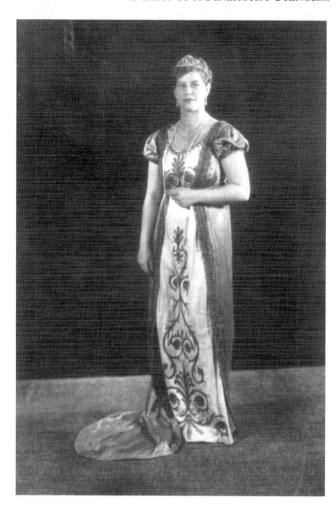

One of the last known photographs of Elva Statler shows her in a fashion show at Pinehurst in 1935. *Courtesy of the Tufts Archives, Pinehurst.*

was right up there with the Tuftses and everybody on the upper echelon of the social circles here at the time. And then there's this little, 'Gee. We're sorry she's gone.' Now, wait a minute, okay? Queen Victoria got more ink than that when she died, and they didn't even know her!"

CHAPTER 16

To Parts and
Places Unknown

R emarkably, it is now possible for posterity to know not only the color of panties that Elva Idesta Statler wore on the day she became Elva Statler Davidson (peach, as noted earlier) but also the colors of the pajamas she wore on her honeymoon: gold and brown.

Those garments were among numerous trousseau items listed on a bill that sat undisturbed inside a dusty file drawer in the spooky, dungeon-like basement of the Moore County Courthouse in Carthage for three-quarters of a century. The statement, dated March 15, 1935, came from the ritzy Milgrim store in New York City. Other items on it included a white satin bridal gown, a white bridal headpiece, a peach satin gown, a blue gown, a white gown, a tea rose slip and a brassiere (size not specified).

The invoice had been sent to "Estate of Mrs. H. Bradley Davidson Jr." and was among a number of other documents submitted by creditors seeking payment when Elva's will was submitted to probate shortly after her death. Elva had gone on a spending (or charging) spree in New York in December 1934, days before Christmas and only a couple of weeks before her wedding. The bills, revealing many of the items that the excited bride-to-be had purchased, add up to a living account of what Elva did in her last few months alive.

The girl had expensive tastes. Among her other stops were Cartier and Saks Fifth Avenue. At Cartier, she ordered two hundred fancy engraved wedding invitations and two hundred visiting cards. She arranged to have some of her own "brilliants" (diamonds), along with others supplied by the store, mounted in a platinum brooch. She also lavished some money on gifts

for Brad: a pair of gold, enamel and onyx cufflinks ($75) and an engraved, gold and silver cigarette case ($135, or nearly $2,000 of today's dollars—and this when there was a depression on). At Saks, she bought a doll cradle and miniature tea set to be shipped to her niece, Joan Marie, in Arizona. Elva returned to New York after her wedding to charge more things like linens and kitchenware. At the Steuben Glass store on Fifth Avenue, she picked out twelve crystal wine glasses and two crystal decanters, a black glass pan and eighteen crystal cordials—which were shipped express on the day she died.

The merchandise bills aren't all the courthouse dungeon has yielded. Other statements and letters tell an all-too-familiar story about H. Bradley Davidson Jr.'s characteristic failure to honor his obligations—and not only his own but also those his late wife had encountered.

The bills range from a handwritten slip showing that the Davidsons owed a few dollars for groceries they had bought during that final week in February to a letter six months later from a lawyer in Boston, seeking payment of $2,000 owed to the Hotel Continental in Cambridge, Massachusetts. The letter indicates that Elva had signed a twelve-month lease on a penthouse on September 1, 1934—providing a clue that that's where Elva had arranged for Brad and her to live when they weren't in Pinehurst. Noting that no rent payment had been received since January 1935, the lawyer courteously but pointedly asked Brad to pay up or at least acknowledge responsibility for the claim—"in order that we may be saved the trouble of instituting suit."

A letter from a Packard dealer in Boston demanded that Brad resume the payments that his wife had faithfully made on her car, lest the company feel compelled to send a repo man around. Another was from an attorney representing Lillian Page, the music teacher who befriended the student Elva and let her move in with her from time to time. Elva apparently owed her $260, which Brad had repeatedly neglected to pay—all the while sweetly telling dear Ms. Page how much she had meant to poor Elva. "I was very glad indeed to have your letter enclosing a statement of monies advanced by you to Elva," he oozed in a letter, "and of course you realize that inasmuch as the Statlers are protesting Elva's will, that it will be impossible for me to do anything until the case has been settled." He strung her along at least

until 1937, by which time one source has him working as a yacht salesman in Manhattan.

A petition filed on June 2, 1936, more than a year after Elva's death, indicates that a Washington plaintiff named Nesbit had previously sued Brad in D.C. over some debts. The court had ruled in his favor then, but Brad hadn't coughed up any money. Nesbit, learning that Brad had inherited a great deal of money from his late wife, was down in North Carolina trying to collect some of it. Article 7 of the yellowed document stood out: "Petitioner accuses Davidson of having removed practically all, if not all, of the property belonging to his late wife from the State of N.C. and taking [it] to parts

Elva Statler Davidson's death certificate, dated February 27, lists "carbon monoxide gas poisoning" as the principal cause of death, with contributory causes "not known." *Courtesy of the Tufts Archives, Pinehurst.*

and places unknown. Also wasting and squandering the same, making away with and disposing of it with intent to hinder and delay, cheat and defraud petitioner and other creditors in collecting their debts."

The files contain one more melancholy document: an inventory sent to "Estate of Mrs. Elva Statler Davidson" from J.N. Powell Inc., Undertakers, Southern Pines, North Carolina. It had been prepared on February 27, 1935, "terms cash," but had not been paid until four months later. Items include: casket, $500.00; shipping case, $50.00; embalming body, $25.00; hearse to hospital, $10.00; hearse for funeral, $10.00; plate and engraving, $5.00; transportation papers and permits to New York, $2.50; personal service, $15.00; telegram to New York, $1.44; and 3 percent sales tax, $10.00—for a grand total of $628.94.

The bill had been notarized for submission to the probate court on June 28, 1935. A written notation and signature at the bottom, in a firm hand whose backward slant might suggest reluctance on the part of the signer, reads: "Approved for Payment. H. Bradley Davidson, Executor. 7/1/35."

More than a dozen other courthouse records tell of civil cases involving Brad's brother, Richard Porter Davidson, and Richard's wife, Elizabeth Hanna (Betty) Davidson—who, though she was part of the wealthy and politically powerful Hanna family of Ohio, seemed to play fast and loose with other people's money. Some complaints tell of house payments missed and grocery bills unpaid by Richard and Betty. In one case, Nolan Motor Company, the local Ford dealer in the 1930s, had sold Richard a top-of-the-line Crown Victoria. Richard had made a couple of payments and then stopped, while continuing to drive the snazzy car around to golf dates and such for month after month. Nolan Motors was about to have a summons served on Richard. The exasperated petitioners alleged that Richard had mortgaged his property to his mother and was about to defraud his many creditors. Upon investigation, they said, they had found that Richard had a number of accounts and judgments against him, but that his bank account back in D.C. had only thirteen dollars in it.

Of great interest as circumstantial evidence in any Davidson investigation would be the existence of a large insurance policy Brad may have taken out on Elva shortly before her death. No such document has ever presented itself,

though there is a fleeting and unenlightening reference in the courthouse records to insurance—a Globe Indemnity policy from which her lawyer had paid some of Elva's legal fees.

Another damning piece of evidence might be a transcript of Brad's divorce from his first wife indicating a possible pattern of abuse. But no such record exists in the Moore County Courthouse, since the divorce took place in Bethesda, Maryland, a Washington suburb. And the forty-page document that turned up there contains nothing particularly incriminating. Quite the contrary, in fact.

In the complaint, it is alleged that "although the conduct of the Oratrix [Jessica] towards her husband has always been kind, affectionate and above reproach, the said H. Bradley Davidson Jr. did on the first day of February, 1931, without just cause or reason, abandon and desert her; and said abandonment has continued uninterrupted more than three years and is deliberate and final and the separation of Oratrix and the said defendant is beyond any reasonable expectation of reconciliation."

The stack of complaints, answers and depositions makes compelling reading as soap opera, but it contains no gun, smoking or otherwise. No hint of spousal abuse is alleged. Indeed, the divorce seems to have been puzzlingly amicable, with liberal visitation rights granted. Which raises the question: was Jessica downright saintly in her forgivingness of the man who walked out on her and their three children? Or could it be that she brought some unspoken, mitigating fault of her own to the table?

The startling apparent answer to that question, arriving from an unexpected quarter, doesn't make itself known until a bit later.

Central to any case such as this would normally be the details from the autopsy report. But no such document on Elva Statler Davidson has ever turned up in any of the most likely places—the Moore County Courthouse, the Moore County Sheriff's Department, the Tufts Archives, two funeral homes, Moore Regional Hospital or Duke University Medical Center.

Oddly, the most complete accounting of the autopsy's content found to date has come to light in, of all places, the microfilm files of *The Cleveland* [Ohio] *News*. That newspaper presumably had taken a special interest in

the case because Brad Davidson's sister-in-law, Elizabeth (Betty) Hanna Davidson, was from Cleveland. In fact, Betty's father was the paper's publisher.

As reported by other media at the time, the pathology lab at Duke University had failed to find the "hole card" that Prosecutor Rowland Pruette had hinted at. There was "sufficient carbon monoxide in the body to cause death." There was "some alcohol, but not enough to produce intoxication." Beyond that, there was no "evidence of any other foreign matter."

Of most interest, in the end, was the number of bruises on the body and their location, giving rise to much speculation. There were thirteen or fourteen of them. The upper surface of Elva's left arm displayed a blue area. A slight discoloration, not quite a bruise, was found on the right side of her back. In the upper third of her right thigh, there was an abrasion or scratch. Just below the right hipbone and just back of the middle thigh was a blue area or hemorrhage beneath the skin. Just in front of this was a similar bruise. In front of the upper third of the right thigh were several areas of similar appearance. Then on the outside of her left arm, halfway up, was something intriguingly described as "a perforation surrounded by a reddish mark."

Bruises can have any number of causes, especially in the case of an athletic girl who rides horses. The description of Elva's bruises doesn't seem consistent with a beating, though there has been speculation that they could have resulted from an attempt to hold her down and have sex with her.

In any case, that "perforation surrounded by a reddish mark" has always seemed harder to explain away. It strongly suggests a hypodermic syringe. Though the autopsy did indicate that Elva had breathed in enough carbon monoxide to kill her, suspicions were raised from the beginning that she could have been injected with some kind of drug—the "subtle poison" hinted at by Solicitor Pruette—that immobilized her long enough for the gas to take effect. Such theorizing seemed farfetched, but it was encouraged by Solicitor Pruette's hints at a "subtle poison" and by the United Press reporter's reference to "a strange and scientific murder." Even if there wasn't a smoking gun, couldn't there have been a dripping syringe?

That possibility, too, must remain a tantalizing mystery almost to the end.

Shrouded in Verdure
and Mystery

Anyone setting out to reconstruct the Elva Statler Davidson story and recapture its ambience encounters some baffling obstacles. But there is also one big advantage: most of the physical structures involved—the sets on which the sensational drama was played out so long ago—are still there, if sometimes put to different modern uses.

Elva's rental house, the garage in which her lifeless body was found, the hospital to which it was rushed, the cramped building in which the inquest took place, the stone courthouse where the caveat trial was held the next year—all remain in existence, though finding and gaining access to some of them can take a while for the uninitiated.

Back in the thirties, the house that Elva Statler leased on Linden Road, like other Pinehurst dwellings, had a name instead of a street number. One reason for that is that there was no home mail delivery—as there isn't to this day in the heart of the village. Press clippings about the Davidson case identify it only as Edgewood Cottage, leaving the location of it and other quaintly named dwellings a mystery unless one knows to go to the Tufts Archives and consult the Cottage File, a special cabinet containing alphabetical index cards on all of Pinehurst's old homes. (In Pinehurst, a "cottage" can be quite impressive in size and cost.)

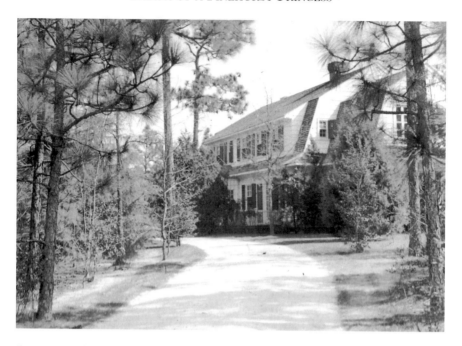

Elva rented this house, located on Linden Road in Pinehurst and known as Edgewood Cottage. Her body was found in a garage behind the neighboring house, known as the Pines. *Courtesy of the Tufts Archives, Pinehurst.*

Located in a quiet residential neighborhood a few blocks west of the village center, the Edgewood property of today—whose current owner was unaware of its dark history and had to be filled in—is so heavily wooded that a passing motorist can't make out much of the building sitting at an angle inside the southeast corner of Linden and McKenzie. It's a two-story Dutch Colonial house whose wood-shingle siding has been painted a creamy white, and the shutters are dark gray. Inside, the original floor plan appears to be largely intact. The kitchen has been modernized, and what was once butler Birch's modest quarters now appears to have been converted into a little back porch. Out front, a swimming pool and cabana have been built in place of the old horseshoe drive, displacing the street entrance from McKenzie around to Linden.

Edgewood Cottage, as the Cottage File divulges, was built in 1917 by one Nils Hersloff, of Orange, New Jersey. He also owned the property adjoining Edgewood to the south, and on it in 1928 he put another "cottage" (this one really a two-story Georgian red-brick mansion) called the Pines, the last brick home completed in Pinehurst before the Depression hit. Behind it he

built a three-car garage with a carriage house. Though a modest garage now stands behind Edgewood Cottage, it wasn't there at the time Elva leased the place in early 1935. Rather, the Davidsons had standing permission to park Elva's Packard in the garage behind their neighbor's house.

The garage, as viewed casually from the street, remains largely shrouded in verdure and mystery. A contemporary driver passing by the Pines on McKenzie, peering through the jungle of trees and bushes that has grown up over the decades, can catch only a few tantalizing glimpses of the two-story brick outbuilding in the left rear corner of the lot, with its three square white doors and original slate roof.

In the 1930s, both the Pines and Edgewood were new and their yards were open, and one could hardly tell where the boundary between the two lots ran. Though Edgewood residents still had to drive out onto McKenzie Road, turn left and then pull into the driveway of the Pines and drive to the back to access the garage, it was possible at that time to walk freely between cottage and garage. No more. Someone has long since put up a wire fence on the property line, and a thicket of bamboo and other foliage has grown up along the garage side. This has created a virtually impregnable DMZ between the two properties.

Upon gaining permission to enter the garage from its current owners—who also had to be brought up to date on its history—one feels a little of the kind of anticipation that archaeologist Howard Carter and Lord Carnarvon must have experienced on November 4, 1922, when they first lifted their carbide lamps and beheld the long-secret tomb chamber of King Tut. While various owners have made significant alterations over the decades (someone in the modern era has partitioned off the leftmost bay with cheap paneling), this is unmistakably the garage discussed at such length in the inquest testimony. Those segmented, white wooden doors are the originals—though now, instead of lifting them thirty-six inches by hand and letting springs take over, you push the button on a handheld electric opener and watch one of them go haltingly chugging up.

There, in the dark far-left corner, is the very faucet that Birch headed for on that seemingly routine morning, intent on giving the Packard a light

washing, only to stop in his tracks when he encountered choking exhaust fumes and saw a small, slippered foot sticking out from under the driver's door. A few feet to the right, nearer the middle of the back wall, is a wooden door leading to what had been a half-bath.

A visit to the garage can quickly clear up what had long been two nagging mysteries.

The first involves what was once another interior wooden door in the right rear corner. That door, which formerly led to a little entryway with an exterior door of its own and a narrow staircase winding upstairs, has since been bricked over. Something about a bricked-over door always fires one's imagination, bringing to mind images out of Poe's "The Cask of Amontillado." Who had sealed off that passage? When? Why? At one point, overactive imaginations speculated that perhaps Brad had done it to prevent Elva from making her escape from this "death chamber" once he had set a murder plot in motion. The truth, which easily becomes evident upon a little exploration, is considerably less dramatic. At some point, previous owners fixed up the upstairs servants' quarters and rented the second floor out as an apartment. The door was permanently closed off simply to keep apartment occupants from having access to the garage and its contents as they came and went through the exterior door in back.

The second mystery concerns the location in which the Packard was sitting when Birch found Elva's grotesquely cherry-tinged corpse. An Associated Press photograph shows jurors swarming over the car inside the garage a week after the death. One of those eager-beaver shutterbugs covering the inquest snapped the picture in the chilly late afternoon of Wednesday, March 6, 1935. "H. Bradley Davidson (extreme right) was a spectator when the coroner's jury probing his wife's death inspected the garage at their home in Pinehurst, N.C., in which her body was found," reads the caption. "The auto in which she was found is shown." At least part of it is. The photographer, standing to the right front of the Packard, aimed his Speed Graphic at an angle across the car's long hood, with the low, flat windshield at the left of the frame. All six curious jurors are at least partially visible as they cluster around the door. Slender, physically fit Brad Davidson, with his dark, receding hair immaculately slicked back and a white handkerchief intricately folded in the left breast pocket of his suit coat, stands apart and looks on with his "pained expression."

The men in the flash picture are all crammed so closely into the narrow space on the driver's side of the car that you can see their shadows on the

blank white wall directly behind them. But which wall? One might logically assume that the car had been driven front-wise into the garage and parked against the left (north) wall, the one nearest Edgewood Cottage. But there was always the possibility that the Packard had been backed into the rightmost bay and parked against the south wall. In either case, there would be a wall to the car's left. Though a window and bare overhead light bulb are visible in the picture, there are (or were) windows and light fixtures on both sides.

A visitor to the current garage can solve that minor puzzle by standing at various angles and comparing the newspaper photo to the layout of the garage. The position of the overhead track proves that the long, sleek roadster was backed in and parked against the right wall, the one farthest from the Edgewood. Of course, it is known that the Packard had been moved at least once since Elva's death—to take her body to the hospital. So there is always a chance that it had been returned to a different position for the jury's visit a week later, but that seems unlikely.

<p style="text-align:center">***</p>

The location of the Community House, in which the Davidson inquest took place, became a matter of unnecessary confusion for a time at the beginning of the current revival of interest in the Elva case. One theory had it that the low, nondescript, almost rustic building in the picture, with its shed roof held up in front by four widely spaced white posts, had been torn down years ago. Another placed it in Carthage, the Moore County seat. Yet another held that the building had been remodeled into a thrift shop that still stands just east of the old firehouse on Community Road in Pinehurst. But that two-story, gabled structure looks so different that it just didn't compute.

For the answer, as it turned out, one had only to look at the squat building on the other side of the firehouse, the west side. Quite small and nondescript and partially obscured by a wooden fence, it is easily overlooked. Yet a glance shows it to be unquestionably the one in the picture: white posts, low shed roof, long porch.

The building still looks remarkably the same, though conventional asphalt shingles have replaced the tin roof and buff-colored vinyl has gone up over the old white wooden siding. The original bare hardwood floor is still there—the very boards upon which the drama that those out-of-state journalists were

covering in 1935 played itself out. The Community House looked brand-new when the picture was taken, having been remodeled in 1934 under a New Deal project. It originally housed all local governmental functions. One reason nobody knew it was there was that nobody had called it the Community House for years, referring to it instead as "the Little Club." It now stands vacant most of the time, except for weekly Boy Scout meetings.

As for the building that once constituted the entirety of Moore County Hospital, to which Elva was rushed in her Packard roadster, it is now a modest two-story gabled affair totally swallowed up on all sides by the larger, more modern structures that make up the sprawling campus of Moore Regional Hospital, home base of a multi-county health conglomerate known as FirstHealth of the Carolinas.

Of the key venues in the story, only Montesanti's Spaghetti Camp has long since vanished. The property is now part of the Lawn and Tennis Club of North Carolina, a posh gated community, and there's a swimming pool where once stood the rustic wooden lodge in which key players partied to accordion tunes in the wee hours of that ill-fated morning.

The ultimate fate of the Packard itself is unknown. But there are hints, intriguing though sketchy, of what happened to it in the years after Elva's death. Among the documents in the Moore County courthouse basement is a bill from a New York garage, dunning Brad Davidson for work done on his late wife's 1934 Packard. The bill specified repairs carried out on a damaged headlight, fender, door, mirror and mud flap—all on the left side—and for a Simoniz wax job. The bill was dated July 25, 1935, six months after Elva died.

So how did the car get banged up? The answer, surprisingly, can be found in an obscure vanity press book called *I'm Fifty—So What?* It was written by none other than the late Edna Foote Campaigne, who had been a houseguest in Edgewood Cottage on that February morning when Pearl the maid came pounding on their door with the news that "something has happened to Mrs. Davidson in the garage." The lanky and gracious Edna, known to friends as "Ted" or "Teddi," spent her last years on Long Island with her husband, Curtis, known as "Camp." They had lived in New Jersey in 1935. Her book

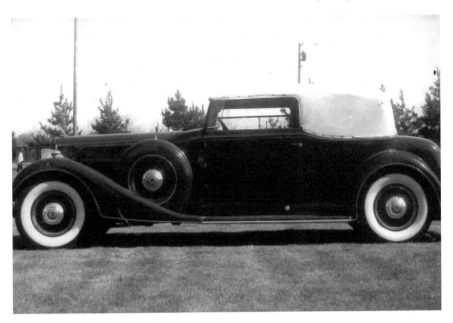

Elva Statler Davidson's body was found slumped half in and half out of this 1934 Packard roadster on the morning of February 27, 1935.

marking her first half-century amounts to a long and disjointed birthday letter to family members. But buried deep under all this dross is a bit of gold.

"There is one incident that should be recorded here," Edna wrote. "Camp and I returned from a hideous two weeks in Pinehurst after Elva's death and had to go to New York on a business party. It was late when we started home, and we were very tired. As we were going down Seventh Avenue, Camp was driving over the white line. 'For goodness sakes,' I said, 'don't get arrested at this time in the morning. I've had all the publicity I want!'"

Teddi wrote that it had been "one of the hottest days of the year" and she was afraid that her husband was falling asleep at the wheel. He told her to close her eyes and stop worrying. She complied, only to wake up in a meadow beside the road. Camp, it seems, had strayed across the centerline again and sideswiped a bus, causing extensive damage to the left side of the car. He also had apparently fled the scene of the accident. "You told me not to get arrested," he reminded her.

Teddi's book later mentioned that Camp had presented her with the bill for the repairs to the car—including, as she noted, a charge for Simonizing. The conclusion is inescapable: that was Elva's Packard the Campaignes

were driving. Brad must have prevailed upon them to drive it back home right after the inquest. They damaged it, and Elva's estate paid the bill. Brad later sold the car to a New York dealer.

There is one more episode before the story of the Packard fades to black.

Googling of the Packard Club turned up a member named James Pearsall—who, as it turned out, had also become intrigued by Elva's case in past years and had done a little sleuthing of his own. "Her Packard was a 12-cylinder," he said. "The VIN number began with the digits 1-3. Unlucky 13." Pearsall, in turn, pointed the way to an elderly man who had once briefly owned the roadster himself. The man agreed to talk, but only anonymously. Call him Jack.

When Jack was a young boy in late 1935, he was sitting on the curb in a rural West Virginia town when "the prettiest car in the world" sped by. He fell in love with it. And when he gave voice to his infatuation, the owner offered to pay him to keep it washed and waxed. That was the year Elva died, and the man had just purchased the Packard from the dealer who bought it from Brad.

The relationship between boy and man continued until Jack had grown up, at which point he became the owner's chauffeur. But when the old man died, things got complicated for Jack. First he had to endure several years of watching the Packard sit out in the weather, neglected and decaying. Then one day the dead man's widow came to see Jack. She was terminally ill herself, she said. Would he like to have the car, since he had always loved it so much?

Jack's dream seemed to have come true. He got the old roadster cranked up, drove it home and began lovingly restoring it. Alas, though, the dying woman had forgotten to transfer the car's title to Jack. Soon her children, squabbling over the will, took it back and auctioned it off. All these years later, one could still hear the hurt in old Jack's voice.

"Nothing good has ever come from that car," he said. "It's cursed."

Why Did He Get the Catbird Seat?

O ne indication of the obscurity into which the Elva Statler Davidson case fell is that the direct descendants of some of the main players in the drama were entirely clueless about it until recently. Consider, for instance, a friendly retired minister quietly living out his eighties in an assisted-living center in Winston-Salem, North Carolina. There would appear to be nothing about his life and career that would make him of interest to anyone looking into the story—except his name: Rowland S. Pruette Jr.

The name Elva Statler Davidson meant nothing to him when he was first contacted. But this aged man's confirmation that his father had worked as a solicitor in the North Carolina court system made it certain that he was the one who had been called in by the governor to preside over the coroner's inquest in 1935. Although Pruette Jr. remembered nothing about the Davidson case ("I would have been a teenager then"), he was more than willing to talk about his father, whom he and his three siblings admired greatly.

The no-longer-so-junior Pruette said of his dad:

> He was a little bit rotund. He was an amiable, loving father in the family. He was very conscientious about his job. He was on the road a lot—going to court in different counties around his district. I remember he was always going to Carthage, to Albemarle, to Laurinburg—places like that. And sometimes my mother liked to go with him. She especially liked to go to Carthage. She said they had good food at the hotel there.

I only remember one thing about a case he had—a private case, I think, just before he became solicitor. He made the biggest fee he'd ever made, and the family bought a new Buick car. It was the kind of car that they called a "pregnant Buick" because it was puffed out on both sides. And mother bought a fur coat. That would have been not long before the time we're talking about.

The elder Pruette had a confident, assertive manner, according to his son—whether in the courtroom or at the dinner table. "I can still hear him talking," he said. "He had a pretty strong voice. He could be pretty emphatic in what he had to say."

One question had to be asked, given all those references Solicitor Pruette had made to hole cards and such: did his father happen to like playing poker?

"Oh, did he ever!" his son said with a little chuckle.

It seems that Rowland S. Pruette Sr. liked to play poker so much that when he and three other students at Wake Forest College had been caught red-handed with cards and money on the table in front of them early in the century, all four had been suspended for a semester. Their class at Wake Forest, a Southern Baptist institution, was scandalized. Rather than go home and face the wrath of his father, a Baptist minister, young Rowland went to Raleigh and spent the rest of the semester in a rented room, keeping the suspension a secret and finally graduating a year late in 1913. He took a certain pride in the episode as an adult and even taught his three children to play poker.

"But with chips," his son hastened to add. "Not money."

The elder Pruette's story came to a melancholy end. Seven years after the Davidson inquest—in 1942, the darkest year of World War II—he was driving his "pregnant Buick" home from prosecuting another case in another small North Carolina town, Rockingham, when he ran off the highway and down a steep ravine. He was fifty-two.

"A big truck ran him off the road, as near as we could tell," his son recalled. "He didn't die immediately. He lived four or five days. In the hospital, he kept saying, 'Oh, that truck. That truck. That truck.'"

Henry Bradley Davidson IV, a personable dentist who lives with his loving family at the end of an unpaved rural road near Lake Cayuga in upstate New York, managed to live most of his life with no inkling that his grandfather had once achieved national notoriety as a suspected wife murderer. But once Brad IV had learned about the long-cold case, he was surprisingly and cordially willing to talk about this late ancestor with the unknown dark side. His wife, Holly, cheerfully joined in.

Everybody in the family, it seems, called Brad Jr. "Bompa," presumably an affectionate variation on "Grampa." Acquaintances outside the family in Cooperstown, New York, where he spent his later years with his third wife, the late Elizabeth Bishop of Philadelphia, usually called him by the more respectful "Colonel Davidson." That was in deference to the rank of lieutenant colonel that he achieved during his apparently honorable army service in World War II.

"I married into the family after Bompa died," Holly said. "I could never keep the family straight—there were too many wives! The only picture of Bompa I have, he's dressed in his army uniform. The Davidson men all had the same nose. Kind of long and sloping. They all hated the name Henry, so we called Bompa's son—my Brad's father—'Dave.'" There were no more Henry Bradley Davidsons coming along, she said—"Brad is the end of the line. Our son is named Gregory."

In a case like this, a fascinating triangulation can result from examining a man's life from two entirely different angles and seeing how that stereoscopic view rounds things out.

"Looking at what a calm, placid man my husband is," Holly said, still trying to get over what they had learned about Bompa's grim secret, "I can't imagine him being descended from somebody who could do something like that—if he did." Brad IV was even more dumbfounded. "What amazes me is that I've never heard a word about any of this," he said. "I remember hearing about a second wife who was supposed to have committed suicide, but we always just thought she had jumped out a window or something."

Though both Davidsons were floored to learn about the very large skeleton rattling around in their family closet, they listened and responded with acceptance and curiosity—and openly shared a wealth of information in return.

"My father, Brad III, whom we called Dave, never breathed a word about anything like this," Brad said. "But then, he was a very quiet guy who never

shared much about anything. He was in the army in World War II, but he never talked about what happened in the war. He hid a lot of things. Now, my mother was just the opposite. Our family never had much, so Mom was always wanting to move up, and she was intrigued by her father-in-law, Bompa, and the wealthy life he had led. This thing really would have intrigued her."

Brad conceded that his father's silence on the nature of Elva's death might have been less a matter of not wanting to talk about it than simply not knowing much about it. During the inquest, Dave's divorced mother, Jessica, had protectively kept all three of her children sequestered in the Retreat, that brooding old mansion on the shores of the Shenandoah River, screening their phone calls and hiding the newspapers.

<p style="text-align:center">***</p>

Attitudes toward lovable old Bompa within the extended Davidson clan were clearly ambivalent at best. The more Brad IV opened up, the more he kept returning to the theme of a relatively poor family and its resentment toward a grandfather who enjoyed wealth that he didn't deserve and was dismayingly reluctant to share.

In short, Brad Jr. seems to have been an old skinflint. But his grandson emphasized that he was also "an elegant southern gentleman" and that he never sensed any arrogance or rudeness in him. Moore Countians would have to smile at the idea that Brad Jr., who seemed like some kind of predatory Yankee to the folks down in rural North Carolina in the 1930s, looked like a thoroughgoing "southern gentleman" from the direction of New York.

Brad said:

> *I knew Bompa pretty well when I was a kid. We went up to Cooperstown to his house several times. It was a formal relationship, which seemed to me kind of like a southern relationship—polite and respectful. Oh, he was family, no question about it, but there was not the kind of warmth we have in our family. He just didn't take care of his kids very well. We didn't have much in the way of money, and he had obviously had a lot—though it was pointed out to me that, while my father had to get money the old-fashioned way, by working, Bompa had gotten his by marrying*

wealthy women. So why did he get the catbird seat when he didn't deserve to be that well off?

All these years later, a particular childhood memory still rankled Brad IV. It seems that word went out one day that Bompa had decided to be uncharacteristically generous with his two surviving offspring, Dave and his sister "Jack" (another Jessica), by giving each a sizable cash gift. It was enough money that Brad IV's parents were able to put a down payment on a new house. The grandchildren were all required to pay a visit to the court of Bompa and show him the appropriate obeisance, humbly thanking him for his munificence. Only later did they learn that Bompa hadn't given that money away just out of the goodness of his heart. He had been advised to do so for tax purposes.

"Even at my young age," Brad said, "I kind of felt it was phony that he should have such stature—that all he had done was marry money. It's not my nature to resent, and I don't think I felt it at that time, though I think my mother did. But I do remember thinking, 'What's wrong with this picture? We have to suck up to this old guy to get a little help for my tuition or whatever. And he's holding the purse strings, when he never filled the purse himself.'"

Although the stars in this play are all long dead, one supporting actress was still alive as this book was begun. Elva's most intimate friend, Isabelle Stone Baer, later Isabelle Baer Famiglietti, lived in Providence, Rhode Island. She died in the spring of 2009 at age ninety-seven.

Isabelle's son, Richard Famiglietti, understandably solicitous of his mother's frail health and vulnerable state of mind, declined for a long time to arrange an interview with her. He offered instead to serve as a telephone go-between, relaying questions and answers. He also provided an update on her post-Elva life. It seems that the artistic young Isabelle, no doubt stressed out from all she had been through, dropped out of Radcliffe College in her sophomore year and went back home to graduate from the University of Minnesota. Then, much later, in 1969, as Isabelle Famiglietti, she graduated from the Rhode Island School of Design.

Richard said his mother had spoken often over the years about Elva—whom friends called by the nickname "Stat," short for Statler—and what happened to her. The two of them had been "very close," he said, and his mother had told how they had had "tons of fun with each other, chasing guys and being chased by guys and getting into her Packard and driving wildly down Fifth Avenue in New York." Richard said his mother had always been upset by what happened, even after all these years, and had buried it in the back of her mind. She clearly hated Brad and said she had encouraged Elva to get her will changed. She didn't attend the inquest in Pinehurst, staying instead with Katherine Statler in Arizona. But she did attend the caveat hearing a year later in Carthage. And once again, she thought, Elva had been terribly wronged.

According to her son, Isabelle could hardly stand to talk about the story even after seven long decades. She thought the inquest had been "a sham" and the case had been poorly handled from beginning to end, and Richard thought she might have repressed parts of the experience that were too painful. She still shuddered, he said, at the memory of the tension and hostility hanging in the chilly courtroom air during the caveat hearing in 1936—which, she said, only grew worse as the proceedings neared their end. She characterized the combative atmosphere as "the Civil War thing" all over again. And she still couldn't get over the disgusting spittoons in the jury box.

Far from answering any lingering questions about the Elva story, Isabelle—through Richard—added a new one of her own: "something about a dog."

Isabelle apparently kept saying that Elva's butler, Emanuel Birch, had phoned her right after Elva's death, placing a then-unusual long-distance call to Arizona, and that he had seemed terribly agitated and afraid, Richard said. "She has spoken of it often," he said, "just agonizing over her inability to remember what it was that he called her about. It had something to do with Elva's dog. But she just can't recall what."

It is known that Elva had two dogs, one of which was a male Great Dane, but no mention of them ever came up at the time of the inquest. At this point, it's possible only to speculate on what got the butler so upset that he went to the trouble of finding Isabelle's number and placing an anguished long-distance call to her. Could one of the dogs have behaved aggressively toward Brad, not allowing him or anyone else near? Had it dug up something in the yard or found something that upset Birch in the house or garage?

Or could the matter of the dog or dogs have had something to do with where they slept that evening? Had they become disturbed by something happening during the night? Had they been found in a place they didn't belong? Or maybe Birch just didn't know what to do with the dogs now that their mistress was gone.

Whatever happened, it's one secret the conscientious Emanuel Birch took with him to the grave.

CHAPTER 19

Let Him Beware

If the sensational coroner's inquiry in March 1935 could be compared
to the O.J. Simpson murder trial, then the so-called caveat case, bitterly
fought out by phalanxes of lawyers in February 1936 at the Moore County
Courthouse in Carthage, might be likened to the subsequent civil suit filed
by the families of Simpson's two victims.

The inconclusive, anticlimactic verdict that the coroner's jury reached—
"death by carbon monoxide poisoning under circumstances unknown to
this jury"—had left a lingering bad taste in many mouths. More than a
few people still thought H. Bradley Davidson had to have been involved
somehow in the wretched death of his young wife, Elva, and they still
wanted to see justice done.

For others, it was more a matter of morbid curiosity of the same kind that
the Simpson case would arouse all those decades later. Despite the reams of
testimony heard at the inquest, the essential questions about what happened
in Pinehurst early on February 27, 1935, still stubbornly defied answers:

- Why had Elva seemed so distraught at Montesanti's on the night
 before her death? The easy answer might be that she suffered from
 clinical depression, or perhaps even what we today would call bipolar
 disorder, strongly suggesting suicide. But the impression persisted
 that there was more to it—that something had happened to turn
 Elva from the happy bride going on a buying spree in New York and
 planning for a new house to the grievously unhappy woman who
 wept inconsolably while others were enjoying themselves at dinner.
 What was it?

- After the newlywed Davidsons and their houseguests had arrived back at Edgewood Cottage in the wee hours, why did they argue so long and hard, if indeed they did, over the insignificant question of who would park the car in the garage? That had never made any sense.

- Why was Elva's body in that strange, much-puzzled-over position when butler Birch found her the next morning, slumped across the running board, half in the car and half out? Dr. Marr said it looked as if she had been placed there. Edna Campaigne said it looked as if she had been trying to back out of the car door and passed out. But to many, the description of the body's position sounded more like somebody crawling *in*. Or could the body have been placed there after it was already dead or incapacitated? And if so, why would someone go to the trouble of arranging the scene and then just plop her down in such a suspiciously unnatural posture?

- If Elva had been dead long enough for rigor mortis to begin setting in, and if the temperature had fallen well below freezing during the night, why was her body still noticeably warm to the touch when she was found?

- What about the way she was dressed? Why no underwear? Why was the skirt later found to be several sizes too big?

- Were the bruises on Elva's body a byproduct of her rigorously athletic lifestyle, or could they have resulted from a violent confrontation?

In any case, this was not to be a murder trial, as the judge would make clear. It was supposed to be a relatively staid matter involving the disposition of a last will and testament. Still, as will be seen, the hearing would turn out to be anything but boring.

<p style="text-align:center">***</p>

For an oddly disparate group of three individuals who lived quietly far from the center of the storm—a mentally retarded boy in England, a curly haired toddler in Arizona and an attractive young woman in Minnesota—the outcome of the caveat hearing would be a matter not just of justice but also of money: several million dollars at today's rates. Though two of them might not even have been aware of it, all three stood to benefit richly from

Elva's original will—the one she tore up just ten days before she died, giving everything instead to her new husband. Now they were out in the cold.

Then there was another group, for most of whom the hearing was a simple matter of money. These were the high-powered, out-of-town attorneys representing all of the above, as well as those on the other side looking after Brad Davidson's interests. They came swooping into the case from all directions, like buzzards squawking and elbowing one another around a rotting carcass.

Ten days after the inquest, no sooner had Elva's new will been filed at the Moore County Courthouse in Carthage than J. Melville Broughton, the Raleigh lawyer and future North Carolina governor who was representing all the Statler family interests locally, entered a legal instrument known as a "caveat." From the Latin for "let him beware," a caveat is a formal notice that an interested party files with a court, requesting the postponement of a proceeding until the filer has a chance to be heard. The effect of the caveat lodged in the Davidson case was to freeze all proceedings under the will until the court could hear a challenge to its validity.

"The Statler family started its fight today on the purported will of Mrs. Elva Statler Davidson, which leaves virtually all of the $560,000 personal estate to her husband, H. Bradley Davidson Jr.," the Associated Press reported on March 18. "Acting in behalf of Ellsworth Statler of England and Joan Marie Statler, three years old, of Tucson, Ariz., J.M. Broughton, Raleigh attorney, filed a caveat to the will in the County Superior Court."

Ellsworth was Elva's only surviving adoptive sibling. Baby Joan Marie, who already had $1 million to her name in her own right, was Elva's niece—the daughter of her brother Milton, who had been killed in an auto accident. Joining their lawyers only late in the game was the attorney for lovely young Isabelle Stone Baer of Minneapolis, Elva's roommate at Radcliffe and intimate friend.

"Their suit alleges," the AP report said, "that the will filed Saturday by Herbert Seawell, Carthage attorney, is not the valid last will and testament of the 22-year-old heiress who was found dead of carbon monoxide gas in her garage at Pinehurst Feb. 27."

Under North Carolina law at the time, objectors could attack the will on three grounds: that there was some defect in the instrument itself; that "undue influence" had been exerted on the testatrix (Elva); or that the testatrix had been of unsound mind when she signed it. The caveators, as they were called, would focus on the second of those three possible grounds,

the "undue influence" angle. They would attempt to show that Brad and his lawyer, W. Barton Leach, had "virtually driven" a suggestible Elva into unwisely changing the will.

They would get nowhere pursuing the first possibility by trying to show that the will was defective or invalid, since its signing had been well witnessed. And they faced an interesting dilemma where the third ground, "unsound mind," was concerned. On the one hand, they would need to portray Elva as confused and vulnerable enough to bolster their contention that Brad and Leach were able to exert their sinister "undue influence." But they wouldn't want to make her appear *too* troubled or unstable, lest they strengthen the suspicion that she might simply have done herself in—with no goading by her husband.

They would spend several days walking that tightrope.

Superior Court Judge Don Phillips gaveled the hearing on the caveat case into order on Monday, February 10, 1936—eleven months after the coroner's inquest had ended. Meanwhile, Brad Davidson had been obliged to keep spending most of his time in Pinehurst, enduring gossip whenever he appeared in public, to maintain his legal residence.

The Moore County News attempted to put the Davidson case in a national perspective. "Intricate legal problems, some of which may have to go before the United States Supreme Court before they are settled, are involved in the Statler-Davidson will case," the paper reported. "Some of them concern the residence of the Davidsons, whether in Massachusetts or North Carolina; the validity of the prior will, if the purported last will is set aside, and the share of the estate H. Bradley Davidson, the husband, would receive if both wills should be invalidated. But win, lose or draw, one attorney not interested in the case gives the opinion that Mr. Davidson will come into quite a bit of money."

To try to keep that from happening, what *The Buffalo Times* called "a galaxy of Buffalo attorneys, reinforced by others from Pinehurst and Minneapolis," converged in Moore County for a strategy session on the weekend before the court date. They would retreat to Pinehurst every night, traveling every morning back to Carthage.

That threadbare little county seat town, home to a few hundred souls, presented the contingent of outsiders with a grim and dispiriting scene of hardship upon hardship. Not only was Carthage still struggling in the depths of the Depression, but the area had also been locked for two months in the iron grip of a cold spell of Arctic bitterness. The lawyers would find both their hotel rooms in Pinehurst and the courtroom in Carthage uncomfortably chilly for their entire stay, and they would have to bundle up against the biting wind for the trips back and forth between them.

Seventy-eight-year-old N.A. Stone, who had lived in those parts all his life, allowed that this was the harshest cold snap he had witnessed since he was sixteen. A farmer just outside town lamented that his prized, full-blooded calf had frozen to death. A revenuer in Charlotte reported that area moonshiners were shivering through a hardship of their own: they couldn't operate their woodland stills because the mash pots kept turning into blocks of brown ice.

More ominously, *The Moore County News* told of a near-epidemic of pneumonia among the county's suffering rural population, largely attributable to a dangerous combination of unrelenting cold, poor nutrition and widespread inability to pay for critically needed medical care.

<p style="text-align:center">***</p>

"Just as the inquest last year ended in mystery," read a Sunday feature article that appeared in *The Buffalo Times* on the eve of the February 10 opening of the caveat hearing, "so will the court action start, it was indicated as attorneys emerged tight-lipped from last-minute conferences. So the mystery which enveloped Elva Idesta Statler almost from birth, which deepened at her death, still continues to cloak her affairs."

The Times had gotten a local stringer to write the pregame scene-setter because of continuing interest in the case in Buffalo, where E.M. Statler's hotel empire had its headquarters. For play-by-play accounts, the paper would rely thereafter on the Associated Press. None of the other big-city papers that had clamored for scoops during last year's inquest bothered to show up for the caveat hearing. No Ed Folliard. No Al. No Larry (Nuts) Byrd.

Besides Broughton, the lawyers, who had been "in almost constant conference for the past two days," included Edwin F. Jaeckle, Edward J. Garono, William L. (Buffalo Bill) Marcy Jr. and S. Fay Carr of Buffalo;

Richard Barrett of Minneapolis; and U.S. Spence of Pinehurst. Jaeckle and Garono represented the institutionalized Ellsworth Statler. Marcy and Carr represented Katherine Statler of Tucson, Arizona, widow of Milton Statler and mother of little Joan Marie. Barrett had been retained by Elva's chum Isabelle, and Broughton and Spence were thrown in for good measure, "looking after the interests of all the claimants."

Of course, that didn't even count the Davidson lawyers huddling in another hotel. Besides Bostonian Bart Leach, they included M.G. Boyette of Carthage and Jones Fuller and R.P. Reade, both of Durham.

The stone courthouse in which Act Two of the Davidson legal drama would be played out had been built in the more optimistic year of 1922. It was described at the time as "crowning the dominating ridge visible against the blue haze of the pines, glistening white in the brilliant Carolina sunshine, a significant exponent in the new age of peace, progress, prosperity and plenty." As of 1936, prosperity and plenty had gone down the drain, peace was about to join them, and no one spoke much about progress anymore.

Despite the sensational nature of the Davidson case, only a handful of hardy spectators had made the twelve-mile trip up from the winter colony at Pinehurst for the first day of the hearing. The number of onlookers increased some as the first day wore on, but most were curious walk-ins from Carthage.

Brad Davidson, wearing his usual dark suit and imperious poker face, sat with his attorneys at a table on one side of the drafty courtroom. His eyes seldom met those of stylish young Isabelle Baer, who sat on the other side, surrounded by the gaggle of lawyers for the caveators.

The laborious process of selecting a jury and putting Elva's purported will into the record took up most of the first day. The twelve-man jury—which would be called upon to sit through days of arcane arguments by nationally prominent legal eagles and then make a Solomonic decision about the disposition of a fortune—ended up consisting almost entirely of farmers from the surrounding countryside. The others were a filling station attendant and a worker at a handkerchief mill.

Given the magnitude of the case (and perhaps the precarious state of the local population's health), Judge Phillips took the locally unprecedented step

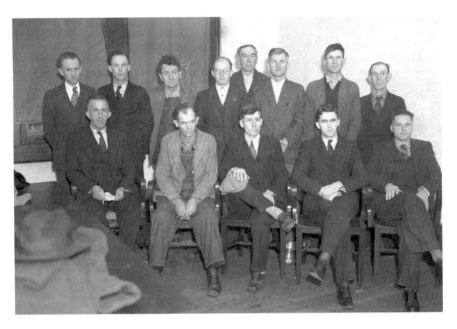

These are the jurymen who heard the 1936 "caveat" case in Carthage, North Carolina, in which lawyers for Elva's family and friends attempted to prevent Brad Davidson from inheriting her fortune. The judge added a thirteenth juror just in case, which proved a wise decision. *Courtesy of the Tufts Archives, Pinehurst.*

of selecting a thirteenth juror, a carpenter named Gus Fry. He would have to sit through all the testimony like a spare tire, to be brought out of the trunk only if the jury had a flat. It turned out to be a wise precaution.

The contrast between the sophisticated northern witnesses and lawyers on one hand and the rustic, rural southern jurors on the other was so marked as to constitute a gaping void. The culture shock obviously made an impression on the youthful Isabelle. She viewed with distaste the demeanor of the "dumb" jurors, who punctuated the testimony by expectorating noisily and messily into strategically placed spittoons.

<p style="text-align:center">***</p>

The sun already hung low in the bleak February sky outside the courthouse's broad windows by the time the jury had been empaneled on that first day. But Leach, opening the case for Davidson, had time to call the only two

witnesses he planned to put on the stand: Livingston Hall, an assistant professor of law at Harvard University; and Victoria L. Mercer, Leach's own secretary in his capacity as a professor at the Harvard Law School.

Their sole function, for which they had been prevailed upon to travel all the way from Massachusetts to this humble North Carolina hamlet in the dead of winter, was to confirm that Elva had signed the will in question and that the version entered as evidence was the right one. They testified that Leach had dictated the will to Miss Mercer, who typed it up and then joined with Hall and Leach in witnessing Elva's signature. Once that had been established, the two witnesses were free to turn around and go back home to Cambridge.

That perfunctory matter out of the way, Leach began straightening his papers, ready to head back to Pinehurst for the night.

"We rest our case," he told Judge Phillips. But not so fast.

"Your Honor," said attorney Broughton, rising to his feet, "We ask the court's permission to call one more witness today."

"Who?" Phillips asked, caught off guard.

"W. Barton Leach."

Leach did a double take. A buzz went through the courtroom. Our story was about to get a new villain.

CHAPTER 20

A Chance to Blow Out the Candles

The judge at first dismissed the unorthodox request to call Bart Leach to the stand. Broughton argued that Leach, who had signed the will along with the other two, was every bit as important as a witness himself. Leach, offended at this assault on his dignity, argued that the request was highly improper, that he was there not to be a witness on this day but to serve as an officer of the court.

When Phillips eventually relented, agreeing to require Leach to testify as "a witness of the court," Broughton directed a self-satisfied little smile back in the direction of his co-counsels. Once he got his opponent on the stand, he would be able to have a little fun with him. He would attempt to show that Mr. Leach was well named—that he had opportunistically sucked his fill of blood first from Elva Statler Davidson and then from her widower, playing both ends against the middle.

"Mr. Leach," Broughton said after some routine questions, "whose idea was it for Mrs. Davidson to change her will in the first place, naming her husband as principal beneficiary of the estate?"

"Why, it was hers," Leach replied warily.

"Really?" Broughton asked. "Didn't you yourself suggest to Miss Statler the night before her marriage that she should make a new will?"

"No," Leach said—then, after a pause: "Not directly."

"Indirectly, then? What did you tell her?"

"I told her that the marriage would invalidate her previous will."

"Isn't it true, Mr. Leach, that you sent Mrs. Davidson a letter on January 7, just four days after her marriage, telling her you would draw a new will for her if she would send you notes?"

Leach acknowledged that he had done so but said Elva had not responded with any notes.

At this point, Broughton started to bring up some other unspecified matter that had come out during the inquest a year earlier. But the judge smacked him down, telling him to stick to the matter at hand: the will. "There is no evidence before you about any inquest," he cautioned the jury.

The chastened Broughton turned back to the witness and took a different tack. "Mr. Leach," he said, "would you say Mrs. Davidson appeared normal at the time she signed the will that you have entered here today?"

"Entirely normal," Leach replied.

"But hadn't she consulted a psychiatrist not long before her marriage on January 3, 1935?"

"I don't know."

"I see. But in any case, it is your testimony here today that she never appeared to you to be moody or abnormally temperamental?"

"It is."

Broughton, having saved the most glee for last, turned to money questions. "Now," he asked, "you represented Mrs. Davidson on some financial matters during 1934, did you not?"

"I did," Leach said.

"And how much did she pay you for your services?"

Leach scowled at the question and looked up to the judge, who nodded for him to answer. He grudgingly replied: "$22,500."

From the jury box, whose occupants were receiving the princely sum of two dollars a day apiece for their pains, one can imagine the sound of a plug of chaw hitting a spittoon.

Leach was squirming now, more than ready to step down. But Broughton had one more question—prompted by the realization that if this had been a year or more earlier and Elva Statler Davidson had been involved in some other kind of legal case, the leech would have been doing his blood-sucking from the other table. The jury already knew that Leach had deftly switched from one partner in the Davidson marriage to the other without missing a beat or a fee, but Broughton wanted to make sure they knew about the *timing* of his decision to jump ship.

"Mr. Leach," he said, "just when did Mr. Davidson retain you as his counsel?"

"Last year," Leach replied in a flat, almost surly tone, knowing where the questioning was leading.

"Early March, would you say?"

"I suppose so."

"And where did this take place? Where were the two of you located when you and Mr. Davidson consummated this agreement that you would begin representing his interests?"

"We were on a train."

"A moving train? En route from where to where?"

"From Pinehurst to New York."

"New York? I see. And what was the occasion that took you to New York?"

"A burial."

"Whose?"

"Mrs. Davidson's."

At that point, there had to have been the sound of another plug of tobacco hitting another spittoon.

The aristocratic, thirty-something W. Barton Leach, slumming it down in the North Carolina boonies for a frigid week, might have gone into the caveat hearing thinking it was going to be about Elva and Brad. But with the tough questioning the lawyers for the other side sprang on him at the end of the first day, they had "let him beware": to a great extent, it was going to be about him.

During three days of often-dramatic testimony and one day of bitterly combative final arguments, Broughton and his colleagues set out to make Leach look like an unchivalrous Yankee creep defending another unchivalrous Yankee creep, H. Bradley Davidson. Those overtones, Broughton knew, could hardly have been lost on the jurors, many of whose fathers and grandfathers had proudly worn Confederate gray.

In addition to portraying Leach as an unethical, opportunistic shyster, the Statler lawyers would try to paint him as what people today would call a male chauvinist pig. The picture that emerged was of a domineering man who would tell a young girl who came to him for help, "Now, don't you worry about a thing, honey. I'll take care of you"—while all the time charging her unreasonable fees and maybe even sinisterly manipulating things to her husband's advantage.

While they were at it, Davidson's opponents would also be pulling out all the stops to portray him as undeserving of his late wife's money.

Over Leach's bitter objection, Judge Phillips did allow Broughton to kick off the second day's proceedings with at least a brief refresher course of testimony about the circumstances surrounding the discovery of Elva's body.

Butler Emanuel Birch was prevailed upon once again to take the stand (this time a proper witness dock instead of a creaky rocking chair) and tell his harrowing story of entering the garage and finding his dead mistress sprawled across the running board of her 1934 Packard, dressed in skirt and sweater. Drs. M.W. Marr of Pinehurst and C.C. Carpenter of Wake

Elva's devoted butler, Emanuel Birch (left), who had found her body a year earlier, was called to testify at the caveat hearing at Carthage, North Carolina, in January/ February. The man at the right is unidentified. *Courtesy of the Tufts Archives, Pinehurst.*

Forest essentially repeated the testimony that they had given at the inquest, including their opinion that carbon monoxide was the cause of death.

None of the three witnesses offered anything startlingly new, though one of the doctors added "shins" to the list of places where bruises had been found. And Birch's mention that the body "was not moved" until the doctor arrived might be taken as contradicting what he had said a year earlier about Brad sitting on the running board and taking the lifeless Elva's head on his lap.

The stage-frightened Birch also provided a rare bit of comic relief, however mild. Broughton showed him a carefully prepared chart and asked him if it was a fair representation of the layout of Edgewood Cottage. Birch puzzled over it this way and that, then looked up and replied, "It don't look to me like it is."

Even if the judge had allowed the Statler lawyers to rehash the question of whether H. Bradley Davidson Jr. might have murdered his wife, they weren't inclined to waste much time doing so. That issue had been gone over ad nauseam at the inquest in Pinehurst a year earlier. Despite the best and most relentless efforts of Solicitor Rowland Pruette to make his case for homicide, the jury hadn't bought it. Nor had anything come of Pruette's follow-up efforts to turn all his evidence over to the grand jury and have it prosecute Davidson criminally. Legally, at least, that horse was pretty much dead, and there was no point flogging it.

<center>***</center>

Once they had gotten their initial scene-setting testimony out of the way, the Statler lawyers put their arch enemy, Leach, back on the stand late Tuesday morning with plans to give him a thorough grilling.

Leach's goal was to seem like anything but the evil Svengali the other side portrayed him as. Far from encouraging Elva to marry Brad, he said, he had tried to dissuade her from doing so. He also insisted again that she had made out the second will, executed twelve days before her death, without "undue influence" from him or anyone else.

"When did you first meet Elva Statler?" Broughton began by asking.

"Sometime in 1934," Leach replied. "She employed me well before her marriage to handle some legal matters for her."

"And when did you first learn she was planning to marry H. Bradley Davidson Jr.?"

"In the fall of that year."

"And did you encourage her in that?"

"No. I discouraged her. I warned her against marrying Mr. Davidson."

"Really? On what grounds?"

"I based my objections on the difference in their ages—twenty years—and on the disparity of their financial positions."

"But you didn't maintain your objections for long, did you?" Broughton asked, pacing the floor in front of the witness stand like a lion circling its prey.

"I maintained them as long as I could," Leach said. "Almost up until her marriage early the following January."

"I see. And why did you withdraw your objections?"

"She told me that Mr. Davidson was the man she had been looking for. That she loved him and had made up her mind to marry him."

Broughton, for some reason, chose that moment to ask Leach if he knew who Elva's birth parents were. Leach replied that he did not, and the subject turned to the contested will.

"Whose idea was it to change her will after she married Mr. Davidson?" Broughton pointedly asked.

"Hers," Leach replied in a firm voice.

"Did Mr. Davidson ever communicate with you about a will for Mrs. Davidson?"

"Certainly not!" Leach snapped.

"Did you try to talk her out of changing it?"

"There would have been no point. She was extremely strong-willed. And she made it clear that she loved her husband."

"I see. And do you know why the new will did not mention her foster brother, Ellsworth, or her niece, Joan Marie?"

"She told me that there was no use leaving any of her property to Ellsworth and Joan, since they were well taken care of already. Instead, she expressed a desire to leave everything she could to Brad."

Leach also quoted Elva as saying she didn't want to leave anything to Katherine Statler, widow of Milton and mother of Joan.

"And what about her best friend, Isabelle Baer?" Broughton asked, making a point of not looking at Isabelle, who sat at his table. "Why didn't Mrs. Davidson leave anything to her?"

This time it was Leach who was able to make himself look like the gentleman. Glancing at Isabelle, he asked the judge if he and Broughton might approach the bench. The judge agreed to this request—an unusual one in that it came from someone on the witness stand. The three of them went into a whispered huddle, during which Leach apparently objected to the awkwardness of making him discuss the matter in front of Isabelle. Broughton ended up withdrawing his question, for reasons that remain obscure. Had something gone wrong with the relationship between the two girls—something that all parties were willing to let slide?

The Associated Press account, as published in faraway Buffalo, leapfrogs from Tuesday's court proceedings to Thursday's, which started off with a bang as the Davidson side rested its case and asked that Judge Phillips order a directed verdict upholding the contested will. He refused. Brad then took the stand, and all ears in the courtroom perked up.

Jones Fuller, one of Brad's lawyers, began by leading him through some back story about his first marriage to Jessica Aylward in 1915, their brief time together on her estate in Virginia, his service in the Great War, his various jobs, his three children and his first encounter with Elva Statler in late 1933.

"Did you court and marry her?" Fuller then asked.

"Yes," Brad replied.

"Did you ever talk to her about her will?"

"No. Never."

Then, Fuller decided to beat Broughton to the punch with a question he was sure to pose in the cross-examination.

"Mr. Davidson," he said, "did you do anything which in any way produced or contributed to the death of Mrs. Davidson?"

"Absolutely not," Brad declared.

In addition to professing his love for Elva, Brad then took advantage of the opportunity to introduce several telegrams and one handwritten letter that she had sent him during their brief marriage.

The 1935 Elva Statler Davidson Mystery

Brad shields his face from photographers as he and his sister-in-law, Betty Hannah Davidson, leave the Moore County Courthouse during the caveat hearing. *Courtesy of the Tufts Archives, Pinehurst.*

His purpose was to show that his late wife reciprocated his affection. But for courtroom listeners and readers outside, these communications—which were undoubtedly genuine—performed another important function: they provided some of the rare examples of Elva speaking in her own voice. And that voice sounded strikingly alive and passionate.

"Darling, I wanted to be in your arms so badly, but you probably would have gone to sleep," she wrote teasingly from New York in the middle of February 1935, after going to Boston to see attorney Leach and change her will. Her note closed, "I love you," and was signed, "Elva."

On her arrival in New York on February 13, she wired: "Good morning, darling; arrived safely though very late; spent horrible night at St. Regis; today will call you around 6:30; be good and don't forget I love you more than anything else in the world."

Besides sending him the warmly devoted love notes, Brad said, Elva had telephoned him every day while she was away. He had arranged to meet her

in New York on her return from Boston, he said. He read a telegram sent from Boston on February 16, the day before he was to meet her: "Not too long before tomorrow. Can hardly wait. Try to know time of arrival in New York when I talk with you at 1. Much love."

Those in attendance seemed to hang on every phrase, as if they could hear the dead girl's musical words echoing faintly in that cold, somber, cavernous courtroom. Reluctant to break the spell, Fuller paused for a beat or two before asking gently: "Mr. Davidson, when did you first learn that your wife had made out a new will, bequeathing most of her estate to you?"

Brad sighed deeply as he refolded the letters and replied: "She told me about it when we met in New York. After her trip to Boston. She showed me a copy of it."

"And what did you say?"

"I told her, 'That was a foolish thing to do. There's no chance of your dying until long after I die.'"

When it was Broughton's turn, he got right to the point.

"Mr. Davidson," he said, "you have said that your divorce from your first wife, Jessica Aylward Davidson, was by mutual consent. But isn't it true that *she* divorced *you* on the ground of desertion?"

Giving a pained, we've-been-through-this-before expression, Davidson acknowledged that she had.

"And after your marriage to Miss Statler, didn't you live on her money?"

"No."

"No? Well, did you have any employment at the time of your marriage?"

"No, sir, I didn't. But I had saved some money from my previous job in Washington, in which I made $250 a month. I gave up that job at the insistence of my wife, who said I could find employment in Pinehurst."

Broughton asked if Brad had not played golf the day after his return from his wife's funeral and if he did not continue at that time to serve highballs in his home. Brad acknowledged that he had played golf. As to the serving of cocktails, he said it was "merely a continuance of a custom started by Mrs. Davidson." He didn't invite anybody, he said, but he did serve drinks to those who dropped in.

The 1935 Elva Statler Davidson Mystery

Brad's stay on the witness stand closed with a particularly hostile exchange. "Mr. Davidson," Broughton demanded to know, "Mrs. Katherine Statler has quoted you as saying that you could—and I quote—'live on Elva's money' after your marriage. How do you respond to that?"

Brad looked at Broughton for a moment and then cast a steely stare in the direction of Katherine, who sat across the courtroom from him.

"With all due respect to Mrs. Statler," he said in a level voice, "she knows that is not a fact."

<p style="text-align:center">***</p>

Pressing their effort to portray the newlyweds as having been madly in love, Brad's lawyers closed out the Thursday session by calling what the newspaper called "a number of witnesses from the Pinehurst society colony" to "testify to the evidence of affection he and his wife had for each other."

Allie Tufts said Elva was so crazy about Brad before their marriage that— "well, she'd sort of rave about him." On her wedding day, she said, Elva was "very nervous but very, very happy." And Brad? "Oh, he was the same way." Edna Campaigne backed up Allie's story. Brad and his wife, she said, "seemed much in love with each other." The husbands of the two witnesses gave similar glowing accounts of marital bliss. Curtis Campaigne testified that Elva had come to his office in New Jersey in December to tell him of her engagement, excitedly saying, "I have found the man!"

Allie Tufts injected a bittersweet note by describing Elva as "unusually bright, emotional—and pathetic." Asked to elaborate, she said: "Pathetic because she seemed to crave attention so." Eyes teared up in the courtroom as Allie recounted something she said Elva had told her shortly before her death. There were two things that the poor little rich girl had always wanted very much and now maybe could have at last, she said: "a chance to blow out the candles on her birthday cake and to hang up her stockings at Christmas."

When Broughton's turn came, he wasn't content to let that poignant note linger for long. He brought Allie back down to earth with a thud.

"Mrs. Tufts," he asked, pausing to confront her face to face, "were you one of those who went to Davidson's house and drank highballs while his wife's death was being investigated?"

"Why, yes," she replied, squirming a bit.

"And wasn't it you," he said, referring to notes, "who sent a telegram to another bride in early 1935, saying, 'I hope you are happier than Elva,' and in another place, 'Elva can't take it'?"

Allie attempted a shrug before answering, "I might have been."

CHAPTER 21

So Cunningly and Craftily

The nearer the caveat hearing grew to its end, the more heavily the tension and hostility hung in the chilly courtroom air. Some in the mostly local audience seemed to view the proceedings suspiciously through a regional prism—as if the northerners were down there looting the South again, trying to steal money that didn't rightly belong to them.

That wasn't it exactly. The lawyers for the Statler family and Isabelle Baer weren't trying to keep Elva's fortune in North Carolina, as it might have appeared. That wasn't going to happen in any case. If the will held up, the money would end up in Washington or Baltimore or Virginia or who knows where in no more time than it would take Brad Davidson to shake the sand of Pinehurst from his shoes. If the Statler interests won and Elva's earlier will was reinstated, the money would go to places like Buffalo and London and Minnesota and Arizona. In neither case would much or any of it stay around locally.

Nor was this a case of invading Yankee lawyers skirmishing with a contingent of Carolina boys defending their homeland, though that would make a better story. It was more complicated than that. The ranks of both teams included a mix of members from both regions.

Still, from that first afternoon's surprisingly brittle and personal exchange amid suggestions of extravagant lawyer fees and unseemly client-switching and unethical solicitation of legal business from an impressionable girl, there was one sense in which the courtroom drama did take on a North-versus-South flavor. What could have been a dry courtroom exercise carried out in relative decorum quickly turned into

an ugly, intimately personal battle between two main protagonists, southern gentleman Broughton and arrogant Bostonian Leach. It made for crackling drama.

The lawyers' closing arguments, which took up most of Friday, were surely among the most eloquently biting, the most slashingly articulate, that the Carthage courtroom had ever witnessed.

Boyette, the first of six attorneys to address the jury (three on each side, with the two sides alternating), began on a civil note, sticking to the facts and trying not to get personal. There was "not one scintilla of evidence," he said, that anyone had induced Elva Statler Davidson to make out a new will in favor of her husband.

Boyette praised Davidson's war record, referring to him as "this stalwart man, this heroic man who gave up home and loved ones and offered his life to his country." Referring to the previously introduced letter and telegrams as proof that Elva had loved her husband, Boyette asked: "Isn't it only natural that she would want to leave her money to him, rather than to her foster relatives who were already wealthy?"

Describing the relationship between Leach and Elva as "right and proper between an attorney and client," Boyette said Leach's standing in the legal community "is attested by his present position at Harvard Law School and the fact that he was once private secretary to Justice Oliver Wendell Holmes of the Supreme Court of the United States."

Broughton snorted at that comment, remarking: "Justice Holmes never taught Bart Leach to solicit law business." As for the law school job, Broughton said, leaping to the attack, Leach deserved to be fired from it. He charged that Leach, by his own admission, had solicited employment as Davidson's attorney, a legal no-no. This act of ambulance-chasing, he said, along with "suppressing evidence" and "becoming a lawyer in a contest over a will he himself had drawn," should cause Leach to "lose his place at Harvard."

Describing Elva's death as one "in anguish, after brooding," Broughton said, "the truth may never be known, but she was found sprawled out there with nothing on but a sweater and skirt, without even underclothes, with the thermometer down to seventeen degrees above zero."

The 1935 Elva Statler Davidson Mystery

Clearly implying that Elva had killed herself, Broughton went a step further by all but accusing Leach of driving her to it with his machinations. Leach had "entered into a conspiracy with Davidson in regard to her money when he withdrew his objection to her marriage," he said, and "her melancholia was caused by a realization that what Davidson wanted was money and by the insistence of Leach that she make the will."

Broughton had been prowling in front of the jury box as he made his sensational charges, his voice raised dramatically. Then, pausing by the rail, his passion spent and his voice subdued, he looked from juror to juror.

"If you sustain this will," he said, "you approve actions of this man who so cunningly, craftily, persistently and indecently brought about the situation."

In his rejoinder, lawyer Fuller tried to turn the tables on Broughton by charging that it was he and "Buffalo Bill" Marcy who were the attack dogs. They had mercilessly "hounded and persecuted Mr. Davidson during the investigation of his wife's death," Fuller said, and continued to hound and persecute him in the caveat suit.

"And why was he subjected to it?" he asked, also pausing before the jury to answer his own rhetorical question. "Because of the love of money," he said, rubbing the thumb and fingertips of one hand together, "the root of all evil." The attorneys for the objectors, Fuller said, were merely trying to confuse the jury with irrelevant arguments and accusations.

"The case my learned friend Broughton presented to you is not the case presented in the evidence," he said. "Remember that you are not trying Mr. Davidson on charges in connection with the death of his wife. There never has been a charge of any kind against him."

When his turn came, attorney U.S. Spence of Pinehurst lost no time in turning the withering fire back on Leach. "He took possession of poor Elva Statler in 1933 and never let her go until her death," he charged, saying that it was "an unnatural thing" for Leach to have broached the morbid subject of a will to Elva when he had come to Pinehurst for what was supposed to be a joyous occasion, her wedding.

"Oh, Leach is smart, all right," he said. "He's as smart as greased lightning. He was smart enough to look out for himself and his friend Brad."

Spence said the marriage itself was "unnatural" because of the difference in the ages of the bride and groom and because of Davidson's status as a divorced man with three children. "That's what Elva got—a divorced man with three children so poor he couldn't pay the alimony," Spence told the jurors. "That's what she got. And that accounts for her distress."

By the time Thursday's closing arguments had ended, the winter sky was growing dark outside the courthouse windows, and most of the people present were feeling weary, restless and hungry. Judge Phillips briefly charged the jurors, reminding them that there were only two issues for them to consider: (1) whether the document produced in court was in fact Elva Statler Davidson's last will and testament and (2) whether her husband and/ or attorney Leach had unduly influenced her in preparing it.

Lawyers and jurors return to the caveat hearing in Carthage. *Courtesy of the Tufts Archives, Pinehurst.*

172

The jurors, "somewhat bewildered and confused by the reams of evidence placed before them and the long hours of testimony," as *The Moore County News* reported, received the case at 6:10 p.m. but were taken out to supper before being brought back to begin their deliberations. When they reported back after ninety minutes that they had failed to reach a verdict, the judge sent them to bed at 8:30 p.m.

They resumed their discussions with fresher heads at 9:30 a.m. Friday, and at 11:43 a.m. they reported that they had arrived at a unanimous decision, and a bailiff brought them back into the courtroom. In contrast with the crowd that had gathered for some of the week's juicy earlier testimony, only a dozen or so spectators were on hand to witness the climax.

"Has the jury reached a verdict?" Phillips asked.

"We have, your honor," the foreman replied.

"How find ye?"

"We hold for the defendant, Henry Bradley Davidson Jr."

And so it was over, just like that. The will was upheld. Brad and Leach had won. Ellsworth Statler, Joan Marie Statler and Isabelle Baer had lost. Still, it all seemed anticlimactic somehow. The show had gone on too long, and now it had ended, and everybody was eager to get out of there and hit the road. The Statler lawyers said they would file an appeal with the state Supreme Court, but nothing ever came of it.

The few spectators began bundling up against the cold that awaited them outside. The judge thanked the jurors for their service and sent them on their way. *The Moore County News* later reported that the jury had initially been split six to six and then voted nine to three for upholding the will upon retiring Thursday night. Votes the next morning had gone ten–two, then eleven–one, and then a rereading of the judge's charge won over the lone holdout.

Phillips, as it turned out, had shown admirable foresight in seating a thirteenth juror as a spare. One member of the panel, seventy-year-old W.R. Lewis, fell ill during the deliberations and had to be excused. But carpenter Gus Fry, the alternate, had sat through the entire case and was able to step in and fill the void.

Brad Davidson was the only principal in the case who was present to hear the verdict, sitting quietly in one of the rear benches with his brother, Richard. Katherine Statler, who had attended the trial, stayed away for the final day. Her lawyer said she would have no comment.

"It is gratifying to know that others think the way I know," Brad said, declining to answer any more questions from reporters. He said he planned to leave immediately for New York, where he had formed "a business connection."

He didn't say what kind.

Attorney W. Barton Leach, representing Brad Davidson, was the big winner of the 1936 caveat hearing in Carthage. But his was something of a Pyrrhic victory, and he went home to Massachusetts to lick the personal wounds inflicted on him during the bruising battle.

He didn't lose his job at Harvard Law School, as his outraged opponent, gentlemanly J.M. Broughton, had said he should. On the contrary, he went on to distinguish himself in it, not retiring until 1969. He was named Story Professor of Law in 1950 and became a nationally recognized and honored authority in the fields of private property law and national defense issues.

But one accusation hurled at Leach in that long-ago North Carolina confrontation seems to have stuck: that the professor was a domineering male who took satisfaction in asserting himself over young women.

In 2003, when Elena Kagan (who recently joined the U.S. Supreme Court) became the first female dean in the long history of Harvard Law School, an interviewer for *Ms.* magazine marked the occasion by noting how far the school had come since the pre–women's lib days of the early 1960s, when "Professor W. Barton Leach, who taught property, would allow female students to speak only on Ladies' Days."

Judith Hope Franklin, class of '64, recalls one of those days in her book *Pinstripes and Pearls*:

> *On Halloween 1961, like trained seals doing tricks for an eager audience, the five women in Leach's section, dressed in high heels, skirts, blazers and pearls, were ready. They left their seats in the front row of the large,*

fan-shaped classroom seating, mounted the steps to the dais, sat down on five folding chairs that had been arranged in a line facing the rest of the class, crossed their ankles, and waited calmly for the first question they knew was coming.

Leach left the dais and went to the middle of the classroom, where he stood to interrogate them, surrounded by 140 or so male students, who hooted and laughed and sometimes stomped their feet, thinking it was marvelous fun. Actually, most of the women thought it was fun, too. It seemed totally normal for Harvard Law School then. Nancy (my classmate) remembers, "It was sort of like Picnic at the Zoo Day—and we were the animals in the cages."

W. Barton Leach, born with the century, died at age seventy-one on December 15, 1971 (just eight months before Brad's death), after falling from a second-story window of his home in Weston, Massachusetts. Like several other characters in this story, he had been married three times.

CHAPTER 22

The One-Hundred-Pound Bulldog

The hardy souls who had sat through both the weeklong inquest and, a year later, the weeklong caveat hearing may have thought they knew about all there was to know about Henry Bradley Davidson and Elva Statler Davidson. But they were denied access to key bodies of evidence that are available to us today—and that would have heavily impacted their theories about what happened on that winter morning behind Edgewood Cottage. For one thing, they didn't know about a remarkable body of work by a diligent Washington reporter whose revelations only recently found their way into the modern consciousness.

Those attending the Davidson inquest in March 1935 knew nothing about a reporter named Pat Frank except that he worked for *The Washington Herald* and that he got in a bit of trouble when he accused Elva's butler, Emanuel Birch, of perjury.

"The little colored man is lying and he knows it," Frank told a *New York Times* reporter. "Birch told me they [the Davidsons] fought all the time." That story got back to Solicitor Rowland Pruette, who at that point was regrouping and scrambling to revise his witness list after being deprived of his smoking gun, the nonexistent (or at least undetectable) "subtle poison." On March 6, he required the reluctant Frank to take his place in the official rocking chair and violate a confidence by revealing what Birch had told him in an exclusive interview the previous Sunday. Under oath, Frank told the jury what the butler had confided in him: that the Davidsons slept in separate bedrooms "because of misunderstandings" and that "sometimes they quarreled."

End of testimony. But as it turns out, that was only the beginning of what he was able to dig up about the Elva Statler Davidson story.

The 1935 Elva Statler Davidson Mystery

The story had clearly created a sensation in Washington, D.C., where Brad Davidson was something of a hometown boy. So *The Washington Post* and *The Washington Herald*, which duked it out daily for dominance of the morning newspaper market in the nation's capital during the Depression, transferred that bitter rivalry to Pinehurst for a few days by dispatching dueling journalistic superstars to cover the inquest.

In that heyday of no-holds-barred journalism, afternoon papers still dominated most cities. *The Post* and *The Times*, the fourth and fifth newspapers in a five-newspaper city, were struggling to survive in a market that *The Evening Star* and two other p.m. papers had largely sewn up. Both morning papers had new, ambitious, aggressive executives in key jobs who were determined to turn them around, and the Elva story gave them something to get their teeth into.

Just five years earlier, in 1930, William Randolph Hearst had installed the feisty but inexperienced Eleanor Medill Patterson as editor in chief of the then-failing *Herald*. One of the few prominent female editors in the country, she was in the process of proving herself by doubling *The Herald*'s circulation to over 100,000. As the granddaughter of *Chicago Tribune* editor Joseph Medill and sister of *New York Daily News* publisher Joseph Medill (and, incidentally, cousin to Betty Hanna Davidson, Brad's sister-in-law), "Cissy" Patterson was a proud and highly competitive member of an American newspaper dynasty and not above resorting to yellow journalism to get ahead. A juicy story from the hinterlands about the death of a socialite could only help boost street sales.

As for *The Post*, it had also been floundering when Eugene Meyer bought it on the bankruptcy auction block less than two years earlier, on June 13, 1933. It had been run into the ground by previous owner Edward Beale McLean, described as a "pathetic man with no chin and no character" who had been tied to the Teapot Dome scandal. Far from the national institution that the aristocratic Meyer would eventually turn it into, *The Post* was still a feeble entity hanging on by its fingernails, its circulation scarcely half that of *The Herald*.

But though he would not willingly take a back seat on any story, Meyer was determined to achieve his lofty goal of turning *The Post* from a pitiful rag into the nation's newspaper of record by taking a more principled and

professional route than the often-sleazy *Herald*. By coincidence, Meyer laid out his principles in a speech delivered on the very day the Davidson inquest began—on March 5, 1935. *The Post*, he said, "shall tell ALL the truth so far as it can learn it, concerning the important affairs of America and the world." But in disseminating that news, he stressed, "The paper shall observe the decencies that are obligatory upon a private gentleman."

In Pinehurst, that genteel attitude would put a newspaper at a disadvantage in covering a story fraught with seamy undertones and titillating rumors.

The Herald's Cissy Patterson and *The Post*'s Gene Meyer, once close friends, had come to hate each other as their papers engaged in mortal daily combat. They even fought a long, angry legal battle over the rights to publish four popular comic strips: *Andy Gump*, *Dick Tracy*, *Gasoline Alley* and *Winnie Winkle*. Patterson learned during the week of the Davidson inquest that she had lost that battle when the U.S. Court of Appeals for the District of Columbia gave the comics to *The Post*. So bitterly did Cissy resent the loss that she sent her triumphant rival a piece of raw, bloody meat nestled amid orchids, a Shylockian pound of flesh that greatly offended the Jewish Meyer.

The Post, with its more sober and serious approach, had the edge on covering the rapidly expanding federal government and keeping tabs on the ins and outs of the proliferation of New Deal alphabet-soup agencies. *The Herald* covered government as well, but it also devoted considerably more ink than its staid rival to stories of the kind that supermarket tabloids specialize in today.

Just during the week of the Davidson inquest alone, *The Herald* published lurid stories about:

- A 100-pound bulldog that had to be shot after going on a rampage in Maryland, killing a 1,200-pound prize bull.
- An elderly woman, "Baby Doe" Tabor, once the toast of Colorado society and the wife of a U.S. senator, who was found frozen to death in a squalid hovel.
- A twenty-five-year-old D.C. woman, victim of sleeping sickness, who committed suicide in the hospital by binding her mouth shut with adhesive tape.

Billing itself as "an American Paper for the American People," *The Herald* endeared itself to its blue-collar readers by playing up blustery, right-wing, unfair and unbalanced articles that made little attempt to separate news from opinion. Next to its March 5 top-of-the-front story on the Elva case, for instance, *The Herald* ran an exposé about sinister Soviet propaganda movies

supposedly flooding U.S. theaters. "The multi-armed octopus in Moscow," warned the lead paragraph, "has many of its colossal, death-dealing tentacles wound around America."

<p style="text-align:center">***</p>

Once the Davidson story broke on March 1, both Washington papers relied on the wire services for their first stories. But Cissy Patterson and her fellow editors at *The Herald* were quicker to see the need to send their own man to the scene. They considered the story of such importance that they immediately decided to put one of their best and most skilled digger/writers on a train to go down and cover it.

It didn't take them long to settle on Pat Frank.

Wiry of build and somewhat nerdy looking, the bespectacled, heavy-smoking Frank was just twenty-seven. Born Harry Hart Frank in 1908, he had already made a name for himself in that golden age of colorful, hard-nosed newspapering and would go on to a successful career not only in journalism but also in popular literature. After learning his way around the corridors of power first as a reporter and then as a public-relations man for various governmental bureaus, he would turn his hand to fiction later in life. His novels include *Alas, Babylon*, a bestselling apocalyptic tale of life in the aftermath of a thermonuclear war.

Frank arrived in Pinehurst on Sunday, March 2, and filed his first story by telegraph that evening. It was the one that appeared in the next morning's paper under the headline "Poison Suspected in Strange Death of Statler Heiress." On his first day in town, the prolific Mr. Frank also wrote the sidebar story telling of slot machines and gossipy socialites and overpriced eleven-cent Coca-Colas—and another one based on that exclusive interview with Emanuel Birch. Not only did the Davidson butler tell him in dramatic detail about discovering his mistress's lifeless body after noticing her foot hanging from the open door of her Packard convertible, but he also obligingly climbed into the car and showed Frank the position in which he found her.

"Here Birch kneeled on the running board," Frank wrote. "He thrust his head and body through the open door of the car, his head resting on the foot pedals, his hands outstretched before him. 'She was like that,' he said."

Buried in Frank's body copy the next day was a brief but significant revelation involving Davidson acquaintance Bernard Freeman, a Pinehurst publicist who had been a guest at the charity ball on the night before Elva's death. He was the one who testified in public that she had said "I'm going to get tight," though he didn't know whether she had carried out her vow. But he privately told Frank that she had downed "three quick drinks, one of whiskey and two of wine." So Elva may have gotten pretty well plowed on the night in question after all.

Chafing at reading Frank's dazzling array of provocative, readable details in the March 3 *Herald*, Gene Meyer's editors back at *The Post* realized belatedly that they had to put their own ace on the case. That's when they called in their widely respected White House reporter, Eddie Folliard, and told him to start packing his bags.

But no sooner had Folliard taken the taxi from the depot in Southern Pines and arrived at his hotel in Pinehurst than he ran into Frank, the man who would become his nemesis for the next few exasperating days. Far from feeling intimidated by the arrival on the scene of the older and more widely esteemed Folliard, Frank took it as a personal challenge. He already had a two-day jump on Folliard, and he clearly resolved to stay a couple of steps ahead of the newcomer for the duration, hitting him with a scoop a day if possible to keep him off balance.

By week's end, poor Folliard must have felt like that lumbering, 1,200-pound bull back in Maryland, with a nimble, 100-pound dog running circles around him and biting him from every angle.

On Tuesday, March 5, Frank—or at least his paper—published an eye-opening sidebar offering a whole new take on the character of H. Bradley Davidson. Somebody on *The Herald*'s staff, possibly Frank himself, managed to get an exclusive telephone interview with Brad's ex, Jessica, who had remarried and was living back on "her vast forested estate on the mountainside above Berryville, Va."

Puzzlingly, she had only the most tender and complimentary things to say about the man who had walked out on her and her three children, failed to keep up on his child-support payments and now stood all but accused

of murdering the woman who took her place as his wife. "I am in deepest sympathy with Bradley Davidson," Jessica said. "He was of a gentle, kind nature and is suffering now that his wife is dead."

Gentle? Kind?

"I have been asked today about our divorce," Jessica told the anonymous reporter, "so I must speak about it for his sake, now that his trial is on. Our separation three years ago was due to our misunderstanding each other. This was because his business took him out West, where he stayed for several years. I had to live in Baltimore with mother and the children. That separation made us feel like strangers when he came back. We were divorced last May, after a separation of three years. During those three years he came to see the children frequently. He is a devoted, affectionate father."

Devoted? Affectionate?

The Herald published a large, two-column photo of Jessica, showing her to be a lovely, full-lipped, passionate-looking brunette with an aristocratic but fragile bearing, an anguished expression and a rather revealing neckline.

Jessica and Brad still had one thing in common, it seems: both had a taste for much younger second spouses. The former Mrs. Davidson, age forty-one, was now Jessica Riely, having married twenty-one-year-old Lee Riely the previous June, not long after her divorce. The callow Lee was the son of a retired army officer. The newlyweds and Jessica's children were back living at Retreat, her 1,150-acre estate stretching along the east bank of the Shenandoah River. The beautiful old mansion, to which Brad and Jessica had moved after their marriage back in 1915, had been closed for several years before they reopened it.

"It was on the vast boundaries of 'Retreat' that high-spirited young 'Brad' Davidson wooed and won her for his bride two decades ago," *The Herald* wrote. "Mrs. Riely was then the beautiful Jessica Aylward, heiress to a vast fortune. Davidson and his heiress bride remained there only two years, and then they went to her family home in Baltimore. In the years before their separation, two sons and a daughter were born."

To shield the children, Jessica had allowed no newspapers with stories about the goings-on in Pinehurst on the premises and hadn't told them anything about the fix their father was in. Since learning about the tragedy herself, she said in a subdued voice, she had been in ill health and unable to receive visitors—which explained the telephone interview. Young Riely, who had taken over the day-to-day running of his new wife's estate and was also "associated with the management of the Charles Town race track," also got

on the phone. He said he knew Brad Davidson and liked him fine. He had never met Elva.

All this took some getting used to. Was the arch villain of the Elva tragedy not such a bad guy after all? There seemed two potential explanations. It was possible that Jessica had simply lied about him—that for the kids' sake, she had chosen not to badmouth their father publicly. But her tone sounded more like that of a woman who knew in her heart that she bore some of the blame for the breakup of her marriage and felt genuine pain at the current plight of her ex-husband.

This question of some "mitigating fault" on Jessica's part came up in an earlier chapter during the discussion of the divorce agreement, which granted liberal visitation rights and at the time seemed oddly amicable, almost forgiving, in tone. The apparent reason for that would remain a mystery for seventy years—until Jessica's grandson, Henry Bradley Davidson IV, happened to shed an intriguing new light on that subject in a telephone interview subsequent to the one reported on earlier in this book. It was well known in the family but never publicly discussed, he said, that Grandmother Jessica suffered from "some kind of drug habit." She had been "sickly and addicted," he said, perhaps to pain pills. And her young son, Brad III, frequently had to "go traipsing somewhere to get drugs for his mother."

This certainly modified the image of Brad Jr.'s first marriage—and of why it possibly might have ended. Had Jessica become some kind of junkie? When had the habit developed? Had it continued into her second marriage, and might that be why she had pleaded that she was "in ill health and unable to receive visitors" during the Elva scandal? Had her first husband, Brad, been obliged to go out and procure her drugs before he abandoned his family and lit out in despair for the Midwest? Had that sad and demeaning chore then fallen on one of their three children? If so, all this would help explain why Jessica had been so hesitant to speak judgmentally of Brad for walking out on her.

A Faded Summer Love

The diligent Pat Frank, reporting from Pinehurst, had another jolt or two for his *Herald* readers.

On February 15, 1935, he wrote, "twelve days before her limp body, half clad, was found in Mr. Davidson's three car garage back of their pretentious mansion here," Elva had been in Boston alone, making out her will, leaving her husband a half million dollars.

Then, "while she was in Boston, Mr. Davidson left Pinehurst. At about this same time he was reported seen in Annapolis with *a vivacious divorcée* who had been his constant companion before he married the athletic, studious Elva."

Though the matter of his Annapolis stop-off would come up a couple of times during testimony, no further mention was ever made of any such divorcée, vivacious or otherwise. One can only speculate on her identity. She might have been Brad's former boss, Rella Abell Armstrong, wealthy owner of the Annapolis Roads development, who had left her philandering playwright husband, Paul Armstrong. In any case, the timing would have been right. It is known from an article in *The Outlook* that Brad was in Pinehurst on Valentine's Day, February 14, dressed as a sailor. He would have had to get on a train immediately thereafter to make his Annapolis rendezvous the next day.

So Brad was running around on Elva after all. And right after their marriage. That may well be the something that "hit the fan." Whoever Vivacious Divorcée was, one thing seemed likely: if Elva later found out about Brad's purported tryst in Annapolis, hatched on Valentine's Day and brazenly

Elva Statler, at age fifteen, participates in a mule race at the Pinehurst Harness Track in January 1928. *Courtesy of the Tufts Archives, Pinehurst.*

carried out at the very time she was in Boston signing her fortune over to him, it might well have sabotaged their brand-new marriage and plunged Elva into the state she was observed to be in on the night of the parties.

But there was more. Readers of *The Herald* were titillated to learn the next day that Brad wasn't the only party in that marriage whose recent past had harbored a passionate romance.

Two of them, actually. And another source would tell of a third.

It's not clear who at *The Washington Herald* managed, through diligent digging, to shine a light into a hitherto unexplored area: Elva's pre-Davidson love life. But apparently there was such a life—an intense one, in fact, whose unhappy end provided a possible explanation for her rather abrupt subsequent marriage to Brad.

"When Mrs. H. Bradley Davidson Jr., young Radcliffe graduate and heiress to the Statler hotel millions, left Boston last June," the paper reported

in a story that bore a Boston dateline but no byline, "she is known to have been deeply in love with a wealthy young Yale graduate, Boston friends of the dead bride revealed today, while officials at Pinehurst, N.C., were probing her mysterious death."

So, pencil another previously unknown member into the dramatis personae of this play: Wealthy Young Yale Graduate. Where did he come from?

"Because of her frank assertions that she loved the young New York heir to a great fortune, and would not consider marrying anyone else, friends here [in Boston] were stunned to learn of her sudden and unexpected marriage to Mr. Davidson," the paper wrote. "She was quoted as saying, 'If I married anyone, I would marry this New York boy. But I don't want to be married, because I am afraid it would interfere with the ambition of my life—a career as a concert pianist.'"

Elva's purported romance with the nameless young man, it seemed, had begun a couple of years previously, when she was an undergraduate at Radcliffe and met the New York swain through a mutual friend at Harvard. "During those years, friends said, the girl telephoned him at least three times a week, and spent many weekends with him and his family at their sumptuous country estate in a New York suburb," *The Herald* wrote. "She also visited him in New Haven to attend Harvard-Yale football games."

At that point, this particular trail grows cold. Having acted out his moment in the footlights (or the sidelights) without speaking a word of dialogue, Wealthy Young Yale Graduate exits the stage and hastens from the theater and into the noisy anonymity of the street, never to be heard from again.

Would Elva's aged best friend, the former Isabelle Baer, be able to shed any light on the matter? Her son, Richard Famiglietti, asked her about it not long before her death in 2009. He came back with an e-mail that was only marginally helpful. "In Cambridge, in the summer of 1934," he wrote, "Stat [Elva] and my mother lived in a Penthouse in an apartment building located between the Radcliffe campus and the Harvard campus. They used to have 'open-house' parties (i.e., invited guests could bring friends). Toward the end, not long before they left for Pinehurst, among the guys 'hanging around' were 'Harvard,' 'Yale' and 'Princeton.'"

Richard said that his mother remembered Harvard's real name, Johnny Dean, because she dated him in 1935 and 1936, when they were both working in New York City. But she knew nothing of the others. Whoever "Yale" was, did he and Elva drift apart? Did Brad catch her on the rebound?

Whatever happened, the story can't be a happy one. Elva Statler, already unlucky in life, was also clearly unlucky in love.

But as an entirely different source revealed, "Yale" wasn't the only love interest who had moved in and out of Elva's life before she met Brad Davidson. There had been somebody else. And he wasn't a boy at all. He was a man—a dark-eyed, hot-blooded, fast-fingered musician.

And this one had a name: Conrad.

<center>***</center>

Though superstar *Washington Herald* reporter Pat Frank got more than his share of scoops, he did miss out on one tantalizing morsel regarding Elva. The only known mention of it came in a cryptic sentence that an anonymous Associated Press journalist let fall while reporting on court proceedings building up to the 1936 caveat case. In the story, attorney Bart Leach tossed off a powerful little bombshell while giving an otherwise mundane deposition about the legal assistance he had provided to Elva before he switched his allegiance to Brad.

"Leach said he was employed by Miss Statler before her marriage," the AP report said, "to handle legal angles growing out *of a love affair between her and a Bostonian named Conrad*, described by counsel as an orchestra member or a band leader."

That was all. "A love affair between her and a Bostonian named Conrad." Newspaper readers scarcely had time to raise their eyebrows before the report moved on to other topics. "The incident was merely mentioned in Leach's narrative," the reporter wrote, "and was not enlarged upon."

Might it be possible to enlarge upon it all these decades later? Who was Conrad? Did he play a role in the lead-up to Elva's death?

Isabel Baer Famiglietti, speaking through her son Richard, was of no help. On the Internet, various search engines revealed that there were several musicians named Conrad during the 1930s—two of whom, Con and Lew, jumped out as strong possibilities. Con Conrad was a jazz band man in the 1930s, and he played in and around the Boston scene. He was successful enough to make his way out to Hollywood in 1936, where he died that same year. There were fewer references to Lew Conrad. One site included an elusive mention that Lew would be playing at a social function

<center>186</center>

at MIT. Another site said that Lew Conrad was a hit with the East Coast society crowd during the late twenties and early thirties. Clues were otherwise scarce, and both men might well have been using stage names.

Then, a chance access to the professional research service Proquest provided the key that unlocked that part of the puzzle. An advertisement gave more details about the party at MIT. And the name of the band playing there was "Lew Conrad and his *Boston Statler* Band of Musketeers."

Bingo. The name "Statler" shouted out across the decades. It seemed all but certain that this was the Conrad in question and that Elva must have met him while staying at her late father's hotel in Boston. One could easily imagine her wandering down to the lounge during a boring evening, whereupon he approaches her table and introduces himself during a break, the sparks fly and the rest is history.

Besides leading his own hotel band, Lew both sang and played violin with the Leo Reisman Band. At one point, he wrote a song for the band called "Moanin' Low," which was performed in a Broadway production called *The Little Show* by Libby Holman, who was about to get caught up in a highly publicized death scandal of her own. Lew performed on the radio regularly, broadcasting for NBC from New York. But there was a gap, from 1933 to 1935 or so, when he dropped out of sight and wasn't on the air. That would have to have been the time when he and Elva would have been together. Then Lew surfaces again, listed as filing with the Southern District Bankruptcy Court of New York in February 1935. He owed more than $8,000. And the date was two weeks before Elva would go to Boston and change her will.

What had happened during those two missing years? How torrid was this love affair between Elva and Lew? They would have had to keep their involvement quiet for any number of reasons. Had they been shacked up at some point? Is that why he dropped out of sight? What were those "legal angles" that Leach was helping with? Was Lew after Elva's money, too? Could Elva have perhaps made Lew a loan that he couldn't repay? Were they both over their heads in the relationship? How had it ended?

One does not have to go too far out on a limb to wonder if Elva had received a desperate call from her old flame just before she left Pinehurst for Boston. Could he have pleaded with her to help him out of his financial ruin? Could the "legal angles" have involved some kind of not-so-subtle attempt at blackmail? If her death was thought to be murder, should Lew have been considered a suspect? Given the timing, if nothing else, police at the time certainly would have considered him a "person of interest."

The Southern Bankruptcy Court of New York offers little enlightenment. Individual bankruptcy records have long since been tossed, and nothing remains beyond Conrad's docket number and a note that his proceedings ended in the summer of 1935, a few months after Elva's death. There is no creditor list or other clue to follow any further. The last mention of Lew Conrad has him playing at a USO show in 1941. Then he appears to have dropped off the face of the earth.

But not before leaving behind a good look at his face.

A now-empty song sheet cover, marketed in 1931 by Leo Feist Inc. of New York and found recently on eBay, was originally folded around the sheet music for a foxtrot ballad called "A Faded Summer Love," written by Phil Baxter. And there on the front, inset along with a color sketch of trees in autumn, is a three- by four-inch photo of "Lew Conrad, Exclusive NBC Artist."

Gazing confidently, almost cockily, from the black-and-white picture is an exotically handsome young man of about thirty, dressed in a well-tailored suit, vest and tie. With his swarthy Rudolph Valentino face and combed-back black hair, he has a definite "ethnic" look about him, leading one to doubt that "Conrad" was his original family name. He could have been of Lebanese extraction. Then again, he bore a slight resemblance to George Gershwin, who came from a Russian Jewish background.

Whatever his history, the Conrad of this photo has a brooding, intense, passionate expression, with a vague danger smoldering about the eyes. He would have been about ten years older than Elva, easily exerting a strong attraction on a none-too-stable young blonde with a rebellious streak. It is entirely possible that she was seeing him in Boston while her new husband was seeing Vivacious Divorcée in Annapolis.

Phil Baxter's "Faded Summer Love" was a popular and oft-performed song in 1931. Feist also marketed the sheet music under a different cover, in which a more amiable-looking Bing Crosby has replaced Conrad in the photo. The lyrics, found elsewhere on the Web, seem to echo eerily across the years as background music to a mysterious and apparently tempestuous love affair that went wrong for reasons now lost in the mist of time:

This song sheet shows musician Lew Conrad, with whom Elva Statler apparently became romantically involved sometime between 1932 and 1934. *Courtesy of Diane McLellan.*

You left today but you didn't say goodbye.
I wonder why.
I'm standing now where you made your vow,
So blue for you I could cry...
I'm like the poor leaves that swayed with the breeze.
I thought that life was sweet.
You are the sweet breeze that tried hard to please,
Then swept me off my feet.
Summer morning dew turns to frost.
Leaves that once were new pay the cost—
Beautiful to see, but reminding me
Of a faded summer love.

A Distant and Faraway Look

Newspaper reports about doomed romantic affairs weren't the only startlingly relevant writings that juries in 1935 and 1936 were deprived of but are available for our perusal today. Another key document that was never made public at the time has only recently turned up in an unexpected place in the basement of the Moore County Courthouse. It was in a bundle that a clerk had long ago filed away under "B" for Isabelle Baer, perhaps simply because Elva's friend Isabelle was the only plaintiff to show up in person at the hearing. Its contents make painful reading.

The tattered old brown file folder contains a hodgepodge of several incidental items: a summons for Pinehurst Resort president James W. Tufts to appear in court and testify (he got out of it); an order to produce all telegrams sent or received by Brad or Elva during their engagement and brief marriage (some of them would be read to the jury); and a request from the Packard Company asking that the car in which Elva's body had been found, the 1934 Roadster purchased on April 21, 1934, for $5,950, be impounded since Brad—surprise!—had not kept up the payments on it.

But the primary document in the folder is a bulky statement filed with the clerk of Moore County Superior Court on July 11, 1935—four months after the inquest in Pinehurst and eight months before the caveat case would be heard in Carthage. The statement bears the signatures of the lawyers for Elva's institutionalized brother, Ellsworth Morgan Statler, and her little niece out in Arizona, Joan Marie Statler. They set forth the argument they will be making for throwing out Elva's second will, the one leaving everything to Brad. The further they go, the more they describe a young woman who

had suffered so many psychological blows that she had been reduced to practically a zombie state:

> *The caveators are informed and believe and so allege that the said purported will was not and is not the last will and testament of Elva Statler Davidson, deceased, for that in the execution of the same…the said Elva Statler Davidson was unduly influenced with respect to such execution of the same and with respect to the provisions contained therein, such undue influence so exerted being of such nature and to such extent as to destroy the free agency of said testator with respect therein and to cause her to do that which she otherwise would not have done.*

The legal language flows on in its almost Elizabethan majesty. In lay terms, the lawyers—apparently getting paid by the word—are saying that Elva's will doesn't reflect her true wishes, since she wrote it at a time when she was under such pressure that it had destroyed her ability to make an independent decision. And the document leaves little doubt as to who was doing the pressuring. "That the propounder, H. Bradley Davidson Jr. or W. Barton Leach…or both acting in concert, unduly and unfairly and wrongfully induced the said Elva Statler Davidson to execute said purported will against her will and contrary to her natural wishes and desires."

When Brad had met Elva, the lawyers say, he was "practically without funds or financial resources." And shortly before the marriage, he was heard to state boldly that he "expected to live on Elva's income." The paper notes that Elva, though "utterly untrained and impractical in matters of business and property," had come into possession of "a very large estate" on February 14, 1935, and executed a new will on the very next day, making her new husband the sole beneficiary and fixing him up with an annuity for life. And twelve days later, the lawyers remind, "the said Elva Statler Davidson was found dead in the garage of her home at Pinehurst, North Carolina, under strange and mysterious circumstances."

Attorney Leach, it is noted, received "very large compensation, in excess of $25,000" (more than a quarter of a million dollars in today's terms) as legal advisor to Elva. But then, after objecting "strenuously and violently" to the marriage, he suddenly saw on which side his bread was buttered and "changed his attitude and became exceedingly friendly with the said H. Bradley Davidson Jr." Thereafter, the domineering Leach, "acting at the instigation of and for and on behalf of said H. Bradley Davidson Jr.," is

accused of repeatedly badgering the already unstable and impressionable Elva to change her will—going so far as to send her a letter to that effect while she was still on her honeymoon. In other words, they ganged up on her.

The Caveators are informed and believe and so allege that the insistence on the part of said H. Bradley Davidson Jr. and on the part of said W. Barton Leach with respect to the said Elva Statler Davidson making a will had a very depressing and troubling effect on the mind and will of said Elva Statler Davidson…

That frequently after said marriage and prior to the date of the execution of the said will she was observed to be in moods of despondency and evident unhappiness and distress; that as caveators are informed and believe, such unhappiness and distress was due very largely to the fact that the said Elva Statler Davidson was being unduly induced and virtually driven to the execution of a will which she did not desire to make…

That the said Elva Statler Davidson…was subject to moods of despondency and mental depression, which condition was augmented and accentuated by the death in the late fall of 1933 of her brother, Milton Statler, who was killed in an automobile accident…that subsequent thereto the condition of said Elva Statler became such that she was treated by a prominent psychiatrist specializing in the treatment of nervous and mental diseases in Boston, Massachusetts.

So she was seeing a shrink. And the depositions prepared for the caveat hearing make clear who this "prominent psychiatrist specializing in the treatment of nervous and mental diseases" was: Dr. Richard P. Stetson of Boston and Cambridge. He testified on paper that he had treated Elva in the Harvard University hospital in 1934, while she was a student at Radcliffe. In describing her condition, he painted a portrait of a virtual psychological basket case. Elva had come (or been sent) to him, he said, because of symptoms such as "halting speech" and "crying spells," which Stetson said were "entirely emotional." He assigned her symptoms to "an emotional shock to her unstable nervous system" and said they were probably attributable to the death of her foster brother, Milton. And we now know that they might also have been aggravated by a couple of intense love affairs gone bad.

"Were the emotional ups and downs of Miss Statler the emotional ups and downs of the average person or were they greater?" one of his interviewers had asked, as a stenographer took notes.

192

"I would say they were greater," he readily responded.

Reinforcing that finding was Robert D. Field, an art instructor who had befriended Elva, who is quoted as making this riveting comment: "She told me she guessed she was just no good."

The sessions with Dr. Stetson had apparently helped Elva, but only temporarily. Then things had taken a more ominous turn.

> *That while this condition of moodiness and periodic mental depression was, following such treatment, greatly improved, it was subject to recurrence; that as caveators are informed and believe, such condition did recur following the marriage of Elva Statler with the said H. Bradley Davidson Jr…*
>
> *That said Elva Statler Davidson at a dinner in Pinehurst on February 8, 1935, just seven days before the execution of said purported will, was observed to be in a condition of deep and desperate mental depression, giving way to tears and other manifestations of unhappiness, and that when talked to at such times by intimate friends, she expressed great unhappiness and avowed the intention of taking her life.*

Clearly, the piano-bench conversation with Herb Vail wasn't the only one in which Elva had spoken of "taking her life." These descriptions summon up an image of a young woman who feels terribly isolated, living alone there at Edgewood Cottage, still reeling from the end of a love affair, with no family or best friend nearby to lean on or cry out to, trying to deal with this bout of depression all by herself.

> *That on the day on which the said Elva Statler Davidson executed the said purported will in the office of said W. Barton Leach in Cambridge, Massachusetts, she was admittedly ill and was observed by friends to have "a distant and faraway look";*
>
> *That by reason of these circumstances and previous observation, these friends and acquaintances, including even the wife of said W. Barton Leach, on hearing twelve days later of the reported suicide of said Elva Statler Davidson, observed that it was just such an event as they were expecting to happen.*

Among those deposed were a Harvard couple who had befriended the student Elva. They both began by trying to portray her as normal, though in the end they can't be said to have succeeded.

Robert D. Field, an instructor in fine arts, said Elva had "problems growing out of her status as an adopted child" and was "subject to moody spells as we all are." But he insisted that she "gave no evidence of undue emotionalism, taking into consideration her background and makeup." Under cross-examination, though, Field conceded that "she was considerably depressed."

Field's wife, Helen Stickney Field, wanted to go on record as saying that Elva had telephoned from Pinehurst after her honeymoon to report that "she was very happy" and that "Brad is grand." But there was this peculiar addendum: "The deposition showed Mrs. Field declined a positive answer to the question whether Mrs. Davidson told her, 'I don't see how I can go through with it.'"

Go through with what? The marriage? The will? Her life? And what did "declined a positive answer" mean? It might have meant that the witness had clammed up or equivocated when asked that question. But if Elva had never told her, "I don't see how I can go through with it," wouldn't a simple "no" have sufficed?

Two witnesses for the caveators testified in person, according to a partial transcript of the once-missing third day of testimony. The first was Dr. T.A. Cheatham, a Pinehurst minister, who told the jury that Elva was "melancholy and perturbed" at the charity ball on the night before her

A youthful Elva jumps her horse at Pinehurst on an undetermined date. *Courtesy of the Tufts Archives, Pinehurst.*

death. The report on the second witness was a bit more compelling, though it raises more questions than it answers: "L.M. Tate, manager of a riding stable at Pinehurst, said that on February 25—two days before her death—Mrs. Davidson came to the stables to arrange for a horse and during a conversation with him said, 'I have been having quite a bit of trouble.'"

<p style="text-align:center">***</p>

In a story loaded with twists and tangles, here is yet another odd footnote: L.M. Tate, the stable manager who testified in the caveat hearing that Elva had confided in him about her problems, was none other than the L.M. Tate who had served a year earlier as the jury foreman in the coroner's inquest!

This gives rise to questions of its own: Did Tate make this conflict known? Did he share the stable conversation with his fellow inquest jurors? Did that revelation affect their verdict? Even if he kept it to himself, didn't it color at least his own vote? For that matter, did Tate know even more than he told?

Though L.M. Tate apparently never shared those secrets publicly, his son, Floyd Tate, was still alive in Pinehurst at this writing—and was privy to some details that his father had told him many years ago about his role in the Davidson case. But he was suffering from a stroke that had severely affected his speech, making it all but impossible for him to communicate. That became clear in a telephone call to his house. His wife answered. After being filled in on the case and the information being sought, she put the phone down and asked if he wanted to talk about it. He could be heard in the background groaning, "No, no!" Mrs. Tate returned to report that her husband definitely wanted no part of an interview. But she agreed to ask him just one more question: whether his father had thought Elva's death was a matter of murder or suicide.

More labored conversation was audible. Then Mrs. Tate came back to the phone, apologizing that she couldn't get much more than a word out of her husband. "Please," she said. "He doesn't want to talk about it anymore. It gets him too upset. But he says—suicide."

CHAPTER 25

The Shore of that Eternal Sea

To balance the Floyd Tate quote that ends the previous chapter, perhaps it is only fair to begin this final one with an indirect quote from another individual who also had personal knowledge of the Davidson affair: Hemmie Tufts, an in-law of the founding Pinehurst clan. Hemmie, who died in 2005, no doubt had many stories to tell, since she had been instrumental in bringing Elva and Brad together and knew the couple as well as anyone. It is her son, Fred, who made available her hard-to-decipher diaries, passages of which are quoted elsewhere in this book.

"From time to time when I was a kid," Fred recently said, "I'd badger my mother to tell me about Elva's death. I've always found it so fascinating."

So what did she think happened?

"To be perfectly honest," Fred said, "it depended on how many martinis she'd had. With every drink, it would go further away from suicide to—well, let's just say not suicide."

It is worth noting, however, that Hemmie Tufts never came forth to testify to that effect—something it would have been her duty to do if she had anything concrete to back up her suspicions. There may also be a broader significance to be found in her son's observation that she apparently tended to believe Elva's death was a suicide when she was sober and only swung over toward the murder side when she was—well, let's just say not sober.

So it is with all of us. Human nature being what it is, we want to believe that Elva Statler Davidson's death was murder most foul and that Brad Davidson did it. If nothing else, it makes a better story that way.

The 1935 Elva Statler Davidson Mystery

A typical reaction is that of Khris Januzik, former director of the Tufts Archives in Pinehurst. In all her years in her job, she once said, two or three stories had stuck with her, and Elva's was one of them. She had always wanted to investigate the case further but had never found the time. "Elva always just kind of yelled at me from the photographs," she said. "Here you have this lovely young woman, and she comes down here hoping for something good to happen to her, and then—boom—she's dead. And it's like, why is there so very little known about her? And why is it all sort of packed away somewhere? Why was it all hushed up? And then I start looking at her husband, and he dropped out of those circles and was completely gone. I don't know. Maybe I've been watching too much television—*City Confidential* and *Forensic Files* and stuff like that. But I keep thinking, 'Hmmm. I wonder...'"

We all wonder. But, though our hearts may tell us one thing, our heads keep insisting on another. In our sober moments, we have to acknowledge that there was never a shred of hard evidence (as opposed to the circumstantial kind) that Brad could have been guilty of uxoricide, or the killing of one's wife. On the other hand, everything that has been learned so far—and surely there can't be a lot more to be learned—tends to compel us toward one melancholy, reluctant conclusion: though she clearly had so much coaxing that some may consider it a kind of murder, the facts strongly suggest that poor, confused, tormented Elva Statler Davidson simply killed herself.

Or not so simply.

To anyone who has read this far, vexing questions must remain about the baffling set of circumstances surrounding Elva's death. They include many of the same questions that led officials back in late February 1935 to throw up their hands and reopen what might otherwise have been an open-and-shut case, thus turning a local tragedy into a nationwide sensation. But to those inclined toward the suicide theory, each of those questions, considered in the light of all that has since come out, now seems susceptible to a logical answer—though not always a likely one.

First of all, there is no reason at all to wonder why Elva was so distraught on the night before her death. She was already unstable and traumatized

enough, for plenty of good reasons. It would be a wonder if she hadn't spiraled into an inconsolable state after losing at least one man and then learning that the man she had just married—and willed her fortune to—was a jerk who was already cheating on her and in cahoots with her lawyer. That would help explain, by the way, why the two of them were already sleeping in separate rooms.

Nor need there be any lingering mystery about the front-porch, after-party argument over what to do with the Packard. If Elva had recently confided in Herb Vail and others that she thought maybe "the best solution would be for me to go out into the garage and turn on the motor," it must have gotten back to Brad. So when she began talking about taking the car back to the garage at that ungodly hour, especially in her volatile and perhaps intoxicated state, surely it would only be natural for him to try to keep that from happening. Though the little spat would have seemed pointless to their houseguests, that is only because they lacked some necessary background.

As we switch to the next morning, we confront three central questions: (1) Why was Elva's body still noticeably warm to the touch when she was found? (2) How did she end up in such a strange position? And (3) Why was she dressed so oddly? The latter two require us to venture a little further into the area of speculation. But with all three, there are scenarios capable of making perfect sense.

As for the first question, an anecdote from Jamie Boles, a local funeral home operator and state legislator, sheds an unexpected light into one little corner of our story. During an interview about the traditionally high suicide rate in the supposedly blissful resort paradise, Boles recalled one call he got about a lonely recent widower who had done himself in by closing up his garage and turning on the engine of his luxury sedan, which idled for hours. "He and his wife had had all these cases of soft drinks stacked up out there," he said. "And it had gotten so hot in the garage—from all that exhaust—that every one of those hundreds of cans of soda had burst. That concrete floor was just flooded with Coca-Cola and Seven-Up and Dr. Pepper."

For our purposes, Boles's story causes a red light to click on. From now on, whenever we wonder how Elva's body could still have been warm when Dr. Myron Marr examined it, even though the temperature had fallen well below freezing during the night and she had apparently been dead inside that unheated garage long enough for rigor mortis to begin setting in, all we have to do is remember all those exploding Coke cans.

Next, the position of the body. To understand one possible explanation, picture Elva deciding, at some point after the others in the house have gone to sleep, to slip down and go for a predawn ride in the Packard to think things over (something she had often done in the past). Perhaps she even sets out to keep that early morning golf date, if there was one—which would explain the tees and other items rolled up in her sweater. But somewhere along the way, she gives in to her overwhelming suicidal impulses and heads back. Or, more likely, she makes that fateful decision in her room and just goes directly downstairs and to the garage, perhaps after moving the car there.

Either way, she ends up pulling the big jointed door closed, starting the engine and sitting down behind the wheel—or elsewhere in the chamber—to wait for the roiling carbon monoxide fumes to take their deadly effect. But as the minutes tick by, she panics or gets cold feet and decides to get out of there. By that time, though, she is almost too weak, dizzy or disoriented to walk straight. Then, while trying to find the exit, she remembers to go back and turn off the ignition. She makes it to the driver's-side door, makes one final, feeble effort to reach across for the key and collapses—in that oft-described posture of one trying to crawl *into* the car.

We now arrive at the state in which Elva's body was found. First, the bruises: nobody has ever made much sense out of the pattern in which they were found. She was a spirited horsewoman who enjoyed tennis and other active sports. Maybe there really was some kind of sexual confrontation that night, with Brad trying to pin Elva down and claim his rights as a husband. Or maybe she thrashed around in her death throes, inflicting some of the contusions on herself. In any case, there seems little reason to concern ourselves with the bruises. They have never added up to anything.

Similarly, the lack of underwear, however titillating, may also be of little significance in the end. Back in her room, Elva had already undressed for bed, at least according to Brad's testimony. If so, she would therefore have been nude under her nightgown. If she later decided to go down and take her own life, she would have tossed the gown on the chair—where the maid said she later found it—and started pulling on whatever clothes were handy. In her agitated and highly distracted state, would underwear have ranked high on her priority list? The reason for wearing slippers instead of shoes should be obvious: she didn't want anybody to hear her going down the stairs and out the door.

Which brings us to that eternal puzzle of the wool skirt, which was found to be two or three sizes too big for Elva. Why in the world was she wearing

it? Fact is, she may never have worn it at all. There are a couple of possible explanations, both a bit far out but worth consideration. And neither involves foul play.

First possibility: Elva was, indeed, wearing a skirt that morning. But in the excitement after her body was found, it got mixed up with another one, which then found its way into the evidence locker. That could have happened at the hospital amid the lengthy scramble to try to revive her. More likely, it could have happened when Assistant Coroner Hugh Kelly drove to the Southern Pines funeral home to retrieve Elva's clothing. According to that story, it will be remembered, the attendant produced the slippers and sweater but became frantic when he went outside to get the skirt, only to find it missing from a clothesline, "to the consternation of all concerned." A nearby fireman later supposedly produced the skirt, saying he had taken custody of it when he saw some boys attempting to steal it. But is that unlikely story what really happened? Or did Elva's real skirt go missing at some point, perhaps stolen by the boys, only to be replaced with another one of a different size by someone trying to cover his tail? That would help explain why the skirt and sweater were described as "mismatched."

The second possibility is rather more intriguing: what if Elva was *nude* when the butler found her? Stranger things have been discovered at suicide scenes. Elva, after all, had just learned that Brad was involved in a relationship with someone else, and hell has no fury like a woman scorned. In her hysterical reaction, perhaps she undressed and presented Brad with a furious, twisted message: "You wanted a naked woman's body? You're looking at a naked woman's body." According to this script, Brad and the others huddled around her the next morning do not want her to be seen in such an embarrassingly indecent state. They decide to get some clothes on her quick, before the doctor gets there. So they send Edna running inside the house, but she doesn't know where Elva keeps her clothes, so she just grabs one of her own skirts and sweaters and comes running back out with them. Then they proceed with the grim and hushed business of dressing the body there on the cold garage floor, discreetly agreeing among themselves never to breathe a word about it.

The 1935 Elva Statler Davidson Mystery

Or not.

Those who cling to the murder explanation would challenge much of the above. For one thing, they would ask whether any of the primary witnesses could be believed at all, since several appear to have been paid off. During his merciless grilling of Brad during the 1936 caveat hearing, attorney J. Melvin Broughton pointed out what he considered a remarkable fact. Virtually everyone around the Davidson home the night of Elva's death, he said, had since been employed by Brad's friends and relatives. Brad, on the witness stand, attempted to shrug that off. "Well, they were out of work," he said, "and these jobs opened up."

Houseguest Curtis Campaign was a regional executive with the British toiletries company Yardley. After the inquest, it seems, he bestowed a nice position with Yardley upon Herbert Vail, the Davidson friend who offered that climactic testimony about Elva's supposed suicidal musings. That employment arrangement would remain the subject of gossip in some Pinehurst circles for years. But Vail wasn't the only one to land a job. Under prodding from Broughton, Brad confirmed that the Campaignes had since employed Emanuel Birch, the butler, and that Vail and Brad's brother Richard had hired "other servants." The clear suggestion of bought testimony or purchased silence hung in the air, and we can't brush it aside—although in an actual murder trial, any defense lawyer would surely attempt to have such evidence thrown out as strictly circumstantial.

The most prominent example of changed testimony, of course, is that of Vail, who first said on the stand that Elva seemed okay but then, in that climactic final day, told his story of suicidal thoughts poured out at the piano. Only one other instance comes to mind, and it is relatively obscure. At one point during the inquest, after Curtis Campaigne told of the argument about the car and how it was ultimately left outside, Solicitor Pruette asked him if he hadn't said earlier that Elva had put the car in the garage and then returned to the house that night. He said he couldn't recall saying that, and the matter was dropped.

In murder trials, lawyers always try to convince jurors of the presence of three elements: means, motive and opportunity. Brad certainly had a motive: money. And the timing of Elva's death, just days after she had signed most of

her wealth over to him, is impossible to ignore. He had plenty of opportunity. But what means could he have employed?

In that regard, much has been made of the "raised red area with a puncture in the middle" that the autopsy report said was found on Elva's left arm. That cryptic reference has given rise to much fevered speculation about a "strange and scientific murder" involving immobilizing the victim with some kind of hypodermic injection and then carrying her out and placing her in the car.

But let's take a closer look.

Asked during the 1935 inquest whether the puncture could have been made after death, Dr. C.C. Carpenter, in charge of the autopsy at Wake Forest, barked, "Absolutely not!" Carpenter also said at the inquest that "a needle puncture was made *in her chest* to inject adrenaline."

But when the aforementioned missing third day of caveat testimony finally turned up recently, it told a different story. Dr. Myron W. Marr, the Pinehurst house physician who had first received the call about the discovery of Elva's body, was called back to the stand. And here the good doctor tossed off a critical bit of testimony almost as an afterthought. "Describing the position of the body as kneeling on the running board," wrote the AP reporter, "Dr. Marr again asserted that he did not believe Mrs. Davidson's body could have fallen into the position in which she was found dead of carbon monoxide poison in her garage."

And then: "Questioned about a bruise on Mrs. Davidson's arm, he said it was caused by *a hypodermic given her in an effort to revive her.*"

Could it really be that simple, that the doctors just gave Elva a shot in the arm on that first morning in the hospital in a failed attempt to bring her back to life? Nothing sinister at all? Then why didn't Marr mention that important fact at the inquest, assuming he didn't—especially when Dr. Carpenter had said in his inquest testimony that the injection was given in the chest?

One might be tempted to theorize that Marr committed perjury the second time—that Brad or Leach or somebody got to him and he lied. Why else would he go along with one version while the case was still fresh on his mind—that the shot had been given in the chest—and then conveniently change his story a year later? But a careful reexamination of the inquest clips appears to straighten the story out. Dr. Marr, after all, didn't say anything about a shot in the chest. Or if he did, it was never reported. That tidbit had come instead from Wake Forest's Dr. Carpenter. "I *understand* that a needle puncture was made in her chest to inject adrenaline," Carpenter had said,

"but none was made in the arm." He understood that. But he wasn't there at the hospital.

So why hadn't Marr, who supposedly administered the shot in the arm with his own hands at the hospital, set the jury straight on that critical error in Carpenter's hearsay testimony? It seems likely that he never knew Carpenter had said that. Solicitor Pruette, after all, had taken pains to sequester witnesses from one another so they wouldn't try to get their stories straight. Marr would have been outside the Community House when Carpenter made his comment about the supposed injection in the heart, and he wouldn't have read about it in the papers until later, if ever.

In one of Arthur Conan Doyle's stories, Sherlock Holmes solves a mystery because of "the dog that didn't bark"—something that didn't happen. This story includes a similar important negative: though the very thorough autopsy report takes pains to describe a puncture wound in Elva's arm in detail, it is silent about any such needle wound in that pigeon-breasted chest of hers. She was given only one shot, and it was in her arm, and its purpose was to revive her.

In the end, only two people ever knew for certain whether what happened on that morning in March 1935 was a heinous felony or a mere tragedy. And neither is in a position to shed light on any of the lingering questions.

The first of those two people lived on for thirty-seven more years and now lies in Upperville cemetery in the Shenandoah Valley of Virginia, under a bulky stone whose inscription reads:

H. BRADLEY DAVIDSON, JR.
Sept. 10, 1892–Aug. 8, 1972
Bethesda, Maryland
World War I—World War II
Lt. Colonel

The stone stands in the extreme corner, in the very last row on the far eastern edge of the cemetery. Right next to an open meadow, it is in a position to be among the first to receive the rays of a rising sun. On the reverse side

is the carved notation "Elizabeth Bishop Davidson, 1909–1998." That was Brad's third wife, Betty, with whom he apparently enjoyed a long and happy (and financially secure) marriage.

To visit there is to wonder why Brad chose that spot, scarcely twenty miles from the former Retreat estate where he and his first wife, Jessica, briefly lived, for his final resting place. Here you have a rootless man who lived in Washington; Baltimore and Annapolis Roads, Maryland; rural Virginia; Waukegan, Illinois; Milwaukee; Ormond Beach, Florida; Massachusetts; and at least two towns in upstate New York—not to mention Pinehurst. This wasn't even his original home. He had been born in the Washington area. This was Jessica's country. It was she who had inherited Retreat. Considering all the ugliness surrounding their long-ago divorce, surely this would have seemed the last place in the world where he would have wanted to be caught dead. After all those years, did he still cherish memories of that young and innocent time, before America got sucked into World War I and everything in his life began to fall apart?

A visitor familiar with the Pinehurst mystery also can't help wondering whether Brad took a dark, hideous secret with him to his grave. Or will he just keep sleeping on peacefully there through eternity with his conscience blissfully clear and, as a newspaper account once said, "his thin face smilelessly imperturbable"?

<p style="text-align:center">***</p>

The second person who knew what happened in the predawn chill in that garage out behind the house next to Edgewood Cottage has lain for seventy-five years under a modest, flat stone marked simply:

Elva Statler Davidson
1912–1935

Her grave is located on a slope in Kensico Cemetery, affording a peaceful vista eastward toward the town of Valhalla, New York, partially visible below along the wooded shore of Rye Lake. Elva's marker is one of seven ranked from left to right in front of a massive upright stone with the single word "STATLER" carved on it in a stark serif typeface.

Elva's gravestone is in
the Statler family plot
in Kensico Cemetery
near Valhalla, New York.
Courtesy of Diane McLellan.

On the far left is Marian Francis Statler, 1907–1927. She was Elva's foster sister, who died a slow and terrible death from pneumonia. Then comes Milton Howland Statler, 1906–1933, her older foster brother, killed in that grinding car wreck in Arizona. Next: Alice Seidler Statler, 1882–1969. The wicked stepmother. Ellsworth M. Statler, 1863–1928, occupies the center space. The patriarch and hospitality king arranged to check into a berth between those reserved for his two wives. The first of them, Mary I. Statler, 1864–1925, Elva's adoptive mother, comes next in line. Elva is sixth, and last is a newer stone, less stained and chipped than the others: Ellsworth Morgan Statler, 1912–1987. Elva's mentally handicapped foster brother (and probably her birth twin as well), Ellsworth, survived her by more than half a century, living out his last years with a couple in Palm

Springs, California, who had taken him into their home after the lawyers had run through all his money.

A comforting sense of calm lies over the manicured landscape all around. In the late 1880s, those who began building Kensico from the ground down—seized with the same utopian sense of optimism and idealism that motivated James Walker Tufts to found distant Pinehurst a half-dozen years later—wisely placed it in a rural area more than thirty miles northeast of New York City. There, they pledged, this "Great City of the Dead" would be forever safe from encroaching urban sprawl, and the rights of the deceased would be permanently protected.

Kensico's promotional people worded that assurance in terms of a sublime promise that one can only hope will someday come true for the poor little rich girl buried under that sixth stone from the left:

> *Those who are interred there will sleep in peace, awaiting the dawn of the glorious day when death itself shall pass away, and there shall be reunion on the shore of that eternal sea where those who meet shall part no more.*

About the Author

S teve Bouser grew up in Missouri, served as a Russian linguist in the U.S. Army, graduated from Southwest Missouri State University (now Missouri State) and worked at papers in Wisconsin and Florida before moving to North Carolina in 1973. He is now editor of *The Pilot*, a prize-winning community newspaper serving Southern Pines/Pinehurst. From 1993 to 1997, he worked with media assistance programs in Russia and other former Soviet countries. He and his wife, Brenda, have a daughter, Kate, and Steve has two sons, Jacob and Benjamin, from a previous marriage. His one-man play, *Senator Sam*, has been produced numerous times, and his play *Ben*, about Benjamin Franklin, is now being prepared for production. He is working on a memoir of his Russian experiences. He has aired a number of commentaries on NPR and teaches journalism at the University of North Carolina at Chapel Hill.

Visit us at
www.historypress.net